# SCENES OF INDEPENDENCE
## CULTURAL RUPTURES IN ZAGREB (1991-2019)

Sepp Eckenhaussen

DEEP POCKETS

DeepPockets #3
*Scenes of Independence: Cultural Ruptures in Zagreb (1991-2019)*
Sepp Eckenhaussen

Preface: Leonida Kovač

Editing: Miriam Rasch and Rosie Underwood
Cover design: Laura Mrkša

Institute of Network Cultures, Amsterdam, 2019
ISBN 978-94-92302-40-3

**Contact**
Institute of Network Cultures
Phone: +3120 5951865
Email: info@networkcultures.org
Web: http://www.networkcultures.org

This publication is published under the Creative Commons Attribution-NonCommercial-NoDerrivatives 4.0 International (CC BY-NC-SA 4.0) licence.

This publication may be ordered through various print-on-demand-services or freely downloaded from http://www.networkcultures.org/publications.

| | |
|---|---|
| 6 | HOW TO USE THIS BOOK? |
| 8 | PREFACE BY LEONIDA KOVAČ |
| 12 | INTRODUCTION: A MAPPING EXERCISE |
| 26 | PART I GENEALOGY: HOW ARE INDEPENDENT CULTURES BORN? |
| 134 | PART II TODAY: WHOSE INDEPENDENT CULTURES ARE THESE? |

194 PART III DIMENSIONS OF INDEPENDENCE: WHAT IS INDEPENDENT CULTURE?

250 BIBLIOGRAPHY

272 ACKNOWLEDGMENTS: FROM AMSTERDAM TO ZAGREB, BACK, FORTH AND IN-BETWEEN

# HOW TO USE THIS BOOK?

This book consists of several differently themed and differently written parts. It contains a personal story of a journey between Amsterdam and Zagreb, a genealogy of Zagreb's independent cultural scene, a mapping of cores of criticality in Zagreb today, a search for futurologies, a critique of the notion of independence, and a theory of the scene. This manual is written to assist you in deciding what to read first or foremost. If you do not feel like being guided, it is recommended to disregard this manual and to start and stop reading wherever.

The *Preface* is a synopsis of the book's argumentation by one of Croatia's leading art historians, Leonida Kovač.

The *Introduction* is a mapping exercise which outlines a basic understanding of independent culture in Zagreb. Closing off this exercise, I position myself as a researcher and explicate the goal of my writing.

The main text of the book consists of three parts. If the first two parts focus mostly on organization, formation, positionality and politics, the latter part is concerned with formulation and theory.

The first part, *Genealogy,* is a historical account of independent cultures. Its central question is: how are independent cultures born? Based on interviews, participatory research, and (archival) literature research, I trace the birth of independent cultures to the point zero of 1991 and distinguish three subsequent stages after

that. The distinction of these phases are propositions towards a genealogy of praxis, in the Foucauldian sense, which tries to understand how new social constellations are born every time the hand of power redistributes the playing cards of life.

In the following part, *Today*, I discuss – freely, speculatively, and in solidarity – the current, lived condition of independent cultures and the struggles around civil society. In some sense, it narrates the fourth and, so far, last phase of independent cultures, but, at the same time, it connects the past to the future through the present and conjures the question: whose independent cultures are these? It could function as an opening up of the conversation with the scene in Zagreb, its practitioners, and its historians, and it sets the stage for the next and more theoretical part of the book.

Part three, *Dimensions of Independence,* is the theoretical core of the book. It addresses the central question: what independence is at stake in independent cultures? It is a proposition towards an aesthetic theory of independence as a renewed notion of critical culture, based on the embrace of untranslatability and the scene as regime in common/s.

# PREFACE BY LEONIDA KOVAČ

Would it be a matter of my fundamental misunderstanding if I argue that Sepp Eckenhaussen's book is an interrogative mode of acting in the same scene which is the subject of his (not only) academic and theoretical research interest? My understanding of the author's comprehensive inquiry of the syntagm 'independent culture', which has circulated in Croatian public discourse during the last three decades, is triggered by his statement (repeated several times in the text) that he has approached the subject from a semi-outsider position. While reading Sepp's wondering upon the meaning of that highly problematic expression within which numerous obvious contradictions are contained, I was trying to understand what that semi-outsider position signifies. To find the reason for such way of a researcher's self-determination, it would be inappropriate to merely point out the fact that the Croatian so-called 'independent cultural scene' emerged in the early 1990s partly thanks to the support of various organizations and philanthropic foundations which at that time were located in Amsterdam, where he lives today. Equally inappropriate would be to understand his semi-outsiderness as a flight from the standard relation between researcher and so-called 'native informers', characteristic of colonial academic disciplines.

In the introductory chapter, Sepp Eckenhaussen clearly states that his intention was not to write a history of that what is locally termed as independent culture but to do genealogical research on those phenomena.

When making this statement, he immediately poses the questions: 'How exactly can a genealogy intervene in the living discourse of the past at present? What does it mean to write a genealogy today?' His genealogical researches based, on one hand on the interviews with protagonists of the 'independent scene', and on the other on the critical reading of the available literature on the origins and manifestations of such cultural formations, led him to distinguish four dimensions of independence within a context of the post-Yugoslav socio-political environment in Croatia. Given that the 'independent culture consists of those actors that were pushed out of the institutions during the post-Yugoslav institutional crisis and regrouped in civil society, the formal dimension of independence in the context of Croatia thus mainly signifies a systemic position: independent culture is formally opposed to institutional culture'. Accordingly, he concludes that 'the very term independent culture is a topos of political contestation'. After meticulous multidirectional, trans-disciplinary and theoretically well-imbued analysis of the independent scene, he emphasized that independent culture is not and mustn't be understood as a sub-culture, and concluded that the last dimension of independence inherent to the scene of independent cultures in Zagreb is aesthetic independence. Writing that, Eckenhaussen is completely aware that 'from the moment of their birth, independent cultures created space for anti-hegemonic and anti-political subjectivities – but also for embracing neoliberalism'. About such a conclusion, I would argue that the main concern of his brilliant book, which began as a case study of something that was locally termed as an independent culture or non-institutional cultural scene, is the reflexion on the possibilities of the critical culture under neoliberalism. And it is exactly that

concern that, in this case, makes him simultaneously insider and outsider with regard to the subject of his research.

Reflecting on the independent culture's resistance to the so-called 'conservative revolution' that is currently taking place, seemingly paradoxically (since Croatia recently became a member of the European Union), Eckenhaussen warns the readers of the interrelation between neoliberalism and neoconservatism emphasizing that these phenomena are mutually stimulating rather than mutually exclusive. To his understanding, neoliberalism is essentially anti-modern economic progressivism which:

> abandons any traditional liberal-humanist aspiration of democratic emancipation in the name of the market and individual freedom. Accordingly, the liberal tradition of appreciating critical and emancipatory cultural practices is replaced with nationalistic and neoconservative reactionary cultural identity politics. In this definition, neoconservatism is the nationalist, post-historic, identity-political supplement of neoliberalism: a culture based on market fueled traditionalism devoid of the aspiration to emancipate or evoke a sense of historical justice. Neoliberalism and neoconservatism then appear to be two sides of the same coin.

In the final chapter, where he exposes a kind of (im) possible, futurological theory of independent culture, Sepp Eckenhaussen pays special attention to the notions of (un)translatability, as well as to the etymology of the word scene, pointing to the meaning and to the contexts in which parrhesia (in the sense of free speech) could be

performed. That is the point where this book becomes not only the first written genealogy of the Croatian independent cultural scene but a precious, challenging study that makes readers ask themselves what it is for that we need word 'art', and what we are doing when we're concerned with cultural production.

Zagreb, November 2019.

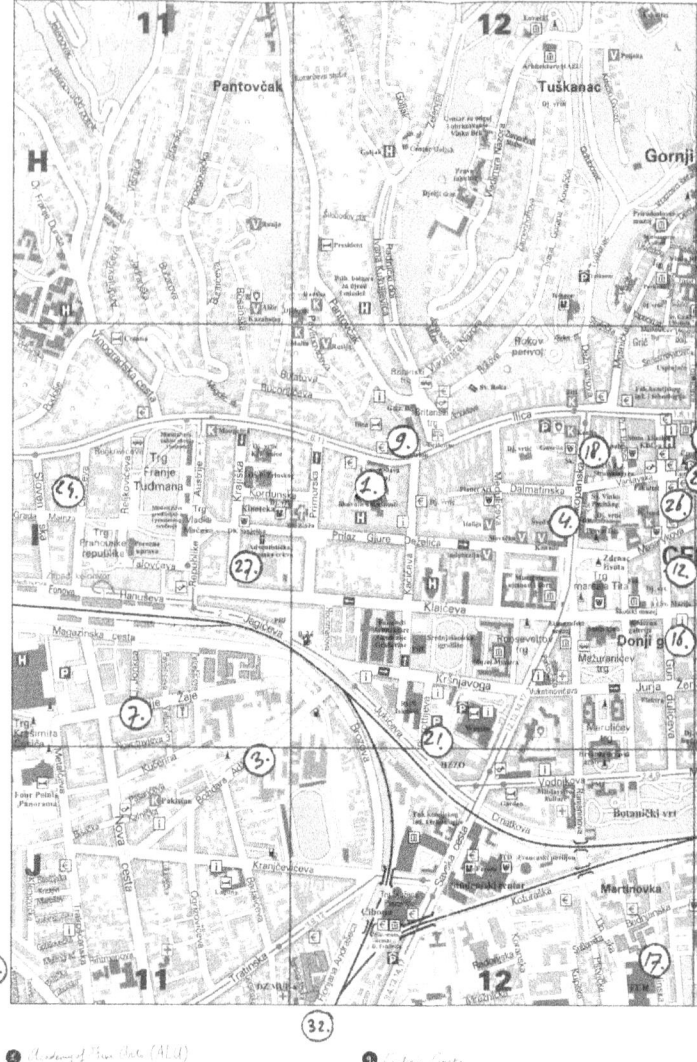

1. Academy of Fine Arts (ALU)
2. Art Show Gret
3. Bara Local Base for cultural Refreshment, BLOK
4. Center for Dramatic Arts (CDU)
5. Badel - Gyenie
6. Clubture
7. Domino / Zagreb Pride
8. Broken
9. Gallery Greta
10. Gallery Miroslav Kraljević (GMK)
11. Gallery Nova / WHW
12. Gallery Siva
13. Centre for Women's Studies
14. Croatian Artist's Association (HDLU) / PM Gallery
15. Institute of Political Ecology (IPE)
16. Kontejner - Bureau of Contemporary Art Praxis

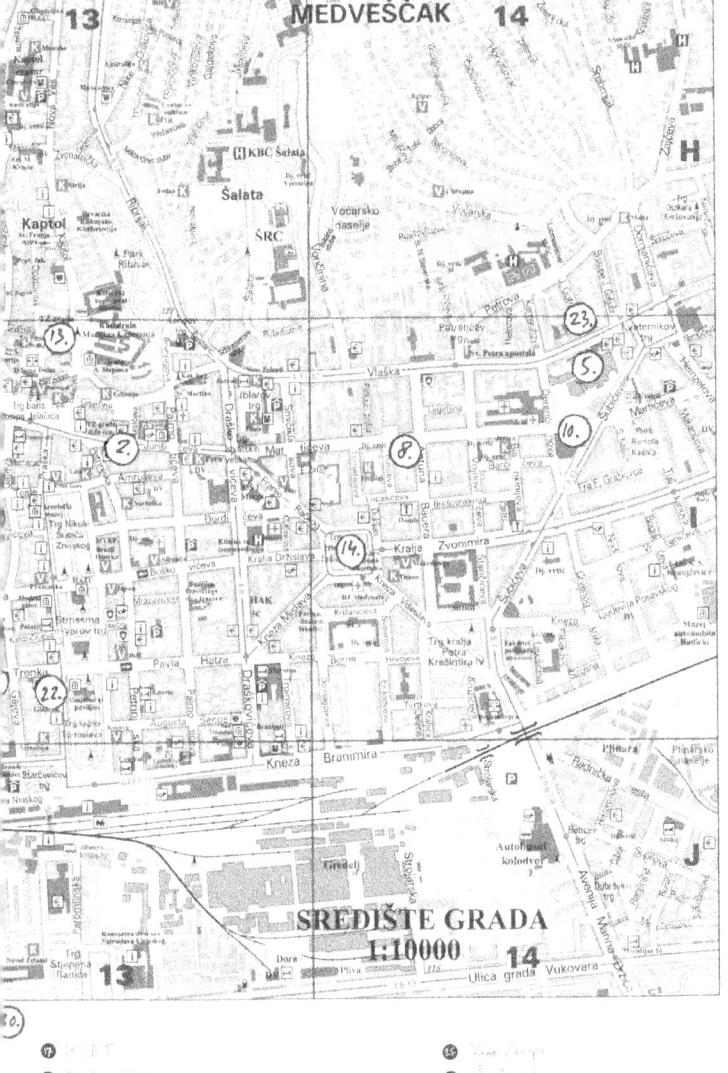

# INTRODUCTION: A MAPPING EXERCISE

Zagreb, Rebecca West says, 'has the endearing characteristic, noticeable in many French towns, of remaining a small town when it is in fact quite large'.[1] She wrote these words in the late 1930s, when Zagreb had just over two hundred thousand inhabitants. By 2019, this number has nearly quadrupled. Yet a similar feeling captures me while roaming the city today. It seems like Zagreb is a capital and a village at the same time. It is almost impossible to get lost in the streets, squares and parks squeezed between Mount Medvenica and the Sava River.

According to West, Zagreb's village-like character is 'a lovely spiritual victory over urbanization'.[2] A dubious compliment. Within a few years after West's visit, two hundred thousand refugees of World War II settled in the city, affirming that in Zagreb, too, the force of urbanization is more than capable of bending the laws of spiritual life. It could hardly be said that West was naïve, though. Her fist thick *Black Lamb and Grey Falcon: A Journey Through Yugoslavia* is widely regarded as one of the greatest – some say the most foreseeing – books ever written about Yugoslavia. It describes with

---

1   Rebecca West, *Black Lamb and Grey Falcon: A Journey Through Yugoslavia* (London and Edinburgh: Canongate, 2006(1942)), 47.

2   West, *Black Lamb and Grey Falcon*, 47.

finesse and wit the life of the Balkan peoples during centuries of hardships and the constant political quarrels amongst Serbs, Croats, Slovenes, Bosniaks, Albanians, and Macedonians. If anything, West's spiritualist interpretation of life in Zagreb hints to the understanding that this is a city that is not so easily readable.

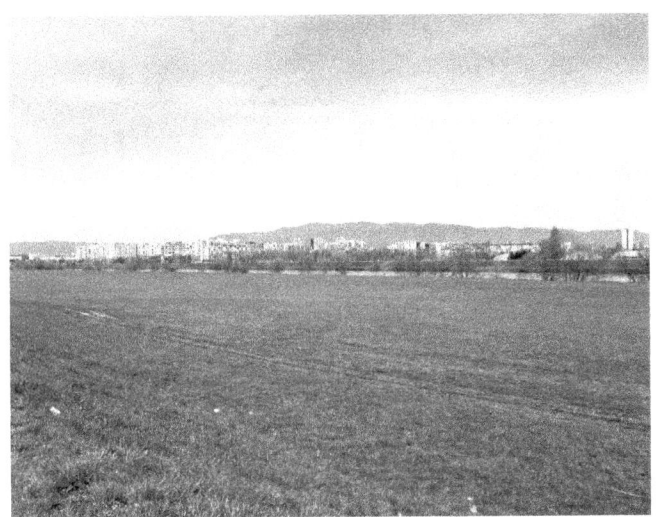

*Zagreb – between Sava and Medvenica.*

Zagreb is a fragmented city; its many neighborhoods seem to be different worlds. Even the city center, which is not very vast, is split up into three parts: one for politics, one for religion, and one for life. The old city, located on a hill and called Gornji Grad (upper town), is the seat of the Croatian government. From here, the county's rulers have a wide view over the rest of the city and the Pannonian Basin beyond it. Over the past decades, Gornji Grad's old age and altitude have also made it into a well-

visited tourist attraction. As a result, a visitor of Gornji Grad will encounter the strange mix of formal power and touristic entertainment usually reserved for royal palaces.

On the slope of the hill stands Zagreb's magnificent cathedral with its towers in eternal scaffolds, surrounded by the clerical complexes. This is Kaptol. Together Gornji Grad and Kaptol are the epicenter of Croatian political and clerical power, which are deeply intertwined.

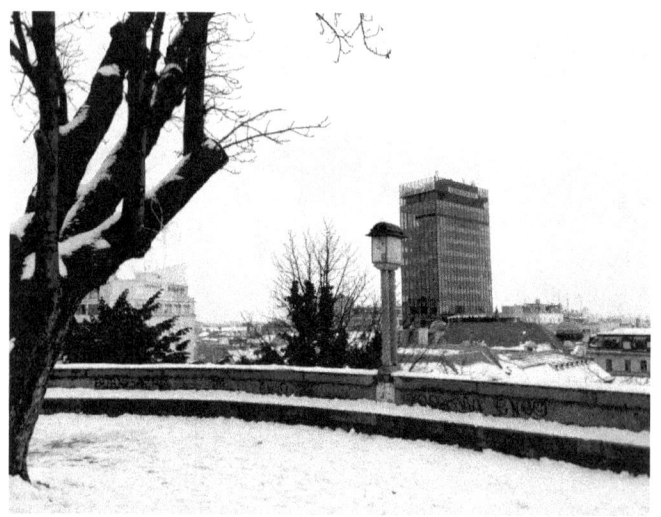

*A view from Gornji Grad.*

At the foot of the hill, Donji Grad (lower town) begins. This part of the city, built in the nineteenth century, is surrounded by Gornji Grad on the north and the Green Horseshoe on all other sides. The Green Horseshoe consists of three boulevards modeled after the Ringstraße in Vienna. Its main elements are leafy parks,

botanical gardens, and neo-renaissance pavilions designed to simultaneously impress and relax flaneurs and other passers-by.

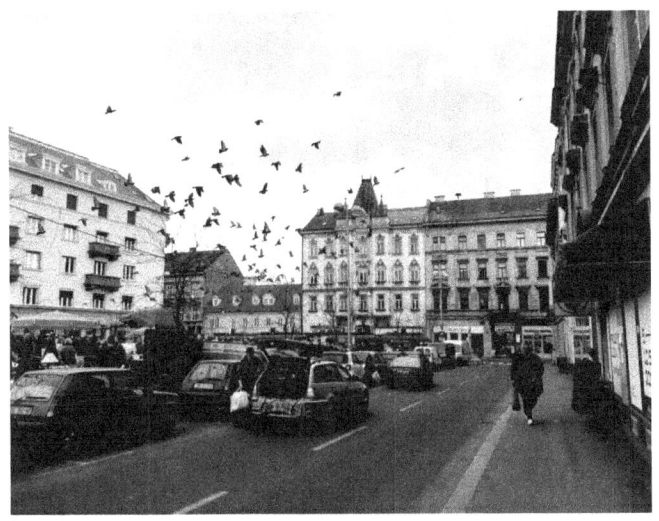

*The Britanski Trg market on an average weekday.*

In Donji Grad, one can find the main shopping street Ilica, restaurants, hotels, a handful of one-room cinemas, the botanical gardens, the train station, and the main square Trg Ban Jelačić - usually simply called Trg. It is here that public everyday life takes place. The fact that Zagreb's urban life is this concentrated is quite joyful since hardly a day of Zagreb life passes without a random encounter with a friend or colleague.

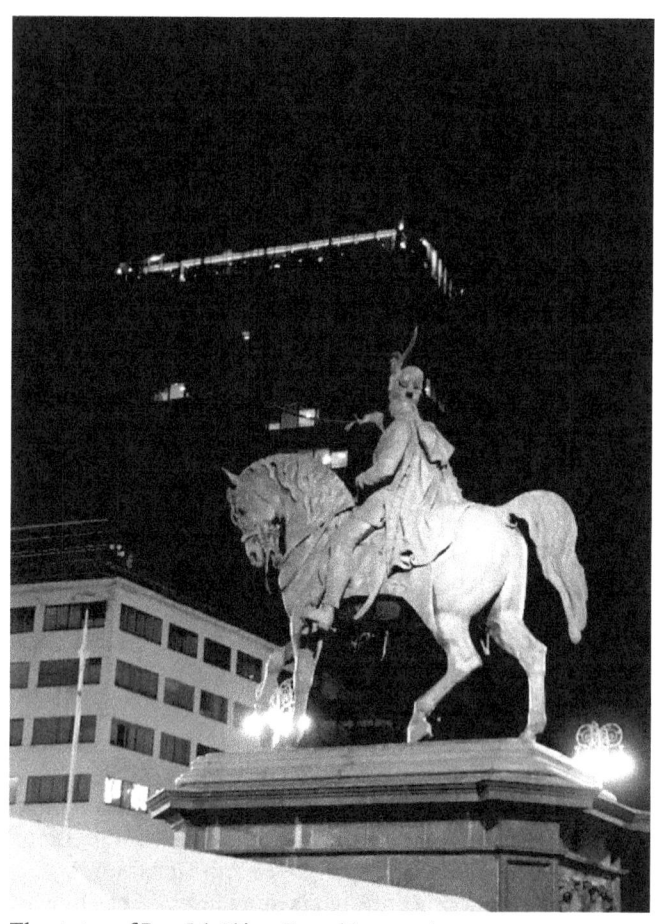

*The statue of Ban Jelačić on Zagreb's central square.*

A few kilometres to the East of the city centre one finds the green pearl of Zagreb: Maksimir Park. The huge park contains five basins full of turtles, a small zoo, a restaurant pavilion overlooking the tops of the trees, and enough lush green and small pathways to wander around

for a full day. No wonder young families, dog-walkers, sunbathers and tourists flock the park whenever the sun comes out. It was built by Zagreb's bishops in the late 18th century and was the first large public park in South-Eastern Europe. A statement of civilization. The famous Yugoslavian writer Miroslav Krleža, who can be called the archetype of Croatian authorship, wrote about Maksimir in his 1926 *Journey to Russia:*

> Where does Europe begin and Asia end? That is far from easy to define: while the Zagreb cardinals' and bishops' Maksimir Park is definitely a piece of Biedermeier Europe, the village of Čulinec below Maksimir Park still slumbers in an old Slavic, archaic condition, with wooden architecture from ages prehistorical, and Čulinec and Banova Jaruga to the southeast are the immediate transition to China and India, snoring all the way to Bombay and distant Port Arthur.[3]

So, this wonderful place of leisure, so progressive at the time of its construction, shows the particular of position Zagreb in cultural discourse; an explosive position on 'the fault line between civilizations'.[4] This strange place on the brink of East and West has for centuries played an important role in the identification of Croatian culture, both from inside and out, and contributed to the Balkan's reputation as the 'Powder Keg of Europe'.[5] For is it not inevitable that, when cultures so different from one another meet in one place, clashes ensue? Croatia is, in

[3]  Miroslav Krleža, *Journey to Russia*, trans. Will Firth (Zagreb: Sandorf, 2017), 26.

[4]  Samuel P. Huntington, 'The Clash of Civilizations?' *Foreign Affairs*, vol. 72, no. 3 (Summer 1993).

[5]  Georges Castellan, 'Les Balkans: poudrière du XXe siècle,' *Guerres mondiales et conflicts contemporains*, no. 217 (January 2005), 5-15.

other words, on the frontier of the Culture Wars.[6] Around the old city of Zagreb, beyond the comfort of the Viennese boulevards of the lower town and the picturesque alleys of the upper town, socialist-era architecture arises. Walking through the maze of streets and courtyards just south of the city center, a visitor might run into the impressive sight of the Rakete: a complex of three rocket-shaped towers designed by Centar 51 in 1968, which will soon be discovered by photographers with a brutalist fetish. And even further south, cut off from the rest of the city by the river Sava, is Novi Zagreb (New Zagreb). This part of town was built by the order of Marshal Tito to accommodate for a new, socialist urban life. Between the typical socialist high rises, a huge horse racing track was built, a new national library, and, more recently, the Museum of Contemporary Art. But despite these grand public works,

6   The Balkans have also been the battleground of military power struggles between West and East for centuries. The expansion of the Ottoman Empire was put to a halt by Western-European forces in the Balkans in the 16th and 17th century. In the early 20th century, the fall of the Ottoman Empire and the emergence of nation-states solidified the border between the liberal, Christian West and the Islamic East. Forced mass migrations and assimilations of ethnic and religious minorities took place, displacing Ottoman Christians West and Balkan-inhabiting Muslims East of the Bosporus. The friction caused between the ethnically and religiously diverse populations that had inhabited the Balkans for centuries, led to two Balkan Wars in 1912 and 1913. In 1914, by firing the mere couple of gun shots that killed Archduke Franz-Ferdinand of Austria, the Bosnian Gavrilo Princip triggered what was briefly considered the Third Balkan War, but is now known as the First World War. This series of events gained the Balkans their reputation as the 'Powder Keg of Europe', a reputation that was reinforced once again in reactions to the Yugoslav Wars in the 1990s. Moreover, the idea of the Balkans as a 'Powder Keg' was deepened by the rise of global identity politics heralded by the fall of the Iron Curtain in 1989. In *The Clash of Civilizations?* (1993), the American historian Samuel S. Huntington argued that after what Francis Fukuyama famously called the 'end of history', the 'great divisions among humankind and the dominating source of conflicts will be cultural. [...] The clash of civilizations will dominate global politics. The fault lines between civilizations will be battle lines of the future.' This theory was utilized, if not designed, to justify the US in upholding the aggressive foreign policy rhetoric it has used throughout the Cold War up to the present day. The argument that the Balkans are on the fault line of civilizations served in this agenda as a justification to keep regarding this area as the place where the West fights off the East. Huntington, 'The Clash of Civilizations?', 22.

social life in Novi Zagreb takes place mainly in the cafés of its malls and on the gigantic flea market Hrelić.

*High rises in Novi Zagreb.*

In this fragmented city with its many testimonies of a rich and turbulent history lives a unique culture. There is the culture embodied by the stately Viennese-style buildings of the Museum of Modern Art, the Archaeological Museum, the Art Pavilion, and the National Theatre, which take up unmistakably symbolic spaces along the promenades of the Green Horseshoe. But then there is also another, more interesting culture in Zagreb. This other culture emerged after Yugoslavia disintegrated in 1991 and Croatia became an independent state for the first time since the Middle Ages. Insiders refer to it as 'independent' or 'non-institutional culture'.

Independent culture is just as present in the city center as the grand institutions, yet not immediately recognizable to the outsider. A stone's throw away from the Archaeological Museum, hidden away in the arcade of a courtyard there is the small Galerija Nova. Galerija Nova is the only exhibition space in Zagreb structurally presenting art exhibitions which carry solidarity with migrants – a highly sensitive topic in this country on the border of the European Union. One block further still, in the back of another courtyard, Multimedia Institute and Hacklab MAMA is located, the base for Croatian media art and digital culture since the early 2000s. It also happens to be the best library in the fields of new media and commons in Croatia. A few minutes eastward by bike, in the poche Martićeva Street, there is a café which at first glance looks like any other. Once inside, however, it turns out that Booksa is a hotspot of cultural life, where cultural workers come to drink coffee, meet, work, and read. A few tram stops from Booksa, in the fold line between the railroads and The Westin Zagreb, there is an old pharmaceutical factory. Today, it is a former squat called Medika. Instead of medicines, it now produces punk concerts and glitch art exhibitions.

I could go like this on for a while. Because with every visit to one of these places, one meets people and finds out about other places like it: the experimental dance company BADco., curatorial collective BLOK, news outlet Kulturpunkt, youth culture hub Pogon, anarchist bookshop Što Čitaš?, the old socialist Student Centre, platform organizations Clubture and Right to the city, and Documenta – Centre for Dealing with the Past. Like a distributed web, these organizations permeate the urban tissue of Zagreb. They make up a village-like social system in which most people know each other

personally and have often worked together at some point. Independent culture is a scene.

Now, if I'm raising the impression independent culture is either a subculture or a purely local phenomenon, I should correct myself immediately. Independent culture includes well-known, (internationally) established organizations. A quick look at MAMA and Galerija Nova is enough to illustrate this point. MAMA's programs include many Croatian contributors, but also Catherine Malabou, Geert Lovink and Pussy Riot. The institute published the latest book by the French philosopher Jacques Rancière, one of my personal favorites amongst contemporary thinkers. WHW, the curatorial collective which directs Galerija Nova, works with internationally renowned artists like Mladen Stilinović, Sanja Iveković, and David Maljković. They have, moreover, been appointed as director of Kunsthalle Wien in the summer of 2019. While certainly embedded locally, independent culture is thus an internationally oriented scene.

It is hard to pinpoint exactly what type of culture is created in independent culture, while the practices of the various organizations in it differ so much. It includes but is not limited to dance, performance art, theatre, visual arts, new and old media, experimental cinema, festivals, education, community work, research, discursive programs, networking, and advocacy. It is clear that independent culture transgresses the boundaries of traditional cultural disciplines. The only general characteristic of their cultural programs is that, while all of these organizations work with culture, none work within the strict confinements of the art world or artistic production – a characteristic so common that it cannot define a scene.

So, what is it that connects the scene, apart from personal relations, a shared urban environment, and the fact everyone in it does 'something with culture'?
If anything, the organizations within independent culture are united by common political outlook (not to be confused with a political agenda). Their programming embodies a conglomeration of activist discourses leaning to the left of the political spectrum. Amongst other things, they focus on anti-fascism, pacifism, commons activism, feminism and queer activism, decoloniality, and ecological activism. Some would say that Yugonostalgia is rather common in independent culture, others would say that they're Yugofuturist.

In order to be able to have this political agency in the context of Croatia, which is predominantly ruled by right-wing and nationalist forces, the scene is organized separately from the state-funded cultural infrastructure. This shows by approximation what the independence is that holds together Zagreb's independent cultural scene. Being rooted in grassroots activisms rather than large institutions governed by state and local governments, independent culture claims to work, indeed, independently from the dominant power of the state.

But contradictions abound. From the moment of its emergence in the 1990s, the independent cultural infrastructure depended largely on international philanthropist organizations such as the George Soros Foundation, the Rosa Luxembourg Foundation, and the European Cultural Foundation, as well as for-profit organizations such as the Viennese Erste Bank. Then, since the mid-2000s, international funds have retreated from Croatia, making independent cultural organizations more reliant on state funding, effectively incentivizing them to engage in advocacy,

self-institutionalization, and cultural policy-making. It is questionable, then, how independent or non-institutional the independent cultural scene really is at this point. Is it a product of local urgency and grassroots engagement, or neoliberal and neo-imperial phenomena like globalization and cultural entrepreneurship? Is it possible that it is both? And if so, what is the interrelation between these forces?

In its analysis of independent cultures, the following text is at times sharp and critical. The struggles it speaks of are real, and addressing them can, as I have learned, be sensitive at times. Yet, in the end, my account is always informed by solidarity. I deeply appreciate the existence of the organizations gathered under the umbrella of independent cultures. Sensing the political subjectivity and collectivity of the scene, however fragile, is a relieving and inspiring experience, especially when coming from Amsterdam, a place where neoliberal hegemony is by now so complete that elements of collective resistance are nearly completely absent from the circuits of cultural production.

My goal in writing has been to instrumentalize my semi-outside perspective and to create an analysis that makes sense to and is useful for the reader in the local context. At the same time, I reckon that the question of independence (in- and outside of culture) is a globally relevant one. This book, therefore, discusses two different (although not separate) questions: What does independent culture in Zagreb look like to an outsider? And what insights do the struggles in Zagreb's independent culture provide into the regimes of global neoliberalisms in culture and beyond?

# PART I

# GENEALOGY: HOW ARE INDEPENDENT CULTURES BORN?

*Still from David Maljković,* Afterform *(2013). Courtesy of Annet Gelink Gallery.*

# Introduction

Where does this independent culture come from? What is its history? One thing is clear. Independent culture emerged concurrently to the break-up up of Yugoslavia in 1991, when war and systemic transition tore apart the existing social structures. After that, the history becomes more fuzzy and complicated. In my view, there are at least three subsequent phases in the history of independent culture after 1991, characterized by different attitudes, discourses, and material circumstances within and around the scene.

In the early years between 1991 to 2000, independent cultures were characterised by autonomism, pacificsm and anti-nationalism. They worked completely outside of the institutional sphere, adopted civil society models, and were dependent upon previously non-existent or non-active Western funds. Then, from 2000 to 2007, they started making more conscious use of the liberal discourses and the seeming normalization of liberal capitalism, multiplying in numbers, creating media and platform organizations to serve advocacy ends, assuming flexible organisational models such as the curatorial collective, and diversifying their sources of funding. In other words, these same independent cultural organizations now started blurring the boundaries between independent and institutional culture and entered into the institutionalised sphere. The third phase, from 2007 to 2013, was characterised by the prefigurative aspirations of independent cultures as emerging cultures, in which a large portion of the independent cultural (platform) organisations actively aimed to prefigure a new Croatian cultural system.

This prefigurative praxis entailed a shift of focus from minoritarian to majoritarian issues, an increase in (self-) historicization, a shift in position from counter-systemic to antagonistic or anti-systemic stances, and, contradictorily, an embrace of the institutional as space of transformation.

It is this model, a point zero and three subsequent phases, which I used to structure Part I of this book. The real fun only starts, though, when we start to dig deeper into the underlying discursive, social, political, and aesthetic patterns and encounter things that are less linear but more exciting. To has to do everything with the historiograpical methodology I use. I therefore need to briefly reflect on my methodology before turning to the actual narrative of independent culture's history.

# What Is a Genealogy Today?

My narrative of of independent culture's history is based on a wide range of sources: a bunch of literature produced within the field of independent culture; a few texts on independent culture written from outside-perspectives; critical theory of a general character; the material gathered in seventeen loosely structured interviews I conducted with actors from the independent cultural scene – including curators, theoreticians, professors, students, funders, and artists; my own observations during visits to most of the independent cultural spaces in Zagreb; and discussions with my friends from the Academy of Fine Art's New Media Department and from the performance art community. This eclectic and participatory research approach leads to a story that is neither exhaustive nor objective. It is instead permeated by extensive quotations from interviews, conversations and literature and grew to be a 'multivoiced ethnography' which goes in different directions at the same time.[1]

The image that appears from this multivoiced historical account of independent cultures in Zagreb is full of shifts and breaks, caused by wars, changes of governments, the conception of new ideas, and other factors that determine how beings are disciplined by power. And although, for the reasons of readability and provocation, I did decide to adopt the clearcut distinction of four phases, the

---

[1] This idea is inspired by Paul Stubbs, who developed the methodology for a 'multivoiced netnograpy' while researching the Zagreb-based pacifist network ZaMir. Paul Stubbs, 'The ZaMir (For Peace) Network: From Transnational Social Movement to Croatian NGO,' in *Internet Identities in Europe*, https://bib.irb.hr/datoteka/233303.stubbs.pdf, 72

historical narrative of independent cultures I present is not unequivocal or straightforward. That is to say, I do not suppose there is evolution, in the Hegelian sense, in this sequence of phases. Doing so would only result in a boring *Abendland*-image of emergence, peak and decline. Rather, new constellations of independent cultural organization are born every time the hand of power redistributes the playing cards.

In fact, as much as there are disruptions, there is a continuity in the praxis of independent cultures as it peaked repeatedly in the 1970s, the early 2000s, and, in some sense, today. Independent culture is a living culture that constantly morphs and transforms. Who knows what shape it will take tomorrow, when the circumstances are different from today? In the face of this liveliness, I cannot write anything else than a situated, effective history of the praxis of independent cultures.[2]

In the following, I simultaneously discuss institutional developments in artistic and cultural production, political changes, artistic tendencies, important developments in discourse, historiography and theory. The point in doing so is to engage with the interrelation between these different historical events and the problems that arise from attempting to comprehend them; thereby to confront how our thinking of the past influences our attitudes in the present. As such,

---

2   I use the notion of praxis in line with that of the school of critical theory, 'in which the performatives of praxis are seen to be [...] directly associated with the entwined phenomena of discourse, communication, and social practices', to signify that the discourses shaping the practices of independent culture as discussed below mainly emerged from the field itself in reaction to changing social and political realities and shifting regimes of power. Calvin O. Schrag, 'Praxis,' *Cambridge Dictionary of Philosophy*, Robert Audi, ed. (Cambridge, MA: Cambridge UP, 1999), 731, *Gale Virtual Reference Library*, http://link.galegroup.com/apps/doc/CX3450001234/GVRL?u=amst&sid=GVRL&xid=f25e1fba, accessed 21 May 2018.

the following is a genealogy rather than a history. The difference, according to Michel Foucault, is that a genealogy 'opposes itself to the search for "origins"' so typical of traditional histories.[3] In a genealogy, history is not considered to be a pure reality covered by the dust of time, waiting to be uncovered 'as it really was', or the material of grand narratives, but a complicated tissue of discourse resulting from the interplay of power relationships and the distribution of capital. The task of the genealogist is to explore the way beings have been disciplined by power in the past. This can be done, Foucault suggests, by looking for the 'Herkunft' (discursive commencement) rather than the 'Ursprung' (historical essence) of historical events.

But what is a genealogy today? How exactly can a genealogy intervene in the living discourse of the past at present? What does it mean to write a genealogy today? Foucault wrote his genealogies in the 1970s, the late days of Fordist labor relationship dominance. Since then, due to incessant globalization, automation and the rise of the internet, a shift to post-Fordist labor took place in the (former) West and created new regimes of disciplining. Italian autonomist philosopher Franco 'Bifo' Berardi has pointed out that regimes of power like social media and the platform economy no longer aim to discipline the body of their subjects, as was the case for the 20th-century ruling class. Rather, they discipline the soul and put it to work.[4]

---

[3]  Michel Foucault, 'Nietzsche, Genealogy, History,' in *Language, Counter-Memory, Practice: Selected Essays and Interviews*, D.F. Bouchard, ed. (Ithaca: Cornell UP, 1977 (1971)), 140.

[4]  Franco 'Bifo' Berardi, *The Soul at Work: From Alienation to Autonomy* (Los Angeles, CA: Semiotext(e), 2009), 21-24.

The type of soul work dominant in independent cultures is 'abstract labor', defined by Bifo as value-producing time with no relation to the specific and concrete utility that the produced objects might have.[5] Since the rise of digital media and the high-tech industries, abstract labor has become widespread, including trades like PR, design, web development, and most of all, the creative industries. But the oldest and most archetypical type of abstract labor could be said to be the creation of high art by the autonomous artist genius. The artist genius attains such a level of specialization that the value of their labor equals the uniqueness of their abstract skills beyond any reference to use value. For instance, the rumor goes that Pablo Picasso was once approached by a stranger in a restaurant and asked to scribble a drawing on a napkin. Picasso complied and said that 'this will be 40.000 Francs, please'. The stranger was astonished and objected: 'But you did that in 30 seconds!', to which Picasso replied: 'You're wrong. It took me 40 years to become Picasso.' This example perfectly shows Bifo's point that abstract labor 'manipulates absolute abstract signs, but its recombining function is more specific the more personalized it gets, therefore ever less interchangeable'.[6]

Every worker of today's global culture class follows Picasso's example, geared up with a silver laptop and an organically decomposable mug of artisanal coffee to use the manipulation of abstract signs to strive for uniqueness rather than homogeneity. The paradoxical situation resulting is that, even though these high-tech workers function like any other type of homogenous work force most of the time, they identify as unique creatives. 'Consequently', Bifo says, '*high tech* workers

5  Bifo, *The Soul at Work*, 75.

6  Bifo, *The Soul at Work*, 75.

tend to consider labor as the most essential part in their lives, the most specific and personalized'.[7]

This new situation requires a different focus for the genealogist too, because the mental automatisms and types of alienation that characterizes high tech workers because of their complete identification with their jobs are nothing like factory workers' physical alienation in which producing bodies become interchangeable. Instead of the split between body and soul caused by Fordism, we encounter an internal split of the soul in post-Fordist labor relationships. Due to the rise of neoliberalism and the dismantling of public social systems, the precarious circumstances in which the soul of high-tech workers is employed results in the internal split of the soul as creative entity and the soul as entrepreneurial entity. While the creative soul creates freely and abstractly, the entrepreneurial soul of the high-tech worker enters into market competition to compensate for the failing social systems.

Independent culture in Zagreb is a circuit full of such abstract high-tech labor. Indeed, the precariousness of mental work is an often talked-about subject in the scene, felt deeply by its members on a daily basis. Their condition means that they have to take care of themselves through the market or funding competition – while being uncertain about their survival from year to year. What's more, the instrumentalized use of precarization by governments is one of the structural threats independent cultural organizations deal with. For many of these organizations, a year without government funding can easily mean the end. Precarity is therefore the red thread in my genealogy of independent cultures.

7   Bifo, *The Soul at Work*, 76.

To address this state of precarity, I borrowed some important definitions from Isabell Lorey's *State of Insecurity: Government of the Precarious (Futures)* (2012). The four key concepts Lorey expands upon in this book are: *precarization*, *precariousness*, *precarity*, and *governmental precarization*. The most general of these terms is precarization, which refers to the phenomenon of living with the unpredictable, the contingent.[8] It is the umbrella term, under which the other three are grouped. Precariousness, precarity, and governmental precarization are three respectively social-ontological, discriminatory, and historical dimensions of precarization.

Precariousness refers to the socio-ontological state of insecurity: all human beings are born into society, disposing of nothing but a harmless and necessarily mortal body. We all know: leave a baby alone and it dies within days. The fact that any full-grown human is alive is because they have taken the necessary care to postpone inevitable death. From the moment we are born, we are dependent upon social structures and the care of others. Precariousness is, then, not necessarily something we are born *with*, but necessarily something we are born *into*. Thus, precariousness is not a natural condition, but at the same time socially constructed and unavoidable. It is shared by all, yet divides and individualizes. Judith Butler has put it this way: 'Although precarious life is a generalized condition, it is, paradoxically, the condition of being conditioned'.[9] Since precariousness is this unavoidable, pre-intentional

---

8   Isabell Lorey, *State of Insecurity: Government of the Precarious (Futures)*, trans. Aileen Dereeg (New York and London: Verso, 2015 (2012)), 12.

9   Judith Butler, 'Precarious Life, Grievable Life,' in *Frames of War: When Is Life Grievable?* (London: Verso, 2009), 23, as cited in Lorey, *State of Insecurity*, 32.

condition shared by all, it exists outside of power relationships, *before* power relationships.

Precarity, on the other hand, is the moment when the fear of precarious life turns into power and constitutes a hierarchic categorization of precariousness and becomes regulatory.[10] Instead of facing the unavoidable danger of precarious life, the fear deflected and projected onto more controllable entities: the lives and actions of others. (Why am I feeling so weak and vulnerable in everyday life? Must be the queers and the immigrants.) Through the discriminatory logic by which some privileged groups project their fear onto others, a hierarchic categorization of forms of life is created. Precarity can thus be understood as a functional effect of political and legal forms of regulation that should ideally function as protection from precariousness. Clearly, the exclusive and regulatory effects of precarity do not only create a sense of safety, but are also closely linked to racism, anti-Semitism, homophobia, etc.

Importantly, this regulatory dimension of precarity is neither necessary nor natural, but a contingently-historically constructed phenomenon. The status quo of power relations in the industrial-capitalist era have from the start been dependent on the individualized, and therefore biopolitically governable, labor market. This was justified in the discourse around individual responsibility and the *sovereign citizen*.[11] Since a sovereign citizen is free to pick their own means of existence (jobs, health care, insurance, social circles, etc.), they are also responsible for the upkeep of their existence and to deal with all the insecurities it comes with. Leap

10   Lorey, *State of Insecurity*, 34.

11   Lorey, *State of Insecurity*, 25.

forward in time: with the emergence of the internet, post-Fordist modes of production, including both cognitive and creative work, precarious living and working circumstances have become normalized. What is more, in this context, normalized means: happily internalized. We, the creative class, all want the freedom of flexible jobs and the ability to work from our MacBooks in any coffee bar around the world. Thus, without any struggle, precarization (and the privilege to be without it) have become an essential tool of contemporary neoliberal government.

Here, Lorey asserts, we discern the third dimension of precarization: governmental precarization.[12] Governmental precarization, according to Lorey, not only entails a precarization of wage labor, but also of existence in general. The emergence of governmental precarization and neoliberalism (the marketization of (every facet of) life) are related. Economic deregulations and the abandonment of Fordist labor have created not only created freedom and flexibility, but also income disparities, precarity and fear. The more individuated and the more marketized our European condition has gotten, the more normalized precarious life has become. But, Lorey emphasizes, the fact that precarious life has normalized and become a tool of governance under neoliberalism, does not mean that insecurity itself has normalized, too. On the contrary, as nation-states proceed to dismantle one social security structure after another, more and more emphasis is put on national security. These fears were then (pseudo-)resolved on the nation-state level by militarization and repression of the Other.

12   Lorey, *State of Insecurity*, 79.

The fear of alien social bodies, terrorism, Islam, racial dilution, cultural digression and aggression towards asylum seekers have all increased with the rise of the precarity. This ideologically installed fear is then eased by rising military budgets, xenophobic refugee policies, and strongman leaders. Hence, the functional dimension precarity has been institutionalized and has become the foundational mechanism of government.

Now, let's approach point zero: the disintegration of the Socialist Federal Republic of Yugoslavia.

# Point Zero: The Disintegration of Yugoslavia

1991 saw the disintegration of Yugoslavia. After a decade of political crisis and 'no future', the Fukuyaman ideology of the post-historical condition – the idea that all major ideological struggles had been played out when the Iron Curtain fell in 1989 and that liberal-democratic capitalism had come out definitively victorious – finally and violently caught up with Yugoslavia. Slovenians, Bosniaks, Croats, Serbs, Serbian Croats, Croatian Bosniaks, Bosnian Serbs, Serbian Bosniaks, Bosnian Croats, and Croatian Serbs fought each other in shifting alliances. Historians still debate whether these are four separate Yugoslav Wars or a single civil war. In any case, as soon as images of Serbian concentration camps went viral on every possible Western news outlet, it became clear that 'something' had to be done. The U.N. intervened while Milošević marched. Even though the Dutch military forces failed to fulfil their duty, the Yugoslav People's Army ceased its campaign under the threat of NATO bombing. The borders of a divided Yugoslav area started to take shape, and the rest is history. A history, moreover, that was later neatly separated from the post-historical present day by means of legal closure in The Hague. With some irony, it can be said that the Iron Curtain separating East from West was replaced by the curtain of justice separating history from the present.

But the Yugoslav Wars have been the subject of many
a historiography and I will refrain from writing one
more here. It is already clear to all that the war time was
a period of such radical social, institutional, political,
ideological, and cultural change and destruction, that
it can be rightfully marked as a point zero. What is of
interest to me, and what is in some sense the core of this
book, is the question what happens *after* point zero. In the
aftermath of the Second World War, Theodor W. Adorno
famously stated that 'to write a poem after Auschwitz
is barbaric'. Auschwitz was an obvious point zero. And
continuing the cultural practices of the 'civilized' society
that led to the atrocities of the Holocaust – such as
writing an old-fashioned poem – without questioning
the role of cultural production and narratives within
that civilization had become a moral impossibility after
this point zero. Now, if the Yugoslav Wars are the point
zero in this case, at stake is the barbarism of poetry after
Srebrenica.

## TRANSITOLOGY

A quintessential idea in the liberal discourse of post-
history was that of 'transition'. Directly following
the fall of the Iron Curtain in 1989, departments of
'transformation studies' or 'transitology' were established
throughout universities in Westeren Europe and the
United States as schisms of Area Studies and Soviet and
Comparative Communist Studies. These departments
studied and supported the fall of authoritarian and
totalitarian regimes in Eastern Europe and their
transition into the Western democratic model. The
foundational hypothesis of transitology was paraphrased
by transitologist James Hughes, stating that: 'The basic
premise is self-evidently normative and linear: that the

values, structures and political procedures of advanced Western democracies are the most developed and should be transplanted [to the rest of the world]'.[13] The insights generated in these departments were soon adopted by the policymakers of Western governments as well as the International Monetary Fund and the World Bank and used to formulate plans for the establishments of free markets, civil societies, and democratic institutions in the East. More than a theoretical enterprise, transitology thus became a practical tool for the smooth implementation of the Western ideals of democracy, free market prosperity, and the open society. It is therefore that the notion of 'the period of post-socialist transition' has come to be used as a synonym to 'the 1990s' in Eastern Europe, including the former Yugoslav area.[14]

In hindsight, not everyone is as happy with the impact of transitology. In his article *Children of Post-Socialism* (2015), the critical theorist Boris Buden argued that the post-socialist transition was not just a traumatic lived experience of war or simply a period of time in between two societal models, but also a discursive tool of neo-imperial and neoliberal subjugation of the (former) East by the (former) West by means of 'repressive infantilization of societies that have recently liberated themselves from communism'.[15] The dominant idea was that, after the end of history, the only rational way

13   Hugh James, 'Transition Models and Democratization in Russia' in *Russia After the Cold War*, ed. Mike Bowker and Cameron Ross (Harlow, New York: Longman, 2000), 21, as cited by Octavian Esanu, *The Transition of the Soros Centers to Contemporary Art: The Managed Avant-Garde* (Kiev: CCCK, 2008), 6.

14   Octavian Esanu, *The Transition of the Soros Centers to Contemporary Art: The Managed Avant-Garde* (Kiev: CCCK, 2008), 5-7.

15   Boris Buden, 'Children of Post-Communism,' in *Welcome to the Desert of Post-Socialism: Radical Politics after Yugoslavia*, Igor Štiks and Srećko Horvat, eds. (New York: Verso, 2015), 125.

forward for post-socialist countries was to follow the lead (or the tutelage) of the already-democratic (former) West by ways of direct imitation. Buden elaborates on the consequences of this demand to imitate:

> Not only [were] the protagonists of the democratic revolutions robbed of their victory and turned into losers; at the same time, they have been put under tutelage and doomed blindly to imitate their guardians in the silly belief that this will educate them for autonomy. It is not only the arbitrariness of the new rulers, but above all the logic of their rule that reveals itself.[16]

What was this new post-socialist and post-historical logic? In their book *Welcome to the Desert of Post-Socialism* (2015), Igor Štiks and Srećko Horvat unpack how the post-socialist transition played out materially and conclude that:

> The dismantling of the remnants of the socialist state was legitimised by demands for the rapid reduction of the omnipresent state apparatus. This process usually entailed the dismantling of existing social protection as well as privatisation [...] or the total corruption of what remained of the state apparatus. [...] When the dust finally settled, ordinary citizens found themselves not only in a devastated country, but also with empty pockets and without the old social safety net.[17]

It appears that, as the curtain of history fell, the dominant logic of rule was not so much ridden of its

---

16   Buden, 'Children of Post-Communism,' 133.

17   Igor Štiks and Srećko Horvat, 'Radical Politics in the Desert of Transition,' in *Welcome to the Desert of Post-Socialism: Radical Politics after Yugoslavia*, Igor Štiks and Srećko Horvat, eds. (New York: Verso, 2015), 5.

teleologic progressivism, but rather of the aspiration of emancipation and Bildung that had always been present in the grand narratives of modernism.

Jacques Rancière formulated an elegant theory about the workings of this post-socialist logic of rule. In his essay *Time, Narration, Politics* (2017), Rancière analyzed how the so-called end of the grand narratives was in fact a redistribution of the hierarchy of temporalities creating a new 'relation between justice and the order of time'.[18] The analysis is quite technical, but nonetheless worth reproducing briefly, because it shows how a new conception of time helped solidifying the Western hegemony after 1989 by determining which histories could and which histories could not be perceived of as historical realities leading to the reality of the present.

At first, Rancière states that the post-historical era advocated by the likes of Francis Fukuyama seem to have a temporality where 'the bare reality of time, stripped of any inner truth and any promise of justice and brought back to its ordinary course'. This is why liberal capitalist democracy could sincerely be perceived as the logical end to history: it was supposedly the neutral or ordinary course of time, beyond the distortions of ideology, an *absolute present*. But, Rancière continues, 'it soon turned out […] that this absolute present had not so easily gotten rid of the passions engendered by the weight of the past and the anticipation of the future'.[19] As we can tell in hindsight, the then-deemed 'outdated' discourses of protectionism and ethno-nationalist narratives were revived in both (former) East and (former) West pretty

18  Jacques Rancière, 'Time, Narration, Politics,' in *Modern Times* (Zagreb: MAMA Multimedia Institute, 2018), 14.

19  Rancière, 'Time, Narration, Politics,' 15.

soon after 1990. Rancière asserts that 'it thus appears that the simplistic opposition between the past illusion of history and the solid realities of the present hides a division inside the "present" itself, a conflict about what is present and what a present is'.[20]

The struggle implied here concerns the 'orderly' hierarchical distribution of temporalities and forms of life. It plays out between those who can actively shape the time that might arrive – those living in the time of science – and those who passively receive time – those living in the time of ignorance. From this understanding of the so-called grand narratives as animated by the split of knowledge of necessity and possibility on the one hand and ignorance thereof on the other, between the know-it-alls and the know-nothings, it was clear that the powerful had not stopped claiming their monopoly to knowledge of history. Rancière:

> Neither the plot of historical necessity, nor its inner splitting have vanished in the so-called reign of the present. [...] While the end of the grand Marxist narrative was loudly trumpeted everywhere, capitalist and State domination simply took over the principle of historical necessity. [...] Historical teleology was replaced by a simple alternative: either the lone possible produced by good management of the existing order or the great collapse.[21]

While the division between knowledge and ignorance of history persisted, the type of knowledge attributed to the know-it-alls changed: in the place of 'historical justice' now came the neoliberal mantra of 'good management'.

20  Rancière, 'Time, Narration, Politics,' 16.

21  Rancière, 'Time, Narration, Politics,' 22-23.

This hegemonic view of world history after the end of history, divided by 'good management' (the West) and 'great collapse' (the rest) has the perverse characteristic of obscuring the historical material condition of Yugoslavia. What was actually true is rendered inconceivable by the simple dichotomy on which the hegemonic narrative hinges: Yugoslavia never belonged to either East or West.

## NON-ALIGNMENT

In September 1961, the first *Conference of Heads of State or Government of Non-Aligned Countries* was held in Belgrade on the initiative of Yugoslav president Josip Broz Tito.[22] The majority of all countries around the world that were never colonial powers (both former colonized countries and non-colonizing countries) united for the first and so far last time in history. Thereby, they constituted a non-Eastern, non-Western world power: the Third World. Today, 'third world' sounds like a negative stigma to us in the former West, since we have forgotten the decolonial potential of the Non-Aligned Movement (NAM). But that is not to say it never existed. A 1967 report on 'The Yugoslav Experiment' by the CIA stated:

> Yugoslavia is a Communist state in name and in theory, but in practice it is a fully independent state which has rejected most of the "socialist" experience of other Communist states, including the USSR. It has deliberately removed a large portion of its economy from direct centralized controls, and despite its retention of a one-party

---

22    'Non-Aligned Movement,' *Wikipedia*, 5 April 2019, https://en.wikipedia.org/wiki/Non-Aligned_Movement.

political system, it has largely freed its people from arbitrary authority.[23]

There was no space for the memory of this material reality in the post-historical world history simplistically divided into the exemplary West and the derivative rest. Three world orders – Non-Aligned, Marxist, and Capitalist – were reduced to two – West and East.[24] The ideological acrobatics with which conservative historians appropriated the distribution of temporalities and legitimized the flattening out of history as well as the abandonment of historical justice, was illustrated well if somewhat Yugostalgically by Ozren Pupovac in *Why is the Experience of Yugoslavia Important Today?* (2013).[25] Pupovac describes how, under the influence of conservative thinkers, a legalization of theorizing about politics has taken place. This postulates the legal framework of the nation-state as the foundation of a sovereign people, instead of the other way around. This legalization of thought denies the sheer possibility that the construct of the nation-state is contingent and maybe imperfect. Therefore, Pupovac concludes:

> Political reaction today thrives on obscurity. We can probably find no better use for the concept of "dominant ideology" than to describe that peculiar subjective operation – present at almost every step in our political everydayness – which assures

23 Central Intelligence Agency, 'National Intelligence Estimate Number 15-67: The Yugoslav Experiment,' 13 April 1967, https://www.cia.gov/library/readingroom/docs/DOC_0000272967.pdf.

24 An influential example of these politics of history, that were mainly fueled by the US, is Samuel P. Huntington, "The Clash of Civilizations?" *Foreign Affairs*, vol. 72, no. 3 (Summer 1993), 22-49.

25 Ozren Pupovac, 'Why is The Experience of Yugoslavia Important Today?' in *Sweet Sixties: Spectres and Spirits of a Parallel Avant-garde*, Georg Schöllhammer and Ruben Arevshatyan, eds. (Berlin: Sternberg Press, 2013), 481-496.

us that every willed rupture with the ordinary course of things, every trace of a collective idea of emancipation, remains obscure and unreadable.[26]

Pupovac echoes Buden's critique of the discourse of post-socialist transition and normalization, adds to that an explicit Marxist critique of ideology, and hints at two aesthetic components of the political struggle for emancipation: the 'rupture' between historical reality and *sensible experience* that makes emancipation 'obscure and unreadable'. I think it is about time for historians like myself to take the history of the NAM seriously and overcome the dogmas of Westphalian political theory.

## SCHIZOPHRENIC MODERNISMS AND IMPOSSIBLE AVANT-GARDES

A similar discussion played out with regard to Yugoslav art within a construct of art history that maybe, just maybe is imperfect. In the modernist narratives of art history, Yugoslavia has consequently been presented as ambivalent at best, and schizophrenic at worst. This is because they are part of the socialist-communist East, yet flirt with the capitalist-democratic West.[27] For instance, the influential Yugoslavian art historian Ješa Denegri developed the concept of 'moderate modernism' to describe how Socialist Yugoslavia's cultural policies and institutional cultural productions leaned simultaneously to the East and the West and thereby receded in

---

26  Pupovac, 'Why Is the Experience of Yugoslavia Important Today?' 481.

27  See, for instance, Tvrtko Jakovina, 'Historical Success of Schizophrenic State: Modernisation in Yugoslavia 1945-1974,' in *Socialism and Modernity: Art, Culture, Politics 1950-1974*, ed. Ljiljana Kolešnik (Zagreb: Institute of Art History & Museum of Contemporary Art, 2012), 7-44.

moderateness.[28] Denegri's account is insightful, and undoubtedly right in pointing out that state influence neutralized criticality in cultural production to a large extent. Both artistic communities and the public were indeed relatively well-aware of and centered on the Western-European art historical tradition.[29] But Denegri lacks criticality towards the political workings of the concept of modernism and ignores the critical potentials of the historical context of non-alignment.

Why modernism, or at least its Western model, is an exclusive regime of historiography in need of critique was elaborated, again, by Rancière:

> The idea of modernity is a questionable notion that tries to make clear-cut distinctions in the complex configuration of the aesthetic regime of arts. It tries to retain the forms of rupture, the iconoclastic gestures, etc., by separating them from the context that allows for their existence: history, interpretation, patrimony, the museum, the pervasiveness of reproduction… The idea of modernity would like there to be only one meaning and direction in history, whereas the

[28] Importantly, Denegri distinguished between the institutionally supported 'first line' in cultural production and the extra-institutional 'second line'. According to Denegri radical and avant-garde practices took place during the socialist era. This localization of the radical – strictly outside of state-governed cultural institutions – is problematic with regard to historical reality, as will be elaborated below. Ješa Denegri, 'Inside or Outside "Socialist Modernism?" Radical Views on the Yugoslav Art Scene 1950-1970,' in *Impossible Histories: Historical Avant-gardes, Neo-avant-gardes, and Post-avant-gardes in Yugoslavia, 1918-1991*, ed. Dubravka Djurić and Misko Suvaković (Cambridge, Mass., London: The MIT Press, 2003), 170-208.

[29] This is convincingly shown in Jasna Jaksić's *Art on Tour: The Invention of the Audience* (2015), which elaborates the 'didactic exhibition' of Western modernist art traveling though Yugoslavia. The exbhition was 'probably the most visited exhibition of contemporary art in what was then Yugoslavia', having been on display in Zagreb, Rijeka, Sisak, Belgraja, Skopje, Novi Sad, Bečej, Karlovac, Maribor, Sremska Mitrovia, Osijek, Bjelovar, and Ljubljana. Jasna Jaksić, 'Art on Tour: The Invention of the Audience,' in *Didactic Exhibition*, Fokus Grupa and Jasna Jaksić, eds. (Zagreb and Rijeka: Museum of Contemporary Art Zagreb and Fokus Grupa), 5-11.

temporality specific to the aesthetic regime of the arts is a co-presence of heterogeneous temporalities.[30]

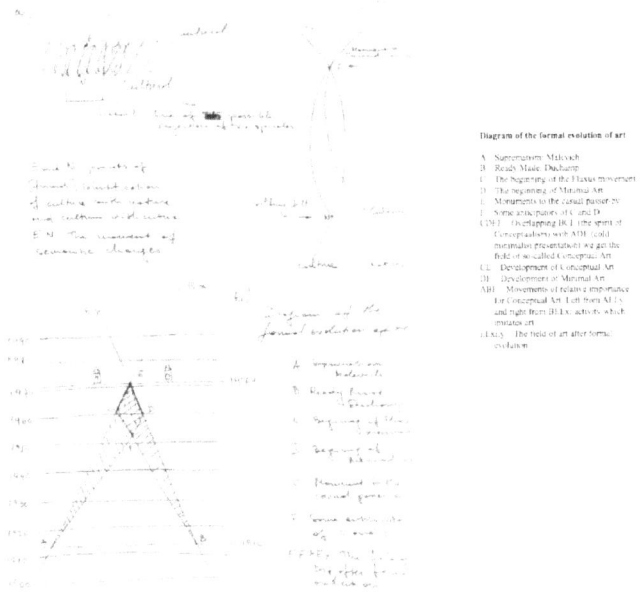

*Braco Dimitrijević, 'Diagram of the Formal Evolution of Art' in* Tractatus Post Historicus *(1976).*

Exactly in this denial of co-presence of heterogeneous temporalities, Yugoslavia was always-already disqualified for not being univocally Western, that is, not running at the supposed fore-front of historical development.

This is best illustrated by the example of *New Art Practice in Yugoslavia: 1960-1978,* an exhibition which took place

30   Rancière, *Politics of Aesthetics,* 21.

in the Gallery of Contemporary Art in Zagreb in 1978, the catalogue of which is still one of the most important literary contributions to the canonical narrative of experimental or 'retro-avant-garde' in Yugoslavia.[31] In the catalogue's foreword, Marijan Susovski states that 'art is not formal evolutionism' but a social and dialectical process defined by 'confrontations with outdated attitudes towards art in the new social situation'. An example fitting exactly in this logic is the *Tractatus Post Historicus*, a booklet written by the young and rebellious Yugoslavian artist Braco Dimitrijević's in 1976. Dimitrijević wrote:

> The idea of art history as consequent and linear evolution is only possible if all cases which don't fit in line with dominating style cliché are overlooked and eliminated. (For instance I'm sure that in Rococo there was at least one artist applying esthetic principles close to minimal art, but he remained unknown because the collective taste and sensibility weren't ready to accept his ideas.) This model of art history is only a reflection of general history because it reflects the ideas of Western man about his own history as a series of changes which through conflicts and struggles nevertheless result in so called "progress".[32]

The funny thing is that, if there is no formal evolution in art, exactly the rejection of formal progress (and

---

[31] The exhibition included works of many artists who were already or would later become internationally recognized, such as Marina Abramović, Braco Dimitrijević, Tomislav Gotovac, the Group of Six Artists, Sanja Iveković, Jagoda Kaloper, Julije Knifer, Ivan Kožarić, Dalibor Martinis, OHO Group, and Goran Trbuljak.

[32] Braco Dimitrijević, *Tractatus Post Historicus*, Aaron Levy (ed), Pennsylvania: Pennsylvania UP, 2009 (1976), 28.

the middle-class *Weltanschauung* on which it is based) becomes the only step forward for the new generation. Accordingly, the contemporary social evolution of Yugoslav art was presented in *New Art Practice in Yugoslavia* as a social-generational break. So, while Susovski rejected formal evolutionism, he simply replaced it with social evolutionism.

In the catalogue's next chapter, *Art in the Past Decade*, written by Denegri, the 'next step' in the socially evolving process of art history is again defined as a generational break of the conceptualists with the formalist pre-occupations of their predecessors. Since development can only be seen from the outside, measurement of this development necessitates some kind of extrinsic measuring unit. The extrinsic unit used by Denegri to measure the development of Yugoslav art was what he called the 'general' or 'international context' which was in fact the Western context. In qualifying the generational break in Yugoslav art as one of art historical progress, Denegri repetitively and exclusively compared it to Western phenomena like Arte Povera in Italy, *Op Losse Schroeven* in the Stedelijk Museum Amsterdam, *When Attitudes Become Form* at Kunsthalle Bern, and *The New Art* at the Hayward Gallery in London.

Why would Yugoslav art historians embrace these narratives? Why was it important to use the West as a measuring tool? It would be farfetched to suppose that this imperialist logic of art history was internalized because of a tremendous intrinsic agreement. It is more sensible to see this as a self-interested but ineffective attempt to emancipate Yugoslavia from a 'peripheral' to 'central' position in world history as seen through the dominant eye of the West. Just after the Second

World War, Western Europe had successfully adopted the American model of modernist art, the model of the victorious nation, and thereby gained itself a central position in terms of common-sense art history. This is exemplified by Alfred Barr's depiction of the origins of modern art, which shows that the American liberal-nationalist favorite movement, Abstract Expressionism, is a direct successor of the European avant-gardes. If Western Europe had been able to emancipate itself like this, why wouldn't Yugoslavia be able to do the same?

However, the effect of this internalization was not emancipation. On the contrary, because of the socialist context of Yugoslavia, this reactive attitude reinforced the image of Yugoslav modernity as an impossible balancing act between Orientalism and Occidentalism, or, at most, of an *almost* Western modernity, always just one step behind. What the catalogue of *New Art Practice in Yugoslavia* shows is, then, the Other avant-garde, the derivative avant-garde, the impossible avant-garde. The histories of radical and critical practices in Yugoslavia are rendered 'impossible histories' by the fact that narratives like Denegri's – which evaluates Yugoslav art history in terms of Westerness – are dominant.[33] Thus, by partly simultaneous, partly post-factual internalization of (former) Western standards of modernity, the co-presence of temporalities inherent to the Non-Aligned experience was denied. Instead a discourse was created

---

33   Dubravka Djurić and Misko Suvaković, eds. *Impossible Histories: Historical Avant-gardes, Neo-avant-gardes, and Post-avant-gardes in Yugoslavia, 1918-1991* (Cambridge, Mass., London: The MIT Press, 2003).

in which Yugoslav art history is necessarily considered always-already failed.[34]

Even if the NAM's import was mainly political and economic, there was a tendency towards creating a Non-Aligned cultural sphere and even a Non-Aligned school of thought. Every summer between 1964 and 1974, renowned thinkers from former East and West, including Herbert Marcuse, Henri Lefebvre, and Jürgen Habermas, would gather on the Yugoslav island of Korčula to teach students from all over the world.[35] These summer schools were the work of the Praxis School philosophers, based in the Belgrade Workers' University and internationally renowned for the philosophical Marxist journal *Praxis*.[36]

34  Ješa Denegri, 'Art in the Past Decade,' in *The New Art Practice in Yugoslavia 1966-1978*, Marijan Susovski, ed. (Zagreb: Gallery of Contemporary Art, 1978), 5-12. Marijan Susovski, ed. *The New Art Practice in Yugoslavia 1966-1978* (Zagreb: Gallery of Contemporary Art, 1978). Marijan Susovski, 'Foreword,' in *The New Art Practice in Yugoslavia 1966-1978*, Marijan Susovski, ed. (Zagreb: Gallery of Contemporary Art, 1978), 3. Braco Dimitrijević, *Tractatus Post Historicus* Aaron Levy, ed. (Philadelphia: Slought Books, 2009 (1976)).

35  'Repertorium: Praxis,' *Memory of the World*, 28 November 2014, https://www.memoryoftheworld.org/blog/2014/10/28/praxis-digitized/.

36  The founders of the Praxis School included Gajo Petrović, Milan Kangrga, and Mihailo Marković. The period between 1963 and 1974, in which they organised the Korčula Summer School, is regarded as the peak of Praxis School activity. All issues of *Praxis* have been digitized in Multimedia Institute's program *Memory of the World* and can be found at: https://praxis.memoryoftheworld.org/#property=authors. For the most part, the authorities were not very fond of the school, despite the fact that they promoted socialism and critiqued both centralism and nationalism. After 1974, the school stopped working in this constellation and fell apart in different factions. During the 1990's, Zagreb's members of the Praxis School remained avid anti-nationalists and took active part in the anti-war campaigns. In Zagreb, Milan Kangrga published regularly in the anti-war newspaper Feral Tribune, while Mihailo Marković joined Milošević's Socialist Party in Belgrade. Today, the legacy of the Praxis School is cherished within the independent cultural scene. MAMA organized the first post-war meeting of various members of the editorial board again in Korčula, helped Rosa Luxemburg Stiftung to organize a conference on Korčula a few years later, and digitised the archive of the Praxis School, thus making it publicly available. In its engagement with both aesthetic and social issues, independent culture often works on the same anti-nationalist interface of Marxism and liberal humanism that the Praxis School sought to inquire.

In their journal, 'the Praxis School emphasized the writings of the young Marx while subjecting dogmatic Marxism to one of its strongest criticisms'.[37] This led the philosophers to develop a humanist strand of Marxism, with a dynamic view on the human being, a focus on praxis and creativity, and consideration of aesthetic issues.[38] During the 1968 student uprisings in Belgrade, which were different from the Western examples because these protestors demanded *more* socialism rather than the end of capitalism, Praxis School professors did not just join the students, they led them.[39] The story goes that, during one of the Korčula summer schools, Ernst Bloch looked out over the Mediterranean Sea after a long day of discussions, a glass of wine in his hand, and remarked that this must be 'Dionysian socialism'.[40]

The resistant internationalist attitude that characterized the Praxis School was also present in Yugoslavia's cultural life and at times seeped through to official or 'first line' culture. As a non-colonial country, Yugoslavia's foreign cultural programs were strongly connected to former colonies through their common anti-imperialist struggle.

37 Joseph Bien and Heinz Paetzold, 'Praxis School,' *Cambridge Dictionary of Philosophy*, Robert Audi, ed. (Cambridge, MA: Cambridge UP, 1999), 731-732, *Gale Virtual Reference Library*, http://link.galegroup.com/apps/doc/CX3450001234/GVRL?u=amst&sid=GVRL&xid=f25e1fba, accessed 21 May 2018.

38 Two important works testifying to this development of 'socialist humanism' are Gajo Petrović, *Marx in the Mid-Twentieth Century* (New York: Anchor Books, 1967 (1965)) and Mihailo Marković *From Affluence to Praxis: Philosophy and Social Criticism* (Ann Arbor: Michigan UP, 1974).

39 Hrvoje Klasić, '1968: Yugoslavia and Student Protests,' *YouTube*, Accessed 26 April 2018, https://www.youtube.com/watch?v=LoSXQUwA2Jw&t=753s.

40 Klasić, '1968.' This seaside residence was not so privileged as it might sound now. As part of Tito's internationalist agenda, an extensive plan of tourism was implemented and dozens of hotels – highlights of Modernist architecture – and highways were built on the Adriatic coast to attract foreign tourists as well as to accommodate Yugoslav workers and their families with yearly free holidays.)

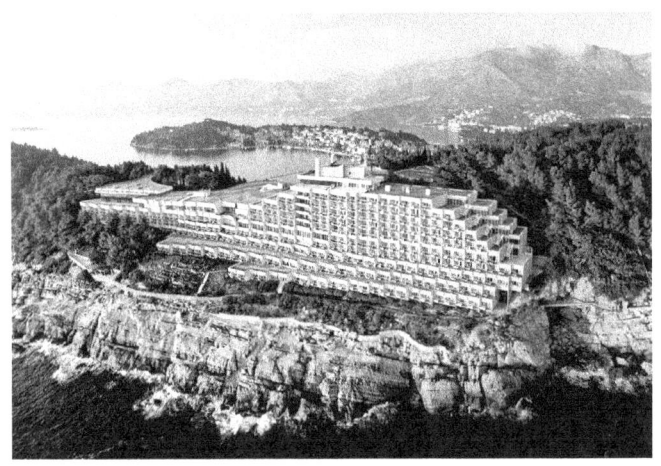

*Hotel Croatia, designed by Slobodan Milićević, 1973. This luxurious Hotel Croatia in Cavtat, a few hundred kilometres South-East of Korčula, was the site of the state-issued Summer School to which the Praxis Summer School was a critical antipode.*

The Slovenian curator Teja Merhar has demonstrated that Yugoslavia officially collaborated with at least fifteen African, seven South-American, and eleven Asian countries on cultural projects during the 1960s and 1970s with concise research in archives throughout the former Yugoslav area. These collaborations ranged from exchanges of resources and traveling movies and exhibitions, to conventions on culture and full-fledged cultural programs.[41] Merhar's research is a part of *Southern Constellations: The Poetics of the Non-Aligned* (2019), an exhibition in Ljubljana's Museum of Modern and Contemporary Art Metelkova and the very first

---

41  Teja Merhar, 'International Collaborations in Culture between Yugoslavia and the Countries of the Non-Aligned Movement,' in *Southern Constellations: The Poetics of the Non-Aligned* (Ljubljana: Museum of Contemporary Art Metelkova, 2019), 43-71.

historical account of the cultural dimension of the NAM by a major institution.

Next to compiling a lot of unseen data, the exhibition and its catalogue show a range of striking examples of non-aligned culture and arts in Yugoslavia. In 1977, the Museum of African Art was established in Belgrade, claiming to be the 'only European anticolonial museum'.[42] Architects and urban planners from Yugoslavia and several African countries collaborating on cross-overs of Yugoslav, 'tropical', and internationalist modernisms.[43] A large exhibition of contemporary Yugoslav prints toured through India in 1976 and 1977. Under the auspices of the United Nations, several huge pan-Yugoslav exhibitions, including works from all three worlds, were created at the Art Pavilion of Slovenj Gradec between 1966 and 1985.[44] In Podgorica (then Titograd) the Gallery of Art of the Non-Aligned Countries 'Josip Broz Tito' was opened in 1984, providing a permanent exhibition space for works of art from almost 60 countries in Latin America, Asia, Africa and Europe.[45]

One exhibit stands out especially. The proto-conceptualist work of the Croatian artists' brotherhood Gorgona is one of the best represented clusters of art

---

[42] Merhar, 'International Collaborations in Culture Between Yugoslavia and the Countries of the Non-Aligned Movement,' 56.

[43] Piškur, 'Southern Constellations,' 14.

[44] Andreja Hribernik and Katarina Hergold Germ, 'Art Pavilion Slovenj Gradec: International Exhibitions at the Art Pavilion Slovenj Gradec: Collaborations with Third World Countries,' in *Southern Constellations: The Poetics of the Non-Aligned* (Ljubljana: Museum of Contemporary Art Metelkova, 2019), 83-87.

[45] 'The Gallery of Art of the Non-Aligned Countries "Josip Broz Tito",' in *Southern Constellations: The Poetics of the Non-Aligned* (Ljubljana: Museum of Contemporary Art Metelkova, 2019), 113-115.

from former Yugoslavia.[46] Historians never fail to observe Gorgona's kinship to Western art-world stars like Piero Manzoni, Lucio Fontana, and Yves Klein, nor do they forget that Gorgona was Croatia's representation at the 1997 Venice Biennale.

Yet, in 1995, Gorgona's work was also shown at the international exhibition *Contemporary Art of the Non-Aligned Countries* in Jakarta, Indonesia, a fact that usually escapes the dominant narrative.[47] It's not just historians who are to blame for this. No documentation of the latter event ever reached the archive, or all of it was removed from storage at the organizing institution HDLU. This left no official traces in Croatia of it ever happening. Fortunately, the political implications of Gorgona's exhibition in Jakarta are remembered by the show's curator Nada Beroš and described in *Southern Constellations*:

> I saw presenting non-state art at such a highly state exhibition in a faraway country in Asia as a small-scale but very important subversion of the leaden atmosphere of 1990s Croatia, where the country's official politics, institutions, the media and also the artists wholeheartedly endeavored to prove that "we belonged in (Western) Europe".[48]

46  Nena Dimitrijević curated an important exhibition and wrote a monograph on Gorgona, *Gorgona: umjetnost kao nacin postojanja*, exhibition catalogue (Zagreb: Gallery of Contemporary Art, 1977). Since, the work of Gorgona has been collected by institutions like the MoMA and slowly entered into the Western canon.

47  Nada Beroš, 'Gorgona in Jakarta: On the Cutting Edge of the Edge?' in *Southern Constellations: The Poetics of the Non-Aligned* (Ljubljana: Museum of Contemporary Art Metelkova, 2019), 118. To my knowledge, only one previous exhibition contextualized Gorgona primarily in the NAM. This was an exhibition with the descriptive title 'Non-Aligned Modernity: Eastern-European Art and Archives from the Marinko Sudac Collection', held in Milan in the Fall of 2016. 'Non-Aligned Modernity,' *Unblock Magazine*, http://www.unblockmagazine.com/art-culture/2016/on-aligned-modernity, accessed 8 May 2019.

48  Beroš, 'Gorgona in Jakarta,' 118. Italics in original.

Surely, Yugoslavia's cultural dominants were flawed. There is no denying that culture in Yugoslavia was instrumentalized as a tool of foreign policy and subjected to Tito's political opportunism, often leaving little room for a critical, grassroots culture.[49] Moreover, while both publics and artists were preoccupied with the West, Yugoslavia's cultural identification as an 'older brother' to other non-aligned countries was imperialist in its own way. However, it is equally true that a large part of the cultural production in Yugoslavia was characterized by internationalism, anti-imperialism and the search for resistant modernisms. All in all, the historical narrative unearthed by *Southern Constellations* is distinctly different from the common tale of schizophrenic modernisms and impossible avant-gardes.

But, as said, it is hard to find this story. The traces of the NAM and its critical cultural implications became somewhat of an inconvenient truth after 1991. As Bojana Piškur, the curator of *Southern Constellations*, put it:
> Today, the Non-Aligned Movement is politically speaking considered more or less something of an anachronism. The fate of this unique constellation is probably one of the least understood phenomena of our times, but it is certain that its disappearance from the world's political stage is directly linked to the rise and triumph of neoliberalism, especially after 1989.[50]

Indeed, the erasure of the Non-Aligned reality from the dominant account of Yugoslav history has been rather

---

[49] A great account of the politics behind Tito's capricious cultural policies can be found in Armin Medosch, *Automation, Cybernation and the Art of New Tendencies (1961-1973)*, Artistic Doctoral thesis (London: Goldsmiths University of London, 2012).

[50] Piškur, 'Southern Constellations,' 20.

useful for the post-1991 neoliberal and nationalist revaluation of historical Croatian cultural identity. Its effects on today's geopolitical situation are clear, and are personified by strongmen like Hungarian President Orbán, former Croatian Prime Minister Tomislav Karamarko, and President Duda of Poland. Fed up with being bossed around, these men reject the tutelage of (former) Western European powers. In reaction to an EU proposal on so-called 'migrant quotas' in 2015, Duda said: 'I won't agree to a dictate of the strong. I won't back a Europe where the economic advantage of the size of a population will be a reason to force solutions on other countries regardless of their national interests'.[51] At the same time, coming from right-wing, conservative, anti-socialist parties, these politicians deny the alternatives to imperial liberalism presented by the ideals and histories of socialism and Non-Alignment. In other words, they reject the dominance of the former West but still accept the liberal end-of-history narratives created in the former West. It is not surprising that ethnonationalism is instead presented as the only way to be emancipated from Western tutelage.

To blame art (history) for the rise of authoritarianism would be an enormous overstatement. However, it has certainly contributed to the erasure of non-aligned memory in the dominant narratives of modernity. With *Southern Constellations*, Ljubljana's Museum of Contemporary Art Metelkova is the first major art institution in former Yugoslavia to criticize this status quo and to show how non-alignment 'enabled

---

51   Wojciech Moskwa and Piotr Skolimowski, 'Poland's Duda Blasts EU 'Dictate of the Strong' on Migrants,' *Bloomberg*, 8 September 2015, https://www.bloomberg.com/news/articles/2015-09-08/polish-president-blasts-eu-dictate-of-the-strong-on-migrants.

the powerless to hold a dialogue with the powerful'.[52] It would be interesting critical historiographers, institutions, and cultural workers to go one step further and ask: what could a non-aligned contemporaneity be?

The general context of the early '90s in Croatia is clear: war, the end of history, a post-socialist transition, the erasure of the NAM, and the promises of a real, democratic, capitalist liberalism. [53] How exactly were independent cultures born from this scenario?

---

52   Vijay Prashad, *The Darker Nations: A People's History of the Third World* (New York: The New Press, 2007), xviii, as cited in Piškur, 'Southern Constellations,' 15.

53   Some helpful texts, ranging from traditional academic publications to radical/activist perspectives; Jason Robertson, 'The Life and Death of Yugoslav Socialism,' *Jacobin Magazine Online*, 17 July 2017, https://jacobinmag.com/2017/07/yugoslav-socialism-tito-self-management-serbia-balkans; Ana Dević, 'Ethnonationalism, Politics, and the Intellectuals: The Case of Yugoslavia,' part of 'I: Disintegrating Multiethnic States and Reintegrating Nations: Two Essays on National and Business Cultures,' *International Journal of Politics, Culture and Society*, vol. 11, no. 3 (1998), 375-409; Mark Mazower, *The Balkans* (London: Weidenfeld & Nicolson, 2000); Dejan Jović, *Yugoslavia: A State that Withered Away* (West Lafayette, Indiana: Purdue UP, 2009); Juraj Katalenać, 'Yugoslav Self-Management: Capitalism Under the Red Banner,' *Insurgent Notes: Journal of Communist Theory and Practice*, 5 October 2013, http://insurgentnotes.com/2013/10/yugoslav-self-management-capitalism-under-the-red-banner/; Stevo Djurasković, *The Politics of History in Croatia and Slovakia in the 1990s* (Zagreb: Srednja Europa, 2016).

# Independencies of Independence

'It took place over the weekend in the capital city of Zagreb. The all-night party of 3000 people took place in former president Tito's nuclear fall-out center, under the city of Zagreb. And MTV News were there to capture some all-too-rare *positive* images of the country'.[54] Thus spoke the anchor woman of the MTV program Pepsi DJ MAG on the 30th of November 1993. Next thing, an ecstatic raver identified as Robert shouts into the camera:

> We love music. We want peace. The whole world knows that. [...] We want peace and we want another life. We hope for a better time; we hope for Europe. We want peace in the whole world. Help us. We want peace and we want to rave.[55]

Through the lens of MTV, we see *Under City Rave*, the first-ever techno rave in Croatia: a bunker full of under-sized black leather jackets, flashlights and the beats of London DJs flowing like the waves of an ocean on acid.

As one British DJ noted: 'Rave is about unity, and I hope that tonight, some unity can come towards Croatia, that young people can really express themselves, through the oldest mode of communication that's known to

---

54 'Under City Rave – Tunel Grič, 30.10.1993, Zagreb (Pt.1),' *YouTube*, https://www.youtube.com/watch?v=Yt4Px59VkrM, accessed 18 January 2019, emphasis in original. The bunker was neither built by Tito, nor as a shelter from nuclear warfare. Instead, it is a regular bomb shelter built in the Second World War by the Ustaše government. It has been open to the public as a tourist attraction since 2016. 'Grič Tunnel (Zagreb),' *Wikipedia*, https://en.wikipedia.org/wiki/Grič_Tunnel_(Zagreb), accessed 13 March 2019.

55 'Under City Rave.'

*Under City Rave, 30 November 1993, Grič tunnel, Zagreb.*

man and that's called dancing'.[56] The rave was a joyfully lived peace manifesto of moving bodies. Under the war-torn city of Zagreb, the last generation of Tito's Pioneers conjured a new social choreography: energetic, liberating, experimental, peaceful, and juvenile. But also individualized and tokenized. A singular, primal celebration of life sponsored by Pepsi Cola and Croatia Airlines.[57]

*Under the City Rave* is an illustrative example of independent cultures between 1991 and 2000, showing exactly what type of independence was sought. For instance, *Under City Rave* was co-organized by the British party collective URO and the Museum of Contemporary Art Zagreb. So, it's immediately clear that there was not a very strict distinction between institutional and independent culture. The independence of independence culture was rather achieved through its modus operandi.

'We had a kind of ironic distance [from our material circumstances]', the former editor of independent cultural anti-war magazine *Arkzin,* Boris Buden, remarked, 'if someone would have confronted us with the term "independent culture" we would have probably laughed and said: "We're not independent. We're paid by this dirty money from Soros, from the Greens." We

---

56 'Under City Rave – Tunel Grič, 30.10.1993, Zagreb (Pt.2),' *YouTube*, https://www.youtube.com/watch?v=HIh25h3Wrug, accessed 18 January 2019.

57 *Under City Rave* was co-organized by the British collective URO and the Museum of Contemporary Art Zagreb. The sponsors of the event included, amongst others, Pepsi, Diesel, Croatia Airlines, Tuna Film and Pizzeria Bambi. Lucia Brajlo, 'Jedan, jedini, nepovljivi: 'Under City Rave 93',' *MixMag*, https://mixmagadria.com/feature/jedan-jedini-neponovljivi-under-city-rave-93/, 15 June 2015. The notion of the 'social choreography' was coined by the Yugofuturist collective TkH [Walking Theory], to describe collective and physical experience of ideology while avoiding the use of 'mass', 'crowd', or 'multitude'. See TkH's artistic documentary *Yugoslavia: How Ideology Moved Our Collective Body* (2013), https://vimeo.com/ondemand/yugoslavia.

were not economically independent, there was no chance.'[58] Dejan Kršić, *Arkzin*'s designer, continued: 'To be realistic, this issue of capital and independence from capitalism was not on the table. There was a war going on. We were concerned with human rights, Balkanism, nationalism. We only turned towards critique of capitalism later, around 1997.'[59] So, the independence desired by cultural actors initially was not the Western conception of independence – independence as financial self-determination. What they sought was independence from the cultural dominants of post-Yugoslav militarism and an escape from war.

*Mladen Stilinović,* Sav novac je prljav, sav novac je naš / All Money Is Dirty, All Money Is Ours, *2006. Collage: acrylic and banknote on cardboard, 20 x 50 cm. Courtesy of Branka Stipančić.*

58 Boris Buden, interview by author, audio-recorded interview, Kino Europa, 5 May 2018.

59 Dejan Kršić, interview by author, audio-recorded interview, Kino Europa, 5 May 2018.

## THE INSTITUTIONAL CRISIS

In Yugoslavia, even under self-management socialism, all (cultural) institutions had been controlled by the local, national, or federal governments. As discussed before, the official international policies resulting from Yugoslavia's political outlook were mostly anti-imperialist and non-aligned. In terms of domestic cultural policies, the institutional situation allowed for a limited cultural liberalism with important pockets of critical practice on the one hand and clear limitations on the freedom of cultural expression on the other.
In 1971, film director Dušan Makavejev premiered his hilarious masterpiece *W.R.: Mysteries of the Organism*. In this documentary-pop-collage-philosophical-film-essay three stories intertwine: the biography of Wilhelm Reich – Freud's student in sex therapy and famous critic of fascism and its sexual origins, who died in a 1950s American prison while his books were ordered to be burned throughout the country (this story consists of documentary footage shot by Makavejev in the US while on a Ford Foundation grant); scenes of gender- and war-critical street performances in New York; and an allegorical story, set in Belgrade, of two sexually liberated women and the interrelation between the socialist and the sexual revolutions. In his critique of the sexually repressive American Dream, Stalin's sexually repressive Red Fascism, and his promotion of the eternal revolution of the workers' socialist state as an eternal orgasm, Makavejev crossed the boundaries of Tito's policies. *Mysteries of the Organism* was instantly banned from the cinemas and Makavejev was exiled from Yugoslavia.

*Still from Dušan Makavejev, W.R.: Mysteries of the Organism (1971).*

Ten years after Makavejev's exile, in November 1981, the experimental film maker and performance artist Tomislav Gotovac made his work *Zagreb, I love you!* by running down Ilica Street to Republic Square (today Ban Jelačić Square) naked and lying down to kiss the pavement. Questioning the boundaries between public and private spheres, Gotovac tested the limits of Yugoslavia's cultural liberalism once again. According to Darko Šimičić, researcher at the Tomislav Gotovac Institute, this work was 'an ice-breaker' because 'it was impossible that any institution would support him' in making such work.[60] That is to say, none of the larger institutions like the Gallery of Contemporary Art or

60   Darko Šimičić, interview by author, audio recorded conversation, Tomislav Gotovac Institute, 12 March 2018.

the Gallery of Naïve Art could support it. However, contrarily to Makavejev, Gotovac did not face any severe consequences from his public interventions and remained a well-known and beloved figure in the Zagreb art world. A state-funded but less representative Zagreb student newspaper, *Studentski List,* even published documentation of the performance and later reported on the court case filed against Gotovac.

These two examples illustrate a general condition: the boundaries of cultural freedom were clear and strict, but Yugoslavia's 'own path in socialism' – policies that were formulated around the time Non-Alignment was established – also provided important pockets of critical practice within the repressive institutions: student newspapers, neighborhood cultural centers, youth centers, artists' clubs, and film clubs. Next to *Studentski List*, such critical spaces in Zagreb included *Magazine Polet*, Galerija Nova, ZKM, Galerija Studentski Centar, and the Extended Media Gallery (PM Gallery) in HDLU.[61]

---

61  Magazine Polet was a weekly publication by the Socialist Youth of Croatia, which wrote on rock music, photography, sub-culture and comics. Gotovac sold copies of Polet during several of his street performances. Galerija Nova was then a property of the socialist youth. Studentski Centar Gallery still exists today but has become less relevant. Extended Media Gallery (PM Gallery) was established within the Croatian Association of Visual Artists (HDLU) by members of the PODROOM group. Even though it is hardly important to independent cultures today, PM Gallery fulfilled an important role for many years. In terms of material structures, especially remnants of student culture and new media from the Yugoslav era, are still present in the contemporary urban and property management of Zagreb. For instance, the cultural center of the socialist youth prior to 1991was in the property complex on Ulica Nikola Tesla that now houses ZKM theatre, Galerija Nova, and Radio 101. An even more direct continuity from the socialist era is the Studentski Centar (SC), a large terrain housing multiple student-run organizations, including the SC Gallery and &TD Theatre. Although SC is no longer as important as it was in Yugoslavia, it is still a significant actor in independent culture. Furthermore, youth culture is an important concern to several newly established independent cultural organizations, such as Pogon, Močvara, and MAMA. Buljević, interview by author, 15 March 2018. Medak, interview by author, 29 March 2018. Šimičić, interview by author, 12 March 2018. Šimičić, interview by author, 12 March 2018. Buden and Kršić, interview by author, 5 May 2018.

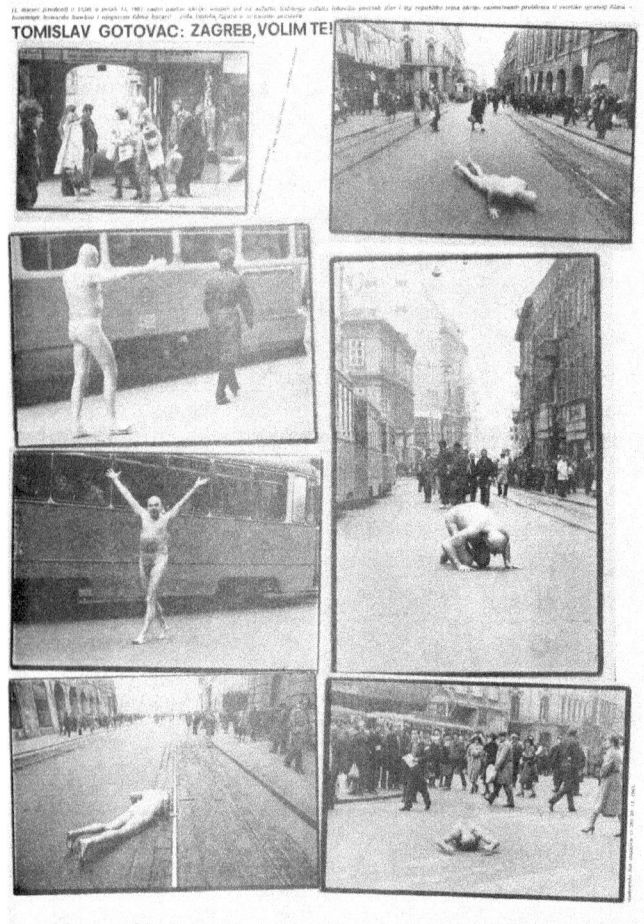

*Tomislav Gotovac, Zagreb, volim te! (Zagreb, I love you!) in Studentstki List, no. 37, vol. 792, November 20, 1981. Sarah Gotovac collection / Courtesy of the Tomislav Gotovac Institute, Zagreb.*

Ivet Ćurlin, a member of the curatorial collective WHW that now directs Galerija Nova, summarized the situation as such: 'There was quite a big state-sponsored culture, that was quite independent [from the big cultural institutions].'[62] This equilibrium of expression and repression was turned upside down in the institutional crisis that took place during and after the turbulent period of the Yugoslav Wars – roughly from 1991 to 1995. Tomislav Medak remembers the moment the post-Yugoslav institutional crisis was triggered:

> [The nationalist government of newly established state of Croatia] instrumentalized the cultural system with the mission of trying to put as much distance as possible between Croatian and Serbian or Yugoslav cultural identity. In that mission, there was little room for various segments of the diversified cultural biotope existing before 1991. [Therefore,] the cultural system was flattened out, reduced to that which was purposeful to the politics of national identity. […] Many people, particularly those who were doing work in high modernism and internationalism, left the cultural institutions because they were either highly marginalized within the institutions or simply fired.[63]

The government headed by Franjo Tudjman used cultural identity-politics to promote the national identity of the newly born state. The common Serbo-Croatian language was abandoned using the leap from socialism to liberalism as an excuse. Almost 3 million books were reportedly burned in a bookocide (Knjigocid) to purge

---

62   Ivet Ćurlin, interview by author, audio-recorded interview, Galerija Nova, 25 May 2018.

63   Medak, interview by author, 29 March 2018.

libraries of books with socialist approaches or authors from foreign former-Yugoslav countries. The influence of Yugoslavian popular music was denied and the music was banned from national broadcast channels. If, before 1991, there was room in the institutions for the transnational and transgressive work of movements like Gorgona or New Tendencies, the nationalist agenda of the young nation-state replaced that with phenomena like Croatian Naïve Art: a supposedly authentic Croatian school of painting celebrating rural life in Croatia.

*Stjepan Večenaj*, Untitled, 1990. *Večenaj was one of the Croatian Naïve Artists, whose work increased in popularity immensely after the disintegration of Yugoslavia.*

Unsurprisingly, this war-time institutional crisis did not only affect the 'biotope' of culture, but also that of academia. As Ljiljana Kolešnik argued in *The Recent History of Art History in Croatia and the Crisis of Institutions*

*Today* (2013), it became increasingly harder for art historians and theoreticians to work with experimental methods and on topical subjects:

> [The] Croatian Liberation War, the process of transition and the ensuing accelerated class division of the post-socialist Croatian society, the outspoken politicization of the traditional institutional infrastructure of art world surrounding the very process of establishing national scenes of visual arts, the sudden inflow of new theoretical paradigms (feminist, post-structuralist, neo-historicist, post-colonial), and a series of "turns" within the disciplinary field of art history (linguistic, visual, philosophical, global) – positively resulted in a new crisis of the profession [of the art historian] and in its reconfiguration in terms of redistributing the roles and blurring the borders between institutional and extra-institutional art-historical practices.[64]

In the same article, Kolešnik elaborated on the structural character of the crisis, which in fact continues up to the present day. The cultural heritages of Bosnia and Herzegovina and Serbia have been rendered inaccessible. Art and academic institutions in Croatia have seen sustained cuts to funding and imposition of neoliberal logics. All Croatian cultural heritage institutions have been instrumentalized by local (i.e. national, as opposed to Yugoslav) economic and political elites.[65] All in all, ideological as well as material structures have made

---

64   Ljiljana Kolešnik, 'The Recent History of Art History in Croatia and the Crisis of Institutions Today,' *Život Umjetnosti*, no. 93 (2013), 12.

65   Kolešnik, 'The Recent History of Art History in Croatia and the Crisis of Institutions Today,' 14-16.

it increasingly harder to work and write critically in cultural institutions throughout former Yugoslavia, especially when invoking the emancipatory potential of Non-Aligned or Yugoslav experiences.

### EVERYTHING CHANGED, OR DID IT?

Different accounts from actors in the field show one remarkable contradiction when reflecting upon the institutional crisis. Some, like Tomislav Medak and Boris Buden, argue that the cultural system underwent a major transformation. Others, like Dea Vidović and Emina Višnić, argue that the problem of the institutional field was exactly the lack of innovation and transformation. Although she acknowledges that 'almost all alternative spaces, for alternative culture were closed during the '90s', Vidović, director of the Kultura Nova Foundation, argues that 'the whole cultural system in Croatia continued to work almost in the same way as in the cultural field under Socialism. Basically, [this] means that it was completely focused on public culture and public cultural institutions'.[66] This post-Yugoslav institutional cultural sphere was never privatised, unlike other Yugoslav-era public goods, such as public infrastructure, the national oil company, and real estate. Therefore, reflecting on the emergence of independent cultures in 2007, Emina Višnić, who is now the CEO of Rijeka 2020: Cultural Capital of Europe, went as far as to state that 'even today, [institutional culture] functions, more or less, in accordance with out-dated and inadequate principles

---

66  Vidović, interview by author, 9 April 2018.

inherited from a previous era.'⁶⁷ In other words: nothing changed between 1991 and 2007.

This apparent contradiction is easily explained. A transition took place, which did not deliver the anticipated liberalisation and modernisation, but rather its opposite. The cultural infrastructure was reformed in a way that reminds some of the negative aspects associated with Yugoslav Socialism: nationally or locally centralized government of public institutions, culturally conservative and nationalist agendas, lack of experiment, political appointment of people in high-ranking positions within cultural institutions, slow and bureaucratized decision-making processes, inflexible institutions, nepotism, and corruption. Boris Buden asserted: 'It was not that we had an old system and now market democracy started. We had a modern system: market socialism. What happened was re-feudalization. Relations of dependency and political power became more important in launching media and getting money after 1990 than they were before.'⁶⁸

So, whether it was because of a transition or the exact lack thereof, it seems clear that there was an institutional crisis in post-Yugoslav culture. As Ana Dević put it, this crisis manifested itself as a 'systematic lack of institutional engagement in the field of museum collections, theoretical interpretations, archives, and knowledge about the history of contemporary art. [...] This inadequate functioning of existing institutions [...]

---

67  Emina Višnić, *A Bottom-Up Approach to Cultural Policy-Making: Independent Culture and New Collaborative Practices in Croatia* (Amsterdam & Bucharest: Policies for Culture, 2007), 9.

68  Buden, interview by author, 5 May 2018.

encouraged the creation of a "parallel system" of cultural activity and circulation of art'.[69]

This is where the concurrent narratives of disruption and continuation become a bit more difficult. As actors moved away from the institutions of socialist-era state-controlled associational life and established independent culture as an extraterritorial space, they created a parallel system that was on the one hand new and on the other hand a continuation of the 'spirit' of Yugoslav culture. Ivet Ćurlin remarked that extra-institutional independent cultural work and historiography were necessary to save the legacies of Yugoslavia's critical culture:

> For us [in WHW], it was important to establish these generational links that were not being established by the institutions. If you wanted to find out something about Sanja Iveković, Goran Trbuljak, Mladen Stilinović, Vlado Martek, or Tomislav Gotovac, you had to meet them and work with them. [...] Things were radically different in the 1990s and 2000s. Now, [in 2018,] it's kind of accepted that the legacy of conceptual art of the '60s and '70s is something that we should look back on. But back then, any kind of practice that was clearly connected to the former Yugoslav space, was considered as "not properly Croatian". So, we stepped into the vacuum of the institutional crisis and nationalist culture.[70]

Identification with the critical legacies of Yugoslav culture thus became one of the core tenets of

---

69 Ana Dević, 'Politicization of the Cultural Field: Possibilities of a Critical Practice,' *Život Umjetnosti* 85 (2009), 20.

70 Ćurlin, interview by author, 25 May 2018.

independent culture by those who were pushed out of the institutions. Mika Buljević finds that a continuous 'trajectory can be seen from the 1960's onwards, through different regimes, through different legal frameworks. In the 2000's, with the liberalisation of the law, with the freedom of association, and with some kind of governmental recognition, the [same] scene flourished or exploded.' In other words, the scene of alternative Yugoslav culture, which was exiled from the institutions after 1991, transformed into the scene of independent culture through a process of NGO-ization. This is the dominant narrative circulated amongst independent cultural workers today: Yugoslav-era critical culture and the parallel system of post-Yugoslav independent culture are based on one and the same scene.[71]

## NEW MEDIA BETWEEN GRASSROOTS CULTURE AND IMPERIALISM

A foundational and catalyzing entity in the parallel system was the pacifist movement Anti-War Campaign (ARK). ARK was established in Zagreb in 1991, the first year of the war, and connected a broad range of peace activists throughout Yugoslavia.[72] The founding of ARK marked what was probably the most important

71  It is true that there are some striking artistic resonances between these two phenomena. In 2001, twenty years after his benchmark performance of nudity, Tomislav Gotovac participated in the first UrbanFestival with a performance of cleaning graffiti-clad facades. Two other performances in that year's festival were Vlasta Delimar's *Lady Godiva* and *Appartment* by Alexandra Schuller, Gregor Kamnikar, and Slavo Vajt, both using nudity and questioning the delimitations between the public and private spheres. See: http://urbanfestival.blok.hr/urbanfestival.blok.hr/01/pdf/Jutarnji%20list%2c%20 27.%20srpnja%202001.pdf.

72  Documenta – Center for dealing with the past, one of the 'successors' of the Anti-War Campaign, is still an active NGO holding, preserving, and distributing documentation of its prior existence. Dora Komnenović, '(Out)living the War: Anti-War Activism in Croatia in the Early 1990s and Beyond,' *Journal on Ethnopolitics and Minority Issues in Europe*, vol. 13, no. 4 (2014), 111-128.

grassroots organization established in early Croatian civil society, and one of the main starting points of present-day independent cultures. Also, the history of ARK offers a prime example of the delightful combination of activist networking, atomization and liberal proceduralism characterizing Croatia's *native NGOs* of the 1990s, to borrow Gayatri Spivak's term. Independent cultural worker Tomislav Medak states:

> The various actors – ethnic and sexual minorities, anti-war and human-rights activists, journalists and public intellectuals, artists and cultural workers, and dissenters in general found themselves in opposition to the nationalist politics, and all converged around the Anti-War Campaign and several media outlets, most prominently the Feral Tribune.[73]

Many civil society actors active today in Croatia were involved in or inspired by the activities of ARK. Some examples of these include Croatia's main environmental justice advocate Zelena akcija (Green Action), the news outlet H-alter, feminist knowledge institution Centar za ženske studije, Amnesty International Croatia, Multimedia Institute, Attack!, the collective behind Medika, and Documenta: Centre of Peace Studies.[74]

---

73    Dietachmair, 'From Independent Cultural Work to Political Subjectivity,' 210-211. The point is illustrated, too, by the accounts of Croatian war-activists involved in ZaMir, as quoted by Stubbs: 'We were different from each other before the war. Our opposition to the war brought us together. After the war, we were able to be different again.' Stubbs, 'The ZaMir (For Peace) Network,' 70. Slightly differently, Medak elaborated: 'The closeness of these various factions, running from centrist liberalists to anarchist factions, has to do with the fact that there was an external repression, or an enemy, a negative factor, that made it come together. […] Franjo Tudjman and his nationalist politics provided cohesion for the opposition, as long as he was in power.' Medak, interview by author, 29 March 2018.

74    *Antiratna kampanja 1991.-2011.: Neispričana povijest*, Vesna Janković and Nikola Mokrović, eds. (Zagreb: Documenta – Centar za suočavanje s prošlošću, 2011), 132-133.

Aspiring to be a 'network of networks' and attempting to circumvent national censorship in the pre-Skype era, in 1992 ARK established ZaMir, a bullet board system communication network to connect all of these peace activists throughout Serbia, Croatia, Slovenia, and Bosnia via an e-mail list.[75] Thus, making use of tactical new media, peace activists from all of the former Yugoslav regions could communicate freely, though not without effort.

The cultural components of ARK's struggle were important for two reasons, as WHW-curator and researcher Ana Dević has explained. First, the peace movement commenced in the shape of artistic street actions, adopting the visual language of counter-culture, and second, Dević considers the entire anti-war campaign to be a resistance against the unmaking of 'wide-spread, all-Yugoslav, urban, cosmopolitan and genuinely non-ethnonationalistic cultural identity'.[76] The Anti-War Movement clung on to commonality.

75 'Originally *ZaMir* in Zagreb was run from a Dutch activist's laptop until a grant from the Government of Switzerland allowed for the purchase of the first 'server', a 386 40 MHz computer with a 'massive' 400 MB hard-disk. For many years it was a bulletin board system (BBS), using Cross-Point software as an off-line reader, a program running on DOS, and only available in the German language.' Stubbs, *'The ZaMir (For Peace) Network,'* 73. In the establishment of this BBS, the tacit knowledge of new media artists, a field always closely related to artistic research and social practices, was extremely valuable. ZaMir continued to exist throughout and after the war, providing a communication infrastructure of activist advocacy campaigns and starting a unique non-profit Internet Content Provider. 'Zamir,' *Monoskop*, https://monoskop.org/Zamir, accessed 1 July 2018.

76 Ana Dević, 'Anti-War Initiatives and the Un-Making of Civic Identities in the Former Yugoslav Republics,' *Journal of Historical Sociology*, vol. 10, no. 2 (June 1997), 127. This statement may have a Yugostalgic ring to it, but it should be acknowledged that the new national governments indeed promoted national identities through cultural identity-politics. On the level of popular culture, the abandonment of the common Serbo-Croatian language, the purging of libraries of books with socialist approaches or authors from foreign former-Yugoslav countries, and the discrediting of Yugoslav-wide popular musical legacies are good examples. This emphasis on national identities will be elaborated below, in discussion of the institutional crisis.

However, as Dora Komnenović described, the initially 'authentic', pan-Yugoslav movement quickly turned into a 'projectized', nationally active organization with international financial aids.[77] Also, as soon as military activities started and ethno-nationalist sentiments increased, ARK was framed by political elites as '"yugonostalgic", pro-Serbian quislings, foreign mercenaries and multi-coloured devils'.[78] In other words, because ARK was critical of the newly established national order, it was framed as an enemy of the people.

Strangely enough, the peace movement was also instrumentalized by the national Croatian government. The Croatian government sought to be acknowledged as a European nation, they therefore carefully complied with the rules of liberalism. Prohibit ARK from operating in civil society would have been a blatant breach of those rules.[79] Hence, the Croatian government simply had to accept ARK's existence and activities. In being an example of a necessarily tolerated opposition, ARK was an example to later civil society organizations. Komnenović therefore argues that ARK 'successfully failed': 'Even if it failed to stop the war, the Croatian anti-war movement constituted an important step in the development (and emergence) of many Croatian civil society organizations.'[80]

---

77     Dević, 'Anti-War Initiatives and the Un-Making of Civic Identities in the Former Yugoslav Republics,' 113.

78     Komnenović, '(Out)living the War,' 115. Dević has argued that this 'ethno-nationalist mobilization was orchestrated from above, while the only grassroots, civic resistance to the war-mongering agendas had an anti-ethnonationalist character'. Dević, 'Anti-War Initiatives and the Un-Making of Civic Identities in the Former Yugoslav Republics,' 128.

79     Komnenović, '(Out)living the War,' 116.

80     Komnenović, '(Out)living the War,' 122.

Making use of this failsafe strategy, ARK shifted its focus from direct anti-war activism to more general human rights and civil society work within the first years of its existence. Thereby, Paul Stubbs argued:

> Crucially, [ARK] evolved into a set of more or less defensive projects seeking inter alia to protect the human rights of oppressed groups and individuals, establish the right to conscientious objection, and deal with emerging victims of war including refugees, displaced persons, and abused women. At the same time, it was being squeezed, more or less willingly, into an emerging shape of the non-governmental organization qualifying for grants from international donors.'[81]

Thus, ARK was of constitutive importance to Croatian civil society and assumed a tolerated counter-subjective position ('to resist an overwhelming nationalist homogenisation') very similar to those taken later by independent cultures.[82]

There is another perceivable connection between ARK and the birth of independent cultures. In 1991, the anti-nationalist fanzine *Arkzin* was established in Zagreb, and in 1993 it was adopted as the 'official' fanzine of the Peace Movement.[83] It started off as a strictly political zine and later fortnightly newspaper, aesthetically characterized by Dejan Kršić's experimental design and regular

---

81   Stubbs, 'Networks, Organisations, Movements,' 15.

82   Stubbs, 'Networks, Organisations, Movements,' 17.

83   Vesna Janković and Nikola Mokrović, 'Arkzine Fact Sheet: Stages, Publicers, Formats, Supplements,' in *Prospects of Arkzin*, Tomislav Medak and Petar Milat, eds. (Zagreb: Arkzin & Multimedia Institute, 2013), 14-15. As Komnenović elaborated, Arkzin was one of the Anti-War Campaign's four main activities, next to peace-building, documentation, and human-rights activism. Kmnenović, '(Out)living the war,' 114.

features of de-skilled political cartoons.[84] Soon after its establishment, still during war-time, it started including discussions around new media and performance art, prostitution, electronic music, and other socio-cultural matters associated mainly with youth and protest culture.[85]

In 1997 and 1998, *Arkzin* published several issues as a radical pop culture magazine, expanding even more on issues of radical culture and theory, such as the relation between the internet, visual art, and soft porn.[86] It included articles by Boris Buden, Slavoj Žižek, and Geert Lovink, amongst others. Klaudio Štefančić remarked that *Arkzin* was unique in that it 'was the only magazine that systematically covered events on the international scene of new media by their extensive definition […], which included the culture of DJ's, VJ's, electronic music created and distributed via computers, urban club culture, etc.'[87]

In fact, this affinity with the broad field of new media had always been a central feature of the Peace Movement. Technically speaking, ARK was not a Croatian NGO. Since the law allowing NGOs to be established in Croatia would only be passed in 1995, the NGO behind the Peace Movement was registered in Amsterdam rather thanZagreb, which leads to an important reflection to the Amsterdam-based researcher:

- 84   For an impression of Kršić's work, see Marko Golub and Dejan Kršić, *Art is Not a Mirror, It Is a Hammer* (Zagreb: What, How & for Whom and Croatian Designers Association, 2016).

- 85   See, for instance, the full-spread article giving instructions on how to produce graffities on Image 2.

- 86   See Image 3.

- 87   Klaudio Štefančić, 'New Media, New Networks,' *Monoskop*, 2017 (2008), https://monoskop.org/images/c/c0/Stefancic_Klaudio_2008_2017_New_Media_New_Networks.pdf.

*Arkzin: Political Pop Megazin*, vol. 4, no. 1, August 1997, p. 52

There is a significant tradition of cultural exchange between these two cities, which was intensified by the atrocities of the Yugoslav Wars in the 1990s. During this violent period, many artists and intellectuals emigrated from Yugoslavia to the area which was in those years transforming from the actual West into the former West. A small but important Yugoslav diaspora settled in Amsterdam, including people such as Darko Fritz, Sandra Sterle, Dubravka Ugrešić and Dan Oki.

Still from Darko Fritz, *Illegal Immigrants Dis.Information*, 2003, online work, screenshot from the video *Migrant Navigator Tools*, 2004, https://vimeo.com/167345081. Courtesy of the artist.

Media and communication were the main benefits for the grassroots movement engendered by this Zagreb-Amsterdam-relationship. All media in former Yugoslavia was strictly controlled by the national governments, independent anti-nationalist and anti-war communication across the new borders was extremely hard. ZaMir was in fact set up by new media artists

and activists to facilitate free communication through access to telephone and internet connections via a laptop in the Netherlands. Even though it was a Croatian-language periodical published in Zagreb, three members of *Arkzin*'s advisory and editorial boards were either Amsterdam-based or moving between the two cities at the time: Dubravka Ugrešić, Geert Lovink, and Jo van der Spek. During the first Next 5 Minutes tactical media festival in 1993, which took place in De Balie, Amsterdam, the organization Press Now was set up by journalists and activists with the sole purpose of stimulating independent journalism in (former) Yugoslavia. The biggest tactical media experiment of them all was the establishment of the Independent Media Center (IMC) in 1999, an international network of collectively run critical media outlets. Not only did the entire IMC fiercely critique of the imperial politics of the WTO, but the Dutch IndyMedia was especially focused on the cultural and political goings-on in former Yugoslavia, where the Kosovo War was still waging. The newly emerging, grassroots, politicized culture of new media transcended national cultures and provided opportunities for transnational, transversal action and solidarity between Amsterdam and Zagreb.

In 1998, some years after the war in Croatia ended, *Arkzin* stopped making magazines. Instead, it started publishing books, the first of which was a Croatian translation of the *Media Archive* by Adilkno (Agency for the Advancement of Illegal Knowledge), a predominantly Dutch squatters' and writers' collective with close ties to the Anti-War

Movement.[88] In the preface for this Croatian edition of the *Media Archive*, Adilkno wrote the following media-skeptical reflection:

> It is clear to Adilkno that the war in Former Yugoslavia is the European antipode of the Gulf War. If, there, history seemed to be replaced by video games, here, the age-old human butcher entered the stage. The existential approach of the fellow citizen was in direct opposition to the American longing for virtuality. The media were abused, but the idea of reality just kept nagging away at the conscience of the European Kulturmensch.[89]

Media culture – identifier of liberalism – might have had its tactical uses to grassroots organizations, it might have born the promise of liberation, but by now it had somehow become clear that the atrocities of the Yugoslav Wars had been gravely mediatized in documentaries, interviews, and news reports to cater to the (former) Western European fetishism of the real. There was more to the relation between Amsterdam and Zagreb and to the proliferation of liberal-critical values than grassroots solidarity.

---

88   See Arkzin's official website: http://arkzin.net/index.php. Dejan Kršić, designer and one of the central figures in Arkzin, joined the curatorial collective WHW in the early 2000's. To keep the name and legacy alive, he has used the brand name Arkzin every now and then for publications by WHW/Kršić. In 2013, the archive of Arkzin was digitised by Multimedia Institute and made available on Monoskop, the book *Prospects of Arkzin* was published, and a major exhibition on the history of Arkzin took place in WHW's Galerija Nova. The digital archive of Arkzin can be found on https://monoskop.org/Arkzin. Tomislav Medak and Petar Milat, eds. *Prospects of Arkzin* (Zagreb: Arkzin & Multimedia Institute, 2013).

89   Adilkno/Bilwet, 'Inleiding bij de Kroatische editie van het Media-Archief,' https://thing.desk.nl/bilwet/bilwet/CROABILW.txt, accessed 18 January 2019. Translation by author.

## NGO-IZATION: PERFECT MACHINES AND THE MANAGED AVANT-GARDE

Even though Croatia's national cultural policies were informed by nationalism and neo-conservatism from the start, simultaneous tendencies of neoliberalization inherent to the adopted model of capitalist liberal democracy shaped the social, political and cultural arenas. Within this new state model, there was no possibility of direct oppression of cultural actors outside of the institutional sphere. So, while critical voices were ousted from the institutional sphere, many self-organizing cultural workers started to work in the newly established sphere of civil society. These newly emerging actors benefited from the neoliberal aspects of the new Croatian condition, assuming the legal form of the NGO, receiving funding from Western philanthropic foundations, and to some extent territorializing on the expanding market of creative industries. Next to an increase in grassroots engagement, the disintegration of Yugoslavia caused a large increase of international philanthropic funding for culture, arts, and civil society which was 'invested' in the region. The most important fund was the Soros Foundation from New York.

The Soros Foundation, established by the American Hungarian stock market broker George Soros, set out to support the post-socialist transition by founding over 20 Open Society Foundations (OSF), one for every post-socialist country except for Hungary, which had two. Thus, inevitably the Open Society Foundation Croatia was founded in 1993. As was the case for all Open Society Foundations, one sub-organization of the OSF Croatia was the Soros Center for Contemporary Art (SSCA). In most countries, the SSCA was a proponent of the artistic tenet of transition: the transition from socialist realism

to 'contemporary art'. The former Yugoslavia, of course, was a different case. Except for the brief period between 1945 and 1949, when Tito was more Stalinist than Stalin, Yugoslavia had no official doctrines of artistic production, no forced socialist realism. So, what did the cultural transition in this case represent?

The co-founder and former director of the SSCA Chisinau, Octavian Esanu, wrote a booklet which like no other describes the Soros approach to contemporary art. To begin with, Esanu remarks that all the non-conformists and cultural dissidents were suddenly called contemporary artists by the SCCA.[90] The foundation thereby adopted a discourse which arose in early the 20th-century UK and US and which was notedly adverse to that of 'modern art'.[91] If, under modernism, artistic life was dominated by a few highly visible artist personas, contemporary art is run by an invisible workforce of mediators, curators, and managers. Rather than by utopian ideas or activism, contemporary art is determined by the regulating structures of civil society and the market (gallery, fair, museum): it is free of ideological or propagandistic constraints and therefore *open*. With the idea of contemporary art, the SCCA introduced the Western model of the 'managed avant-garde'. It did so by postulating three very clear goals for the SCCA Network: '1) to promote contemporary art [...] 2) to exchange information among its members 3) to organize an annual festival or exhibition'.[92] The SCCA was a smoothly running PR machine for contemporary art striving towards an open society.

90  Esanu, *The Transition of the Soros Centers to Contemporary Art*, 4.

91  Esanu traces back this discourse to the establishments of the Institutes of Contemporary Art #

92  Esanu, *The Transition of the Soros Centers to Contemporary Art*, 15-16.

What did this mean on the ground in Croatia? Soros singlehandedly financed a boom of a wide range of non-governmental organizations, amongst which MAMA Multimedia Institute and the Anti-War Campaign. The Center for Contemporary Art funded international residencies for Croatian artists, organized topical exhibitions, and built up archives of documentation on contemporary artistic productions.[93] Moreover, it supported already existing NGOs such as Atelijeri Lazareti in Dubrovnik and other important organizations – both financially and by facilitating collaborations.[94] This influx of money and expertise created the space for many new, young, experimental actors in Zagreb's cultural life to establish themselves as cultural professionals, and a diversification of the cultural field took place in the 1990s. According to Emina Višnić, these new 'organizations were mostly self-centered, they worked more or less independently, and the whole field of became atomized'.[95]

So, while the institutional cultural sphere was cleansed of dissidents, new opportunities for subaltern voices to speak arose outside of it. It seems that this simultaneous withdrawal from the institutional sphere and re-politicization of culture in civil society during the transitional crisis is best characterized as autonomist.

---

93  The first artist to receive funding from SSCA Croatia for a residency in New York was Tomislav Gotovac. In 1993, the SSCA curated a large exhibition on the relation between artistic production and the experience of the war. The SSCA archive, now housed in the ICA, is still a unique collection of documentation from the 1990s. Some impression can be gained from the outdated website of the SCCA: http://www.scca.hr/eng/about_us.html. Vukmir, interview by author, 9 March 2018.

94  See: http://www.arl.hr/hr#naslovnica. In the 1990s and early 2000s, Art Workshop Lazareti was directed by artist and curator Slaven Tolj, currently director of the Museum of Modern and Contemporary Art in Rijeka and one of the most influential figures in independent cultures.

95  Višnić, *A Bottom-Up Approach to Cultural Policy-Making*, 12.

In spite of this, there was not a generally anarchist, tautologically self-affirmative or anti-social attitude amongst these organizations. On the contrary, it seems that independent cultural workers often embraced the promises of the post-socialist transition and the introduction of liberal democracy. Goran Sergej Pristaš, who was active in the independent Center for Drama Arts since 1996, characterized this period as one of 'proceduralism': 'a period in which [independent cultures] leaned on the legacies of democratic decision-making'.[96]

Now, the question is why this proceduralism of the cultural transition towards the 'open society' was embraced by artists and activists alike in Croatia. At least partly, they were motivated by idealistic reasons, arguing that the idea of open society was aligned with the legacies of anti-nationalism and anti-fascism they supported. As Geert Lovink put it, the SSCA was a 'perfect machine' for the emancipation of subaltern voices.[97] However, there was also a pragmatic element to embracing an 'open society'-discourse in former Yugoslavia. Internationally funded foundations were necessarily a constitutive part of the newly emerging parallel system in a country ruled by chaos. During the war-torn 1990s, the SCCA was one of the few – if not the only – institution to structurally fund contemporary artistic practices.[98] Ultimately, it was clear that hardly anything could be produced in terms of critical culture without Soros or other international funding bodies.

<ol start="96">
<li>Pristaš, interview by author, 14 May 2018.</li>
<li>Aaron Moulton and Geert Lovink, 'The Soros Center Was a Perfect Machine', *Art-Margins*, 15 July 2019, https://artmargins.com/the-soros-center-was-a-perfect-machine-a-dialogue-between-aaron-moulton-and-geert-lovink/.</li>
<li>Other smaller but important funds for early Croatian cultural production in civil society included the Rosa Luxembourg Stiftung and the Dutch national funds for 'ontwikkelingssamenwerking' (development-collaboration).</li>
</ol>

Operating in civil society and running on private money thus, independent cultures were part of the rise of the logic of creative industries and benefited from being a symbol of it.[99] What might have been suspected already from the example of *Under the City Rave* was thus true. In effect, the independencies of the independent cultures that emerged from the newly independent state of Croatia embodied an entirely new type of dependence: dependence upon liberal models of cultural production, the systemic sphere of civil society, and the money of (Western, private) philanthropists.

Dejan Kršić and Boris Buden argue that there was a sense of half critical, half complacent irony in this pragmatic embrace of NGO-ization, liberal discourse, and cultural industries:

> Of course, we were part of the Human Rights discourse to get the money from the Western sources. I remember we had one file on a computer full of phrases like "development of civil society" and "free and independent media". We would just cut and paste these to feed them, but we knew that it was stupid. We said: "We want freedom and Human Rights and civil society development." But at the same time we were laughing about it, because civil society was part of the problem. Civil society was the Catholic Church, this fascist institution that controls the State. Do we want a stronger civil society? No, we

---

99 It should be noted that the parallel system established in the 1990's was not the exclusive terrain of independent cultures but was situated within the general context of the 'creative industries'. Some art market existed in Yugoslavia already since the 1960's. Yet, there were never creative industries like those in Western Europe and the US.

> don't. We want a policeman to protect us from the too strong civil society![100]

All in all, this first phase in the history of independent cultures in Croatia seems to have been a stage of independencies from independence: the singular 'independence' refers to the cultural dominants of the newly established independent state of Croatia, while with the plural 'independencies' refers to the anti-nationalist logic of independent cultures. The independence of the new state of Croatia was post-historical, culturally conservative or revisionist, economically crony capitalist, and nationalist in every sense. The independencies characterizing the logic of independent cultures were independent exactly from this nationalism of the new independent state of Croatia. But at the same time, independent cultures made use of the same post-historical and liberal discourses of transitology. Hence, from the moment of their birth, independent cultures created space for anti-hegemonic and anti-political subjectivities – but also for embracing neoliberalism.

The problems inherent to this pragmatism still haunt independent culture. For instance, the Amsterdam-based European Cultural Foundation (ECF), a lottery-money funded grant-giving organization, has donated money to independent culture for decades and continues to provide project-based funding. This means that independent cultures in Croatia remain partially dependent upon the Dutch lotteries to this day. But, in all fairness, this is a very small part of the funding received by independent cultural organizations. Most money today comes from local and national governments, because the scene

---

100   Buden and Kršić, interview by author, 5 May 2018.

overcame its condition of atomization and almost complete dependency upon philanthropism in the early 2000s and started a process of systemic territorialization.

*Installation shot of the 26th Youth Salon in Zagreb Fair's 5th Pavilion, organized by Kontejner.*

# Systemic Territorialization

Pictures of 59 shipping containers scattered across a huge warehouse show the first image of independent cultures *as a scene*. Peeking into the containers, they capture an oil painting of a bathing family, strange devices with EU flags, SM dolls, a lizard-headed toy pilot, hundreds of people standing between a billboard depicting oral sex and a band playing on a large red stage, youngsters hanging around on yellow mattresses, automated graffiti writing vehicles, shady yellow figures on white backgrounds, and charcoal-black diamond sculptures.[101] These pictures were taken in January 2001, during the 26th Youth Salon of the Croatian Association of Artists. The organization and curation of the Salon were the first activities of a new collective that gave itself the suitable name Kontejner.[102]

In hindsight, Kontejner-curators Olga Majcen Linn and Sunčica Ostoić still consider this first activity of the collective as their biggest one:

> The exhibition took place in Novi Zagreb and was an experiment to reflect on the space of art in Zagreb and the position where the new Museum of Contemporary Art would be built. We used cargo containers to build a city structure, opened

---

101 For this picture gallery, see: '21ˢᵗ Youth Salon,' *Kontejner*, https://www.kontejner.org/en/projekti/salon-mladih, accessed 17 January 2019.

102 Kontejner, which was at that point a collective of art history students, collaborated with four curators for the exhibition: Slaven Tolj of Art radionica Lazareti in Dubrovnik, Michal Koleček from the Czech Republic, and Jurij Krpan and Vuk Ćosić both from Slovenia. The Croatian army helped moving the containers, which were leant for free by their owner.

> it up to the independent cultural scene and invited subcultures like skaters and basketball players. […] Art was mingled with all these other urban situations and types of creativity. […] This empowering and stimulating event, which lasted for three weeks, was the first gathering of the Croatian scene in the space of 10.000 square meters. Along with international organizations, artists and theorists, they generated an enormous amount of energy while presenting their art and cultural practice.[103]

The energetic and experimental scenery of the industrial pavilion at the Zagreb Fair provided space for more than containers full of art. One contained the MAMA library, another hosted a vegetarian community kitchen by Attack!, and one which Močvara used to organize their program of concerts. Political commentary, civil society networking, pop culture, sports and artistic practices flowed into one another with apparent self-evidence – not only in terms of programming, but also for the pubic: 'The city-like structure provoked city-like behavior. While a concert took place on the Youth Salon city main square, the clubs were also working. This collaborative process made it into a huge attraction. It was very well visited; many people were coming in all the time.'[104] So, the scene of independent cultures became visible to the public.

---

103 Olga Majcen Linn and Sunčica Ostoić, interview by author, audio-recorded Skype call, 12 June 2019.

104 Majcen Linn and Ostoić, interview by author, 12 June 2019.

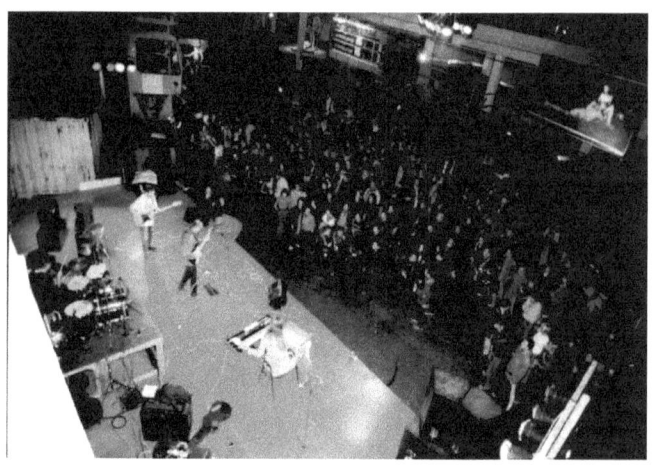

*Installation shots of the 26th Youth Salon in Zagreb Fair's 5th Pavilion, organized by Kontejner.*

The sense of joint venture, common agendas and public awareness – that surrounded the independent cultural scene and was so tangible at the Youth Salon – was typical for the early 2000s. The years of 1999 and 2000 were, according to Petar Milat, 'a threshold (and not just for the culture of Croatia)'.[105] While the constellations of power in Croatia where still relatively new and solidifying, a small break occurred. In a rapid sequence of events, Croatia's autocrat president Franjo Tudjman passed away, the conservative-nationalist party lost power, and a progressive-liberal coalition started governing the country. All of a sudden, the legitimacy of independent cultures was acknowledged by national and local authorities and a limited part of the financial resources dedicated to culture were granted to the independent scene.[106] Within this 'crack' provided by the socialist-liberal government, new possibilities appeared and independent cultures reconfigured their internal discourses and external tactics. New actors entered the scene assuming inventive, flexible, project-based organizational forms like curatorial collectives and festivals.

The new acknowledgement of non-institutional culture and the possibility for all of these various actors to gather and present themselves as a scene, resulted in a growing sense of networked communality amongst different organizations. Even the very term 'independent culture' was coined in this time.[107] This sense of normalization, of being an integral and legitimate part of the cultural system, had a profound effect on the organization of civil

---

105     Milat, interview by author, 8 March 2018.

106     Višnić, *A Bottom-Up Approach to Cultural Policy Making*, 43-44.

107     Buljević, interview by author, 15 March 2018.

society. According to Teodor Celakoski, independent cultures started 'taking real positions within the cultural system'.[108] Different organizations started gathering on platforms and in tactical networks such as Clubture, Operation:City, PolicyForum and Zagreb – Cultural Kapital of Europe 3000, thereby practicing advocacy, diversifying their funding (now also drawing from municipal and national foundations and funding programs), and re-engaging in affirmative political action.

At the same time, the Open Society Foundation, previously one of the sole funders of independent culture, lost much of its relevance to the scene. Because of the seeming normalization, the Soros Foundation started, first, to spin off a series of NGOs, including Multimedia Institute (mi2), Centre for Drama Arts (CDU), the FACTUM film production company, and the SCCA (later Institute of Contemporary Art), and then slowly to retreat from the Croatian context. Mission accomplished, or so it seemed.

Generally, it can be stated that independent cultural organizations were no longer satisfied upholding a parallel, alternatively funded cultural system but started claiming space within the hegemonic cultural system. Looking back, Goran Sergej Pristaš describes this period as a 'prescriptive phase' in which independent cultures 'stepped into a role of active proposing of policy and organization'.[109] Independent cultures started to really believe in their ability to change the world around them.

---

108   Celakoski, 'Tactical Media and Right to the City.'

109   Pristaš, interview by author, 14 May 2018.

## A CRACK IN THE SYSTEM

How exactly did this crack in the political system work? In January 2000, the first social-democrat-liberal coalition (consisting of SDP, HSLS, and other minor parties) of the independent state of Croatia was established.[110] The new government introduced a system of cultural councils to manage the allocation of the budget for culture, which included one Council for Media Culture (later called Council for New Media Cultures and today named Council for Innovative Cultural and Artistic Practices). According to Tomislav Medak, this council was of great strategic importance to the funding of emerging independent cultures: the council 'used the notion of (new) media culture, which used to denote the video art, computer art or, maybe, the conceptual art practices that have been around since the 1970s but that are still today not fully considered as part of the visual arts, as an umbrella to finance a range of new non-institutional cultural practices'.[111] In similar vein, Dea Vidović asserts that the establishment of this council 'was the first step in our cultural system to change the position of independent culture, because this specific council opened up finance for different NGOs which work in different media'.[112]

The formation of the National Foundation for the Development of Civil Society in 2003, which ran on lottery funds, was another important change in policy. Furthermore, the liberal-socialist coalition relaxed the

110    For general facts and analysis of the fragmented parliamentary political situation of Croatia in the early 2000's, see Mirjana Kasapoović, 'Coalition Governments in Croatia: First Experience 2000-2003,' *Politička misao: časopis za politologiju*, vol. 40, no. 5 (Spring 2004), 52-67.

111    Medak, interview by author, 29 March 2018.

112    Vidović, interview by author, 9 April 2018.

Croatian law on establishing NGOs in 2001, making it much easier to gain NGO status, thereby contributing to the NGO-boom. Whereas they previously existing only abroad, the infrastructures for collecting funding for civil society work were thus also established within Croatia. Vidović argued that 'it's definitely a neoliberal model and for many governments, it was a kind of excuse to cut funding. [Yet,] it was the inspiration and proof that it's possible to establish a new institution, to give support to civil society organizations, to support some of the democratic instruments.'[113]

The conservatives of HDZ returned to power once again in 2003. But by then, independent cultural organizations had already taken advantage of the temporary crack in the system.

### THE TRANSCENDENTAL SHACK

Multimedia Institute was one of the important organizations to benefit this chain of events. In mid-1999, they were established as a spin-off of the Open Society Institute – Croatia (OSI), employing mainly software developers from the Soros Foundation and young Croatian cultural-theoretical workers. They received funding from the OSI to open the venue MAMA in the courtyard of Preradovićeva 18 in 2000. Despite the dot-com venture capitalist takeover of the field of cybernetics in the second half of the 1990's, there was a distinct atmosphere of euphoria around the establishment of this hack lab and net.culture club. It was the place where people played around and experimented; made and played electronic music; established a copyleft music label; danced; choreographed; and organized the

---

113   Vidović, interview by author, 9 April 2018.

experimental music festival Otokultivator on the island of Vis.[114] MAMA was buzzing with activity and optimism.

According to Petar Milat, the purpose of the space was, 'to become a kind of living room for the Zagreb alternative scene'.[115] Visitors today will still find MAMA with its original airport-inspired design: grey walls, concrete floor, red furniture, red light-box signposts, screens and cables scattered throughout the space. This interior tells us that MAMA is a no-space or Temporary Autonomous Zone, and a mother ship where 'the most vulnerable, the most fragile minorities, mostly but not exclusively culture-wise' are hosted.[116] These groups included theorists, hackers, LGBTQ+ people, feminists, greens, animal rights activists, etc. By hosting this broad variety of subcommunities, MAMA created a transversal space

---

114 Multimedia Institute quite literally created the spaces for many of the actors in the independent cultures to start working by being based in MAMA and extending their practices far beyond it. Mi2 did groundbreaking work, especially in its early years, by, for instance, organizing the culture and tech festival Otokultivator on the island Vis, running a copyleft electronic music production company, and providing space for the first independent contemporary dance platform Eks-Scena. Over the following two decades, Multimedia Institute went on to produce the Human Rights Festival, an extensive editing and publishing program, lectures by internationally renowned theoreticians and activists, and several digital archives, while the practices of advocacy and political activism were taken over by other organizations (sometimes including the same people). By now, Multimedia Institute has published nearly 40 books, all of which are available on Monoskop: https://monoskop.org/MaMa. These books include everything from translations of Italian autonomists and a catalogue of Arkzin to Jacques Rancière's latest book *Modern Times* (2018). The major importance of Multimedia Institute thereby shifted from the pragmatic level to the discursive level. What nonetheless remained constant is mi2's influential, even iconic, role as one of the largest and most durable actors in the scene.

115 Milat, interview by author, 8 March 2018. Because of his love for the Italian autonomists, Milat prefers the terms 'alternative culture' or 'autonomous culture' over 'independent culture' but refers to the same scene.

116 Milat, interview by author, 8 March 2018. For an elaboration of Hakim Beys term TAZ/Temporary Autonomous Zone, see 'Temporary Autonomous Zone,' *Wikipedia*, https://en.wikipedia.org/wiki/Temporary_Autonomous_Zone.

for chance encounters. It became a 'transcendental shack' for the scene.[117]

*Screenshot of the website of Otokultivator Festival, organized by Multimedia Institute, EASA and URK on the island of Vis, 2001-2003, www.desk.org:8080/ASU2/mi2mama.pro.otokultivator.*

## TACTICAL NETWORKS

Of course, a mere sentiment of communality in a moment of political tailwind was not enough to establish independent cultures a scene. A crucial strategy in the maintenance of these cultural organizations – beyond the (in hindsight) brief crack in nationalist politics – was to establish durable and tactical networks, essentially a systemic territorialization. Antonija Letinić stressed:

---

117   Milat, interview by author, 8 March 2018.

> [Actors in the independent cultural field soon] recognized that one of the main ways [to maintain themselves was] to network, to exchange, to support each other. They were all dealing with institutional critique, contemporary culture, new experimental artistic practices, DIY culture, culture of youth, progressive, critical, experimental culture: different streams within the arts and culture, that would not be included in, for example, "modern art".[118]

Thus, it was necessary to create 'a platform that would encourage exchange of programs, touring of programs through different cities and places', and that would also promote the decentralization of the Zagreb-centered cultural system.[119]

In 2001, Multimedia Institute brought together 15 independent cultural and youth organizations throughout Croatia. In 2002, the network proposed a multi-annual partnership with the Open Society Institute – Croatia and held its first Assembly, which was the foundational moment of Clubture. Clubture was conceived of as 'a non-profit, participatory network of organizations, which aims to strengthen the independent cultural sector through program networking, raising public awareness, encouraging organizational development within the sector, as well as promoting change in the institutional framework'.[120] It was designed as a catalyst for long-term collaborative practices within the independent cultural scene, while the improvement

118 Antonija Letinić, interview by author, audio-recorded interview, Kursiv office, 3 April 2018.

119 Letinić, interview by author, 3 april 2018.

120 Višnić, *A Bottom-Up Approach to Cultural Policy-Making*, 19.

of resource (space) allocation for urban cultural and youth organizations was set as its short-term goal. The first proof of Clubture's effectiveness was delivered already in 2003, when they successfully campaigned to preserve the government funding for Cultural Councils.[121] In 2007, the organization gathered over 80 organizations.[122] The projects Clubture realized were, and still are, initiated by its member organizations (peer-to-peer), are managed with participatory decision-making processes, and are evaluated with criteria consisting of socio-cultural values that indicate 'the potential to positively influence the development of a socio-cultural capital'.[123]

In 2003, another important tactical network, *Zagreb Cultural Kapital 3000,* was launched by CDU, mi2, Platforma 9.81, and WHW, later to be joined by Shadow Casters, BLOK, Community Art, and Kontejner. Its mission statement claims that this network appropriated (in hindsight successfully) the language of creative industries in order to question it.[124] With the establishment of Clubture and Zagreb Cultural Kapital, 'social activism', tactical networks and the prospect of systemic transition through institutional territorialization formally entered independent cultures for the first time.[125] The sense of optimist communality materialized in tactical networks.

---

121  Medak, interview by author, 29 March 2018.

122  Višnić, *A Bottom-Up Approach to Cultural Policy-Making,* 18.

123  Višnić, *A Bottom-Up Approach to Cultural Policy-Making,* 18.

124  'Zagreb – European Capital of Culture 3000,' *mi2.hr,* http://m.mi2.hr/en/suradnje/zagreb-kulturni-kapital-evrope-3000/, accessed 29 June 2018.

125  'Zagreb – European Capital of Culture 3000.'

Now that the political climate was favorable for independent cultures, the idea arose that an independent cultural organization did not have to be radically anti-systemic to be important to the scene or society. It appeared that NGOs could also partake in the cultural system and territorialize it. Take, for example, Booksa, a book club and independent bookshop which opened in 2004. According to co-founder Mika Buljević, their goal was to 'promote literature and to connect literature to other art fields, but also to society and living culture'.[126] As a gathering and co-working space, Booksa started sharing MAMA's role as the meeting point for the scene, which it retains up to today.[127] This is however not to say that MAMA and Booksa are the same. Booksa leans much more towards being a café than a transversal no-space. And, indeed, there is a different logic at play. Booksa is one of the first independent cultural organizations to self-finance a significant segment of its income by charging small membership fees and selling drinks. Additionally, Booksa turns into a market place for locally grown organic vegetables once a week. In doing so, Booksa both embraces market logic – even though only at the community level – and promotes its resilience to funding cuts.

In 2003 WHW took over the post of directing Galrija Nova as an NGO, rather than as one or more private persons. This is a second example of the hybridization of independent cultures. Ivet Ćurlin remembers that 'this

---

126    Buljević, interview by author, 14 March 2018.

127    The NGO Kulturtreger was established to run the venue Booksa, but it later also developed three more 'flagship programs': the web portal Booksa.hr, the Centre for Documenting Independent Culture, and an educational program. Buljević, interview by author, 14 March 2018.

was quite revolutionary, or very innovative at the time. There were no such things as public-private partnerships. [...] It was really important that we continued working and ran the space as a collective, so we negotiated this contract'.[128] Klaudio Štefančić, the curator of Galerija Galženica, finds that this affirmative stance towards creative industries had an emancipatory effect for the entire scene:

> WHW started to play the role of four young successful women, a living proof that it was possible to be successful in the cultural market (they were and still are free-lancers). [...] Reading about the international success of WHW in the Croatian media, every young art historian and scholar has learned that you don't have to work in some dusty museum to call yourself a curator, that curating is not a boring job in the cold museum depot, but that it means traveling all over the world, working in beautiful architectonic spaces, meeting new people, getting new experiences, and so on. Accidentally, and in spite of their effort to criticize neoliberal capitalism, WHW became one of the Croatian symbols of the creative industries. [...] And we needed that story of four young women capable of earning money without help from the corrupted political elite.[129]

Around 2007, the city tried to kick WHW out of Galerija Nova. WHW resisted and was able to negotiate a new contract using the fact that it was by then internationally recognized and had curated the Istanbul Biennial –

128 Ćurlin, interview by author, 25 May 2018.

129 Klaudio Štefančić, correspondence with author. WHW did get some funding from the government during their first four years in the gallery, consisting of one salary to be divided over four curators, payment for guards, and some investment in furniture (including the purchase of a few dozen Vitra Panton chairs).

thereby appeasing Croatia's insecurities regarding how Western they are as a nation – as leverage. However, this new contract has expired too, and WHW has used Galerija Nova without a contract for the last five years, thus they occupy a legal grey zone, turned from a hybrid into a bastard.

Through their innovative non-governmental models, Booksa and WHW tried to find a middle ground between autonomy and institutionalization, striving to contribute to a 'hybridization' or 'bastardization' of institutional culture and independent cultures. By being partly affirmative of the hegemonic cultural system, they were capable of providing a public infrastructure for the scene. They created a public space where social values such as emancipation of the LGBTQ community, anti-fascism, and protection of urban commons can be articulated and where civil discourse can emerge. There are more examples of organizations like this. As Buljević noted, Pogon is another 'example of such hybridization of the system, where public-civil partnerships have been established. Public-civil partnerships, not public-private partnerships, are a good direction.'[130] But, while this type of systemically moderate practice gained momentum in the early 2000s, other directions were also opened up.

## MARX AND SUICIDAL CLOTHES AT BADEL

'Marx and Suicidal Clothes as Part of Program at Badel', *Jutarnji List* headlined on the 27th of August 2005. Badel, an abandoned industrial warehouse in the center of Zagreb, and the neighboring property Gorica, were occupied by a number of independent cultural organizations on the initiative of curatorial collective

---

130    Buljević, interview by author, 14 March 2018.

BLOK and Platforma 9.81.[131] During a ten-day festival the scene organized an extensive cultural program attended by 15,000 people – one of the biggest manifestations of independent culture so far.[132] The program included works by Lara Mamula, Ana Hušman, and Boris Bakal & Shadow Casters, amongst others, and probably featured burning garments.[133] On the opening day, even the Mayor of Zagreb, Milan Bandić, showed up to officially open the festival. Impressed by the number of visitors, Bandić promised that the site would be turned into a cultural youth center. But the promise remained unfulfilled, and the Badel and Gorica properties remain unused up to the present day.

So, the Badel-Gorica festival turned out to be a culturally vibrant, while politically ineffective exercise. But despite its lack of direct political effectiveness, or maybe because of it, the Badel festival was an important catalyzing moment of political subjectivation of the independent cultural scene. It became clear that, politically, an energetic gathering of tactical networks in culture in itself was not enough – that new, better and smarter modes of practice were necessary.

On this issue, Tomislav Medak has argued:
> The events around the Badel-Gorica industrial site made us aware that we were dealing with a much broader process of social transformation [beyond culture], one that started with the

---

131   This event was officially BLOK's fifth Urban Festival, which took place within the context of the platform-collaborations/projects Zagreb Cultural Kapital 3000 and Operation:City.

132   BLOK, 'Urban Festival 2005 Editorial,' *Urban Festival*, http://urbanfestival.blok.hr/05/eng/editorial.html, accessed 29 June 2018.

133   For the program, see 'Urban Festival Zagreb 9-17 September 2005,' *Urban Festival*, http://urbanfestival.blok.hr/05/eng/programme.html, accessed 22 May 2018.

process of privatization of social property in the 1990's [and that] what we were facing was the continuation of that privatization of worker-managed factories and the bailed-out banking sector. Privatization of companies is perceived as a criminal primitive accumulation. Privatization of space was a continuation of that process, a second privatization.[134]

'*Marx i odjeća za suicide, dio programa u Badelu*', Jutarnji List, 27 August 2005, http://urbanfestival.blok.hr/05/pdf/Jutarnji-list-27-08-05.pdf.

---

134   Dietachmair, 'From Independent Cultural Work to Political Subjectivity,' 216-217.

In this way, a Marxist perspective on the injustices of the post-Socialist situation was articulated at Gorica. It was this experience of economic injustice which later enabled Right to the City to become a mass movement. What is more, something that was already notable at the 26th Youth Salon became obvious from the Badel-Gorica occupation: curatorial collectives make up a foundational part of independent cultures.

Since around 2000, one curatorial collective after another was established in Zagreb, most notably What, How & for Whom?/WHW (1999), Kontejner (2000), BLOK (2001), and later DeLVe (2009). Initially being flexible, playful, loose, informal, low-cost, event-focused and nomadic, these organizations were able to take advantage of the new socio-political reality. WHW and BLOK were amongst the first independent cultural organizations to operate almost entirely without Soros funding but instead with money from the national and municipal governments.[135] This nomadic existence also meant that curatorial collectives were, from the outset, focused on the local and urban embedding of artistic production. They examined the impact of art in the transformation of urban spaces. They brought a microscope to the exclusionary workings of spatial borders and they highlighted the role of art in the accumulation of

---

135 According to Ana Kutleša, the playful nature and flexible format in the early days of BLOK and its main activity, the Urban Festival, enabled this mode of practice. Kutleša stressed that BLOK started professionalising around 2005 or 2006 (official employment by BLOK, differentiation of programs, structural funding from the National Fund of Civil Society Development) and received its and only first Soros funding in 2011. Ana Kutleša, interview by author, audio recorded interview, BAZA, 11 May 2018.

capital.¹³⁶ It will hardly have surprised anyone that BLOK brought Marx to Badel.

Since the early 2000s, both WHW and BLOK had started running venues on a long-term basis, Galerija Nova and BAZA respectively. In that sense, only Kontejner remained a nomadic curatorial collective. Still, all three continue to be important actors in the independent cultural field, as they continue to be concerned with the (problems of) artistic production and its 'use value' in relation to urban space, (art) history, knowledge, emancipation, and the public.¹³⁷

136   Illustratively for independent cultures in general, these curatorial collectives entered the scene from different backgrounds and perspectives. WHW includes mainly art historians and has focused on the intersections of social practices and visual arts from the outset. BLOK, on the other hand, was established by a heterogeneous group of students from throughout the faculties and initially focused on international theatre studies, contemporary performance, everyday life and urban interventions. In this approach, it was mainly inspired by theoretical perspectives derived from Debordian situationism and psychogeography. Kutleša, interview by author, 11 May 2018.

137   This is certainly not to say that these organizations still exactly what they did around 2000. BLOK has recently become concerned with issues of social and community art with a direct, grassroots interventionist focus, organizing programs such as Artists for Neighborhood and Micropolitics. See: http://www.blok.hr/en. WHW often takes approaches that are theoretical and international rather than focused on direct, local interventions in public space. Next to running an extensive exhibition program in Galerija Nova, WHW has curated the 11$^{ch2\_th}$ch2_ Istanbul Biennial in 2009 and contributed extensively to Tania Bruguera's *Arte Útil* program, amongst other things. '11$^{ch2\_th}$ch2_ Istanbul Biennial,' *Frieze*, 1 November 2009, https://frieze.com/article/11th-istanbul-biennial. 'Really Útil Confessions: A Conversation between Nick Aikens, Annie Fletcher, Alistair Hudson, Steven ten Thije, and What, How & for Whom/WHW,' in *What's the Use? Constellations of Art, History, and Knowledge: A Critical Reader*, Nick Aikens, Thomas Lange, Jorinde Seijdel, and Steven ten Thije, eds. (Amsterdam: Valiz, 2016), 448-465. According to Ivet Ćurlin, this international focus causes WHW to be 'more present on the local scene at times, and less present at other'. Ćurlin, interview by author, 25 May 2018. Yet, all three have been of constitutive importance to the independent cultural scene. They have an extensive publishing record and a concern for the education of a younger generation of artists in common. Since 2016, BLOK has been organizing the Political School for Artists and from next year onwards WHW will run the WHW Academy.

This concern with 'the public' required independent cultures to take on the new role of creators and distributors of public discourse, a role that was fitting to the rising optimism and the new ambitions of systemic territorialization. Independent cultures had to uphold an effective flow of advocacy in order to reach out to the public and enter the public discourse This also to solidified their positions as real actors in the system. Therefore, in 2005, Clubture established the online portal www.kulturpunkt.hr to cater to two needs of the scene: a visible medium that would function as a bridge to the audience, and a space for critical contextual analysis.[138] Then, in 2009, Kulturpunkt was spun off from Clubture, and Kursiv was established as the NGO behind it. Within the limitations of the legal framework, Kursiv was set up to be a horizontally governed organization with equal decision-making power amongst its editors. Since then it has been running the portal as a steady flow of information on what is happening in contemporary culture and arts, civil society, media, and education from a left-leaning perspective. It is therefore one of the only steady influences of independent cultures on popular discourse in Croatia and as such of major importance.

Also, since Kursiv was established, Kulturpunkt started fulfilling another important role on the interface of independent cultures and public discourse: being an entry point to the scene for the younger generation. Kulturpunkt was one of the first organizations to realize that most independent cultural workers are members of

---

138  Kulturpunkt was the second ever independent medium to be established in Croatia (after H-Alter, which dealt with civil society and ecology). Letinić, interview by author, 3 April 2018.

Screenshot of Kulturpunkt.hr.

the same generation and, if independent cultures were really to be a durable player in the system, something should be done about this. So, since 2009 they have organized the Journalistic School and, since 2011, *Criticism: Past, Present, Future*, a program that deals with affirmation of critical discourses in media on contemporary cultural and artistic practices. The Journalistic School has been especially important because its freely accessible program has educated about 100 participants. From these roughly 30 have continued working in media, independent cultures, civil society organizations, or cultural institutions.[139] This means that the education provided by Kulturpunkt is both a driving force of public discourse and an important portal where younger generations can become acquainted with the production of independent cultures.

---

139   Letinić, interview by author, 3 April 2018.

# Prefigurative Practices

An exodus from the city center of Zagreb took place on the night of December 11, 2009. Masses of people crossed the Sava river southwards and wandered into the barren lands of Novi Zagreb. On the crossroads of Večeslava Holjevca and Dubrovnik Avenues, they convened to witness something never seen before. Over the past seven years, a grand new municipal Museum of Contemporary Art had been erected there. There was a coffee bar, a restaurant, a rooftop terrace, a movie theatre, a library, a lecture room, a kids' workshop, residence studios, offices, an underground garage, and thousands of square meters of exhibition space. From the outside, every wind direction had its own eye candy. The Western wall of the building was one big neon screen. On the Southern side, large colorful panels paid homage to four artists represented in the museum collection and four random passers-by: Kasimir Malevich, Ivan Rautar, Francis Picabia, Stjepan Śarič, René Magritte, Marko Oršulić, Marcel Duchamp, and Ana Mešnić.[140] On this side, too, the building's concrete access platform blended into a small waterfall temple.[141] From the opposite North wing, two large slides screwed out of the building, back in, and out again.[142] Only from the East could Igor Franić's architectural creation be observed in its purity: an elegant silver block box on slim white pillars.[143]

---

140     These panels are a work by Braco Dimitrijević, *Posthistorical Dyptich* (2009).

141     This is Mirosław Balka's *Eyes of Purification* (2009).

142     This is Carsten Höller, *Double Slide* (2009).

143     The Croatian architect Igor Franić designed the new building of the MSU after winning an international competition. It is unclear whether Franić's Croatian nationality was of import in the selection process.

Something much more grand than the opening of a building was happening here. Born on this night was not just a new museum, not just a new cultural system, but a new culture!

*The new building of the Museum of Contemporary Art in Novi Zagreb during its opening night, 11 December 2009. View on the South façade, including Braco Dimitrijević's* Posthistorical Dyptich *(2009) and the silhouette of Mirosław Balka's* Eyes of Purification *(2009) in the foreground.*

Things have changed since 2009. The MSU is still open, but visitors can easily wander through the enormous museum without seeing a soul. The museum restaurant is closed. So are the wardrobe, the coffee bar, and the rooftop terrace. The huge 'collection in motion' has remained largely motionless. The waterfall temple, a work by Mirosław Balka with the title *Eyes of Purification*, stands empty and graffiti-clad, the water no longer running through. After my first visit to the MSU in 2018, during which I met exactly three other visitors, I expressed my wonder to a Croatian friend. 'Really?' he replied, 'I was there yesterday, and it was completely full. There were at least ten visitors besides myself.'

But back to the start of the millennium, to the birth of a new culture. The prestigious project of the new museum building clearly showed the governmental ambition for Zagreb to be a culturally progressive and influential city. Independent cultures were doing well at this time, and the city government's attitude offered new prospect. By 2006, many independent cultural organizations had been established and were able to sustain their practices with sufficient funding from local sources. 'Independent culture was producing the most important programs here,' Ivet Ćurlin said, 'but also the most important discourse, the most important advocacy, and it was opening up to other, younger, smaller actors'.[144] Successes like that of the Badel-Gorica festival and the establishment of Clubture showed that independent cultures had accumulated a critical mass with the ability to mobilize resistance on a large scale. The issues of impact of artistic production raised before by What, How & for Whom/WHW and BLOK started to have a broader resonance within the scene. Unsurprisingly, the ambitions of independent cultures grew even bigger: to be trendsetters of the new cultural system at large.

At the same time, independent cultural actors began being more aware of their responsibilities as social actors with an (admittedly limited) amount of power. For instance, according to Petar Milat, organizations started 'to reflect on [their] own role within the process of gentrification' because they 'realized that [they] could be misused or instrumentalized by the city government'.[145] Of course, being a 'real actor' in a system that might misuse them was not enough to independent cultures. Instead, a new type of independence was sought, the

---

144   Ćurlin, interview by author, 25 May 2018.

145   Milat, interview by author, 8 March 2018.

independence of a collective counter-subjectivity to oppose the reasonably mistrusted dominant system. It was thought by some that the only way forward from the old-fashioned cultural system co-opted by nationalist agendas was the way of independent cultures. So, again, a renewed discourse of self-understanding was formulated by the independent cultures, in which they presented themselves as the only logical prefiguration of a new cultural system.

There are two important elements to this new discourse: a majoritarian focus, and the emergent prefiguration of a post-transitional condition. Up to this point in around 2007 independent cultures were 'primarily interested in minoritarian issues in society…[the movement was] not anti-systemic. […] There was no central place of articulation, no shared political program, but there were minoritarian forms of opposition,' according to Tomislav Medak.[146] This changed around 2007 and 2008, when the economic crisis set in and independent cultural organizations 'started to look at the majoritarian issues, such as labor, public ownership, issues that concern the larger part of the citizenry if not everyone. It relates to how the housing system is being transformed and transitioned, providing opposition to on top of how minority-groups in the system are being repressed'.[147]

The second element in the prefigurative discourse of independent cultures was that of emerging culture in the post-socialist condition. For the most part, independent cultures were, as Dea Vidović describes in her 2012 PhD, 'emerging culture' in this period. Emergent culture is a dialectical term coined by the

---

146 Medak, interview by author, 29 March 2018.

147 Medak, interview by author, 29 March 2018.

Marxist cultural theoretician Raymond Williams to describe counter-hegemonic culture that, on the one hand, struggles against cultural and political structures and the commercialization of culture, while, on the other hand, it aspires to become dominant itself.[148] In the context of Croatian independent cultures, Vidović – and there seems to be some contradiction with the Marxist/Williamsian take on emergent subjectivity here – connected 'emerging cultures to terms such as flexibility, hybridity, networking, dynamic, interactive etc. as opposed to those terms which can still be connected to Croatian and Zagreb public cultural institutions, such as static, homogenous, isolated, passive etc.'.[149]

Within this context of prefigurative practices and majoritarian focus, the discourse of post-socialist transition became relevant once again, this time as a positive tool for the advocacy of independent cultures. In this case, the discourse of transition and normalization presumed 1) an initial dichotomy between rigid, old-fashioned, uncritical, inapt state institutions

---

148  In her 2012 PhD, Dea Vidović wrote about the non-institutional or independent cultural field in Zagreb between 1990 and 2010 from a Cultural Studies perspective – as practiced in Zagreb by academics such as Andrea Zlatar. Vidović found the term 'independent culture' of very limited use value for critical analysis: 'If you use this kind of term, basically, you cover the whole area: private and civil sector, profit as well as non-profit', including, for instance 'for-profit, private companies, in the audio-visual sector.' Instead, Vidović used the term 'emerging cultures', as developed by Raymond Williams in *Marxism and Literature* (1977), which differentiates between dominant, emerging, and residual cultures. Thus, like 'non-institutional', 'independent', and 'alternative', the definition of 'emergent cultures' hinges on a dichotomy that demarcates it from the mainstream culture. Yet, emerging culture is a more strictly demarcated notion than independent culture. 'I was interested only in the part of the independent cultural scene which started with the advocacy process, fighting for changing their position in the whole cultural system. I found the term of emerging culture very useful to explain my basic interest.' Vidović, interview by author, 9 April 2018. Dea Vidović, 'Summary: The Development of Emerging Cultures in the City of Zagreb (1990-2010),' unpublished PhD-Thesis.

149  Dea Vidović, 'Summary.'

(museums, cultural institutions, art academies, schools and universities, etc.) and critical, flexible, action-oriented, progressive cultural networks, platforms, and organizations, and 2) a desired, if not necessary, reform of state policy and institutions, informed by the practices and actions of new actors – such as the independent cultural scene – which would lead to a renewed aptitude of already-existing institutions and stabilize into a 'normal' situation of liberal democratic capitalism. Independent cultures started actively producing historiography and presenting themselves as a prefiguration of the general post-transitional cultural system.

Hence, independent cultures moved from a counter-systemic position to an agonistic or anti-systemic one, while simultaneously embracing the institution as a space for transformation.

## RIGHT TO THE CITY

Just as it was during the 26th Youth Salon and the Badel-Gorica festival, collective transformations of public space remained central to the subjectivation of independent cultures. In 2006, Pravo na Grad (Right to the City) was established, with the aim of protecting urban commons and public space. Pravo na Grad constituted a collective political subjectivity that was unprecedented. Contrary to Badel-Gorica, it was an action-based critique of the material regimes of property distribution in Zagreb rather than an *ad hoc* tactical collaboration.
What exactly where the material regimes against which Right to the City started acting? In *Taking Stock of Post-Socialist Urban Development* (2007), Kiril Stalinov observed that 'the Leitmotiv of post-socialist urban

change' is privatization.[150] Croatia is no exception to this rule. After the disintegration of Yugoslavia in 1991, the unique Yugoslav system of proprietorship – known as 'community ownership' – was dismantled. This was done by nationalizing all real estate with community-ownership status, and immediately after de-nationalizing.[151] The market that this created was hardly regulated. Even though most citizens cheaply acquired ownership of their own homes because of the 'resident's right' in the early 1990's, lack of regulations created the opportunities for predatory accumulation.[152]

In their study of the development of urban planning in Zagreb, Branko Cavrić and Zorica Nedović-Budić conclude that 'as a result of the overly flexible approach to planning and development, a lot of room remains in the system for land speculation, illegal construction, and environmental degradation'.[153] Tomislav Medak argues that the real estate market only escalated under the socialist-liberal-democrat coalition established in 2000, rather than under the previous nationalist governments:

> In the early 2000's, as the nationalists were demoted from power and a social-democrat led government came into power, some barriers to foreign investments suddenly fell down. The Croatian banking system was bailed out in the end of the 1990's, and then it was sold off to mostly

150 Kiril Stalinov, 'Taking Stock of Post-Socialist Urban Development: A Recapitulation,' in *The Post-Socialist City*, Kiril Stalinov, ed. (Dordrecht: Springer, 2007), 7.

151 'The Right to the City: Zagreb's Spatial Politics, recorded with Iva Marčetić in Zagreb,' *The Funambulist Podcast*, 1 October 2015, https://thefunambulist.net/podcast/iva-marcetic-the-right-to-the-city-zagrebs-spatial-politics.

152 'The Right to the City.'

153 Branko Cavrić and Zorica Nedović-Budić, 'Urban Development, Legislation, and Planning in Post-Socialist Zagreb,' in *The Post-Socialist City*, Kiril Stalinov, ed. (Dordrecht: Springer, 2007), 391.

Italian and Austrian banks. Then, the money started to roll in and the building boom started. The building boom was predating on spatial recourses left disused after the privatization in the 1990's.[154]

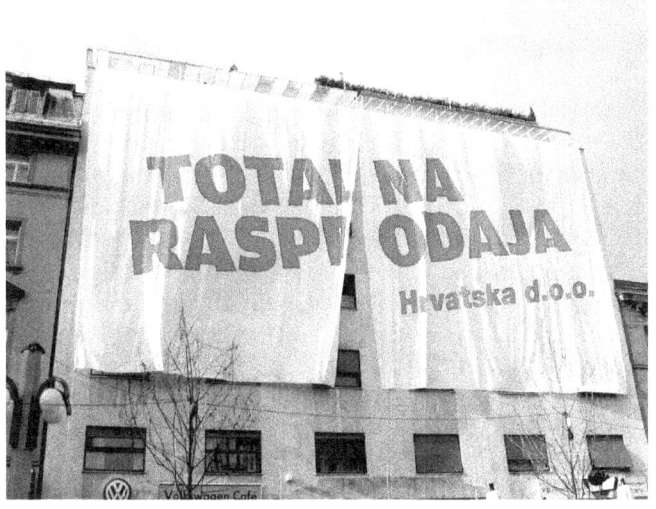

*'Clearance Sale,' public intervention by Right to the City and Green Action on the occasion of the dubiously managed redevelopment of a monumental property in the Lower Town (between Varšavska, Gundulićeva, Ilica, Preobraženska and Petra Preradovića Square), December 2006, http://timeline.pravonagrad.org/#12.*

Two discussions from independent cultures that informed this rise emerged around 2010 and 2011, centering around the notions of 'gentrification' and 'commons'. Ana Kutleša from BLOK explained that gentrification became a frequent buzzword within and beyond independent cultures:

154  Medak, interview by author, 29 March 2018.

> We felt the need to reflect on this process. Although in Croatia gentrification is very different from that in Western countries, because of the legacy of socialism and different distributions of property and wealth, [...] we also have to be aware that art, as part of economic processes, can be misused, especially in the case of public space management.[155]

Thus, independent cultures were a fundamental contributor to the anti-gentrification movement. This crystalized in 2006, when the then-informal platform organization Right to the City was established. This string of events not only changed the public discourse, but also altered the make-up of independent cultures. With the co-establishment of this organization inspired by Henri Lefebvre, 'the first proper, big social movement in Croatia to take people to demonstrate on the streets' was born.[156] Independent cultural actors claimed a direct political voice and agency in a primarily political struggle. No longer a subject to the rule of the governments, independent cultures became a counter-subject with emancipatory, utopian, and prefigurative imaginations.

In order to fight privatization and enclosure, Right to the City used the narrative of the (urban) commons to connect actors from the independent cultural scene to environmental activists and youth organizations.[157]

---

155 Kutleša and Hanaček, interview by author, 11 May 2018.

156 Milat, interview by author, 8 March 2018

157 Petar Milat explained that the people around MAMA, who had started the activist discussion on the commons in the early 2000's in the context of philosophy, digital media and publishing, started recognizing urban development as a topic to be considered within the commons discourse. Milat, interview by author, 8 March 2018.

Tomislav Tomašević, who works at the Zagreb-based Institute of Political Ecology, remarked that these different sectors, now coming together in action, 'had different methods: Green Action was focused on civil disobedience and public actions, while independent culture used performances. In the Right to the City-campaign, we combined the two'.[158] Some of these early actions included the distribution of billboard advertisements showing abandoned land-mark properties with the text 'clearance sale'. This drew attention to many properties, mostly industrial heritage landmarks, that were left unused until redevelopment investors stepped in. Over the course of years, Right to the City grew in size and power. The movement's humorous actions mobilized significant civil resistance involving thousands of people and finally caused the government to succumb in a number of cases.[159]

## A BOTTOM-UP APPROACH TO CULTURAL POLICY-MAKING

The best written example of independent cultures' prefigurative aspirations is Clubture's publication *A Bottom-Up Approach to Cultural Policy-Making: Independent Culture and New Collaborative Practices in Croatia* (2007). In this volume, Emina Višnić formulated the first formal definition of independent culture in English:

158   Tomislav Tomašević, interview by author, audio-recorded interview, Institute of Political Ecology, 9 May 2018.

159   One of the major achievements of Right to the City was the implementation of a citizen's petition for a referendum aimed at preventing the long-term private concession of the national highway network in Croatia. For a chronological overview of Right to the City's activities, see 'Pravo na grad: arhiva,' http://timeline.pravonagrad.org/, accessed 25 June 2018, or Danijela Dolenec, Karin Doolan, Tomislav Tomašević, 'Contesting Neoliberal Urbanism on the European Semi-periphery: The Right to the City Movement in Croatia, *Europe-Asia Studies*, vol. 69, no. 9 (November 2017), 1401-1429.

> All those organisations that (a) have not been set up by the state or by other external organisations but have established themselves; (b) that independently decide on their organisational structures, bodies and processes of decision-making and management; and (c) that depend neither on the state or any other entity for their programme of content or finances.[160]

It is interesting to note that this formal definition probably did apply to most independent cultural organizations back in 2007 (this is something I can't tell for certain), but by now hardly any cultural organization is financially independent from the state – let alone of 'any other entity'. Also note that this sounds a lot like a definition of entrepreneurship: to make something up on one's own initiative, effort, and risk. Maybe, Višnić's definition is more applicable to companies than to independent cultural organizations. In any case, its logic is a prime example of what Julia Kristeva would call 'entrepreneurial freedom'.[161]

It becomes clear why this entrepreneurial attitude in independent cultures was supposedly of import to the entire cultural system further on in *A Bottom-Up Approach to Cultural Policy-Making*. Although the political and social reality in Croatia has been characterized by a rapid political and economic transition after 1991, as is the case in most post-socialist countries, Višnić argues that this is not the case for the institutional cultural system: 'Even today, it functions, more or less, in accordance with

---

160  Višnić, *A Bottom-Up Approach to Cultural Policy-Making*, 10.

161  Julia Kristeva unpacks the concept of entrepreneurial freedom and its Kantian roots in Julia Kristeva, *Hatred and Forgiveness*, Jeanine Herman, trans. (New York: Columbia UP, 2010).

out-dated and inadequate principles inherited from a previous era'.[162] The basic argument in this text is that a post-socialist transition is therefore still necessary in cultural institutions, and that independent culture should be considered a prefiguration of the post-transitional institutional condition.

In analyzing *A Bottom-Up Approach to Cultural Policy-Making*, some problems of the prefigurative advocacy discourse become clear. It is true that the existence of the larger cultural institutions as well as some important organizational characteristics have remained unchanged since 1991. For instance, the directors of all major cultural institutions are directly appointed by political leaders on the national or municipal level. However, Višnić's claim is problematic both on theoretical and historical levels. Theoretically, it uses the teleological argument of belated modernism that makes transitology so problematic. One could address the problems of institutional culture – and even argue for the necessity of institutional transformation – without assuming that the problems addressed stem from the fact that institutional culture is part-and-parcel of an old-fashioned system that was in hindsight defunct from the start. Moreover, it is incorrect that the Yugoslav cultural system has remained entirely intact. Even though the larger cultural institutions and their governance structures might have remained the same or similar, the people appointed within these institutions and the programmatic characteristics have changed significantly. Also, fringe or alternative spaces for cultural production facilitated by the system in Yugoslavia have been largely defunded and deinstitutionalised.

---

162   Višnić, *A Bottom-Up Approach to Cultural Policy-Making*, 9.

This is not to say that the prefigurative advocacy of independent cultures was unsuccessful. In 2011, the Kultura Nova Foundation was established by the national government of Croatia with the specific aim to fund independent cultures. According to its director Dea Vidović, 'Kultura Nova is definitely a result of successful advocacy processes led by civil society organizations'.[163] It promotes participatory governance and the evaluation of art in terms of 'positive social change'.[164] Vidović acknowledges that, for pragmatic reasons, independent cultures embraced these discourses, and in general adopted neoliberal values.[165] However, since the retreat of the Soros Foundation, Kultura Nova is the only foundation that funds independent cultural organizations on a structural basis and thereby relieves the general precarity of the scene to a certain degree.

163   Vidović, interview by author, 9 April 2018.

164   One of Kultura Nova's mission statements is that it promotes 'positive social change', which was defined by Dea Vidović as follows: 'Positive social change could be different things in different times, in different political systems, different geographical areas, different countries, and so on. But, basically, it should be inclusive, open, equal, this kind of values. They make positive changes.' This concept is, to Vidović, connected to contemporary culture, which is defined by Kultura Nova as 'everything that is happening right now, and which is actual.' In Kultura Nova's definition, this 'contemporary culture' produces 'positive social change' mainly in two ways: 'Firstly, it is very experimental, the direction of artistic practices, testing new ideas, models, orientations. It could be very progressive, in the sense of experimentation and innovation. [...] And the second one is social engagement.' Importantly, one should 'be aware that what is innovative in Knin, definitely is not innovative in Zagreb.' Thus, the discourse of social impact has entered the field of cultural policy in Croatia and was more or less equaled with living culture. Participatory governance is one of the main focuses of the advocacy in and for the independent cultures, represented by organizations such as Clubture and Kultura Nova. In 2007, Emina Višnić wrote about the scene, that 'its players can be recognized as the key (and maybe only) force to continuously press for participatory cultural policies – policies that include as many stakeholders as possible in the decision-making processes and in the monitoring of their implementation.' Višnić, *A Bottom-Up Approach to Cultural Policy-Making*, 6. For Kultura Nova's promotion of participatory governance, see the Participatory Governance in Culture project: http://participatory-governance-in-culture.net.

165   Vidović, interview by author, 9 April 2018.

*The 'plenum' at the Faculty of Philosophy of the University of Zagreb in 2009, in* The Occupation Cookbook: Or the Model of Occupation of the Faculty of Humanities and Social Sciences in Zagreb *(New York & London: Minor Compositions, 2009), 36. Photos by Boris Kovačev. Design by Dejan Kršić.*

# THE STUDENT OCCUPATION OF THE FACULTY OF PHILOSOPHY

In Croatia, as in virtually every other part of the world, (higher) education has been incessantly privatized over the past decades, causing unrest and protests amongst students and teaching staff. This unrest came to a peak in 2009, when the Ministry of Education announced a plan to implement tuition fees for University students:

> For thirty-five days in spring and two weeks in autumn more than twenty universities all over Croatia were occupied, with students practically running them. [...] The students set up citizens' plenary assemblies – called "plenums". [...] The most active plenum at the Faculty of Humanities and Social Sciences [i.e. the Faculty of Philosophy] gathered up to 1,000 individuals each evening to deliberate on the course of action.[166]

Rather than using traditional forms of protest, such as marches and petitions, the protestors at the University of Zagreb experimented with prefigurative practices of direct democracy. As Marc Bousquet has argued in *The Occupation Cookbook: Or the Model of the Occupation of the Faculty of Humanities and Social Sciences in Zagreb* (2009):

> The goal of this renovation and reopening [of the University by its inhabitants] is to inhabit school spaces as fully as possible, to make them truly inhabitable – to make the school a place fit for living within the broader social context.[167]

---

166  Štiks and Horvat, 'Radical Politics in the Desert of Transition,' 13-14.

167  Marc Bousquet, 'Introduction' in *The Occupation Cookbook: Or the Model of Occupation of the Faculty of Humanities and Social Sciences in Zagreb*, translated by Drago Markiša (London & New York: Minor Compositions, 2009), 7.

Discussions fueled by the protests included contestation of the 'consensus that the introduction of tuition fees in higher education was principally indisputable' as well as broader discussions on EU accession and liberalisation, erosion of social rights, and the meaning of democracy.[168]

Tomislav Medak, Petar Milat and Ana Kutleša all argued separately that these protests were of major importance in independent cultures' turn towards majoritarian issues and, I would add, prefigurative practices. Kutleša simply stated: 'It introduced Marxist discourse. […] That says it all'.[169] Medak elaborated:
> By that time Right to the City had emerged as a mass movement, alongside student protests and student occupations, which would become a big moment of subjectivation for a generation younger than us. Most of them have by now entered civil society, working mostly not in culture, but as media, research, or worker-support organizations, such as Breed.[170]

Other such organizations include the critical media outlet Bilten and Slobodni Filosofski. Milat even sees these student protests as 'a very specific break' that created the most important 'turn' in independent cultures. According to Milat, 'a new facet of cultural activism arose: the Marxist or neo-Marxist perspective',

---

168 *The Occupation Cookbook: Or the Model of Occupation of the Faculty of Humanities and Social Sciences in Zagreb*, translated by Drago Markiša (London & New York: Minor Compositions, 2009), 76-78.

169 For BLOK, the introduction of Marxist discourse meant a shift away from the discussion around public space characterized by authors such as Chantal Mouffe. The conversation moved towards a majoritarian-Marxist perspective critiquing privatization and liberalization. It also coincided with the introduction of young, recently graduated curators Kutleša and Hanaček into the collective. Ana Kutleša, interview by author, audio recorded interview, BAZA, 11 May 2018.

170 Medak, interview by author, 29 March 2018.

which replaced independent cultures' left-liberal 'broad, umbrella-like agenda of caring about minoritarian issues from a transversal perspective'.[171]

## HISTORIOGRAPHICAL TURN

Historicization (mainly self-historicization) is one other aspect that entered the discourses surrounding independent cultures in the late 2000s. According to Goran Sergej Pristaš, independent cultures started 'looking back at the 1960s and 1970s, into different collaborative and individual practices in the arts, into the ways they related to questions of work and labor, questions of valorization of the arts, questions of critique, and so on. We somehow rewrote the history of what we were doing and where we came from to be in line with the 1960s and 1970s (not necessarily 1980s)'.[172]
Ana Dević's article *Politicization of the Cultural Field: Possibilities of a Critical Practice* (2009) is a perfect example of such historical re-orientation and its importance within the prefigurative discourse. To affirm the prefigurative and transformative potential of independent cultures in the late 2000s, Dević cited the legacy of the critical artistic practices of the 1960s and 1970s in this text. The aim of *Politicization of the Cultural Field* was to outline 'the contours of various forms of critical practices, their critique of existing institutions, and the creation of innovative institutional forms and processes of self-institutionalization from the local perspective, marked by "problems with the institutions".'[173]

---

171    Milat, interview by author, 8 March 2018.

172    Pristaš, interview by author, 14 May 2018.

173    Dević, 'Politicization of the Cultural Field,' 18.

> **FOOTWRITING**
> The subject of my work is the language of politics, i.e., its reflections on everyday life. I should like to paint. I paint, but the painting betrays me. I write, but the written word betrays me. The pictures and the words become not-my-pictures, not-my-words and this is what I want to achieve with this work - not-my-painting. If the language (the colour, the image, etc.) is the property of ideology, I too want to become the owner of such a language. I want to think it with consequences. This is neither criticism nor ambiguity. What is imposed on me is imposed as a question, as an experience, as a consequence. If colours, words and materials have several meanings, what is the one that is most imposed, what does it mean and does it mean anything - or is it just a dry run, a delusion? The question is how to manipulate that which manipulates you, so obviously, so shamelessly, but I am not innocent - there is no art without consequences.
>
> MLADEN STILINOVIĆ
>
> ORIGINALLY PUBLISHED IN THE CATALOGUE FOR MLADEN STILINOVIĆ'S EXHIBITION IN THE STUDIO OF THE GALLERY OF CONTEMPORARY ART, ZAGREB, 1984

*Mladen Stilinović*, Footwriting, *1984, in* Art Always Has Its Consequences *(Zagreb: What, How, and for Whom/WHW, 2010), 4.*

The implicit pretense is that independent cultures prefigured the solution to these problems with institutions. To make this argument, Dević sketched a continuity from artistic practices of institutional critique from the 1960s and 1970s in Croatia and independent cultures in 2009, stating that independent cultures were building directly upon the legacy of institutional critique, as well as extra-institutional and

interspatial cultural activity. Dević continued to argue that independent cultures were not, like historical institutional critique, an 'alternative' culture, but rather 'an ever increasing number of informal, self-organized, networked organizations, the institutionalization of which is taking place in the precarious and oscillating conditions of institutional spaces "in between".'[174] This kind of self-institutionalization, which is at stake in the field of independent culture, was, to Dević, a viable third way to 'two equally problematic models of institutions': 1) the traditional, non-functional, state-funded model, and 2) the populist, globalist 'cultural enterprise' model. With this emphasis on self-institutionalization, Dević advocated 'creating a model for politicizing cultural practices and establishing modes of collaboration that will influence even the field of dominant cultural ideology'.[175]

A typical example of how these aspirations of pro-active collaborative historicization played out in the practice of cultural production is *Art Always Has Its Consequences,* a two-year 'collaborative platform' of new media center_kuda.org in Novi Sad, tranzit.hu in Budapest, Muzeum Sztuki in Lódź, and WHW in Zagreb, in collaboration with the Subversive Film Festival in Zagreb. 'Collaborative platform', in this case, certainly meant 'collaborative fund-raising', for the range of funders was as broad as that of the collaborators, including Erste Foundation, the European Commission, the ECF, the National Cultural Fund of Hungary, the Ministry of Culture of Croatia, the Croatian National Foundation for the Development of Civil Society and the Zagreb Office for Culture, Education and Sport. Drawing on

174    Dević, 'Politicization of the Cultural Field,' 20-21.

175    Dević, 'Politicization of the Cultural Field,' 32.

regional and often socialist-era art (history), *Art Always Has Its Consequences* 'explored practices through which art reaches it audience and their significance for broader relations between art and society, focusing on four thematic strands: the history of exhibitions, artists' texts, conceptual design, typography, and institutional archives'.[176] Specifically, by including them into the resulting exhibition the platform aimed to (re)politicize canonical neo- and retro-avant-gardistic works by artists like Sanja Iveković, Mangelos, Vlado Martek, and Mladen Stilinović. Thus, the institutional history of art was invoked to address majoritarian issues from the perspective of the contemporary cultural 'collaborative platform' with all its emancipatory as well as neoliberal implications.

An important moment in the historiographical turn of independent cultures was the establishment of the independent cultures' community-archive. In 2009, Kursiv started the program *InFocus*, which soon changed its name to *ABC of Independent Culture*. Initially, *ABC of Independent Culture* consisted of an archive of oral history including transcripts of interviews with people from the scene.[177] The material was later expanded by others, and, currently, Kursiv produces approximately five to ten new interviews for *ABC* on an annual basis.[178] In 2011, when Booksa decided to close down its bookshop, the freed-up space was used to establish

---

176 'Introduction,' in *Art Always Has Its Consequences* (Zagreb: What, How & for Whom/WHW, 2010), 5.

177 Vidović, interview by author, 9 April 2018.

178 Letinić, interview by author, 3 April 2018. All texts and videos can be found on Kulturpunkt: http://www.kulturpunkt.hr/category/rubrikaprojekt/projekti/abeceda-nezavisne-kulture. This material has been used to create exhibitions on several occasions.

an offline part of *ABC*, the Center for Documentation of Independent Culture, an archive for the scene.

*Centar za dokumentiranje nezavisne kulture (Center for Documentation of Independent culture) in Booksa, Martićeva ulica 14.*

They started actively collecting magazines, fanzines, books, flyers, program booklets, and publications from other organizations. The Center for Documentation of Independent Culture was set up as a community archive, which means that its ordering principle, as formulated by Buljević, is 'the community decides what goes in and what stays out'.[179] This principle entails two sub-principles: contributors must be part of the independent cultural scene and contributors decide which of their materials are relevant to the collection. Hence, the ordering principle of the archive relies on the definition of independent culture, which, in this case, is taken from Kultura Nova's and Pogon's definitions, in

179   Buljević, interview by author, 15 March 2018.

addition to the social relations built up during Kursiv's and Kulturtreger's work. The archive is therefore not primarily inquisitive or critical, but rather focused on functioning as a community-based, open, and affirmative collection, which preserves valuable and unique documents.

# PART II

# TODAY: WHOSE INDEPENDENT CULTURES ARE THESE?

*She asked herself, whether it was of historical significance that her life had split in fragments. Did fragmentation have different categories, depending on the intentions of the fragmentee? If the fragment were truly a symbol of modernity, then she was indeed truly modern. Does a fragmented city become a radically critical city, due to its formal qualities? Neither theoretically, nor disarticulatedly, nor sublimely. Subliminally, she thought. Subliminimally, she thought.*

*Still (image and citation) from Nicole Hewitt,* This Woman is Called Jasna, Episode 3: Ruins, 2015-2017, *as performed at Sonic Acts Festival 2018, Amsterdam.*

Despite adverse conditions, independent cultures have managed to sustain themselves for several decades. They have become an alter-establishment through years and years of struggling, proliferating, territorializing, politicizing, and theorizing. At the same time, the limits of independent cultures have been tested over the past few years. Croatia's ascendance to the European Union in 2013 was followed almost immediately by a neoconservative and nationalist back-lash. Large budget cuts have struck the cultural field. New actors with less subversive or critical political agendas and more hierarchic internal governance structures have emerged and appropriated the spaces of civil society. The resulting precarization of independent cultures was met with varying responses from the scene. While some independent cultural organizations have become more institutionalized, others have ceased to exist. Yet others have adapted themselves to work in other fields such as the political sphere or the squatting. An important question has become how non-institutional this non-institutional cultural scene still actually is. In this difficult time, which could even be called a crisis, the two most important questions appear to be: to which social groups do independent cultures – and the spaces they have created over the past twenty-five years – belong? And, what are viable forms for independent cultures to remain vocally critical yet safe today?

# The Backlash

INSIDE THE EUROPEAN UNION

On the 1st of July 2013, Croatia became a member state of the European Union after nine years of candidacy. This is arguably the moment that Croatia's epic journey through the 'desert of post-socialist transition' came to a definite end. According to Tomislav Medak:

> Now that we reached our promised political eschaton of being a member of the NATO and the EU, we find ourselves in the EU that is ridden by a similar type of polarization as pre-war Yugoslavia was. The hegemonic narrative is collapsing. There is no developmental promise. [...] Something else is happening, which follows a similar trajectory as the processes of the political swing to the right elsewhere in Europe.

Something else, in this case, is the rise of anti-European, neo-conservative politics throughout and beyond Europe. Goran Sergej Pristaš argues that 'the situation we are in now, on a European scale, reminds me of Yugoslavia in the 1980s: it's a situation of institutional collapse, of the re-introduction of problems of disbalances between countries. The discourse on the right to capital is coming back in a much larger scale.'[1] With some cynicism, one can argue that the final steps in Croatia's 'translation' to the (former) West coincided with the start of the end of the global regimes of the translational condition.

---

1  Pristaš, interview by author, 14 May 2018.

Unsurprisingly, Croatia's long-awaited entry into the EU was soon met with a neo-conservative backlash.

*Joseph Daul, Chairman of the EPP Group in the European Parliament, and Tomislav Karamarko, former leader of HDZ, 2016.*

In February 2016, a heavily right-wing coalition came into power. This was led by HDZ's controversial President Tomislav Karamarko. Karamarko's Minister of Culture, Zlatko Hasanbegović – if possible even more controversial than Karamarko himself – 'immediately mounted an attack on independent media and progressivist culture across both institutional and non-institutional domains'.[2] For instance, the Board of Directors was removed from Kultura Nova and

---

2   Dietachmair, 'From Independent Cultural Work to Political Subjectivity,' 221. Hasanbegović's appointment was immediately criticized by the Croatian Journalists' Association and NGO-platform Platform 112. Several foreign denunciations followed after Hasanbegović rejected the value of Croatian anti-fascism and denied the relevance of funding for NGOs. Also see: 'Minister Says No Need for Nonprofit Media Commisison,' *EBL News*, 5 February 2016, https://eblnews.com/news/croatia/minister-says-no-need-nonprofit-media-commisison-9156.

eventually the Director was withdrawn for some months too, all because Hasanbegović postponed assigning new members and renewing employee contracts.[3] Some organizations had to fold, such as the critical cultural magazine *ZAREZ* – the direct offspring of the '90s Peace Network discussed before. The Karamarko coalition collapsed in June 2016, but HDZ was voted back into power and continues to govern with a different president up to today.

The consecutive right-wing governments in Croatia implemented many policies which resulted in major cuts to the structural funding of culture. The national budget for culture was reduced from 1.2% in the early 2000s to 0.48% in 2018.[4] According to Jasna Jaksić, curator at the Museum of Contemporary Art, this trend has made it increasingly difficult to realize anti- or non-hegemonic programs within the institutional sphere as well as outside of it.[5] It is even harder for new initiatives to find the necessary funding to get going. Dea Vidović understands the situation as a structural lack of appreciation of 'living culture'.[6] These policies are part of a tendency of shrinking public spaces and contribute to a general precarization of cultural workers in both institutions and in independent cultures.

Interestingly, independent cultures have, according to Goran Sergej Pristaš, reacted to the privatization, defunding, and dissolution of the institutional sphere with 'a bit of left-wing conservatism'. According to him,

[3] Vidović, interview by author, 9 April 2018.

[4] Jaksić, interview by author, 13 March 2018.

[5] Jaksić, interview by author, 13 March 2018.

[6] Vidović, interview by author, 9 April 2018.

independent cultures started promoting 'a protectionism of the institutions that comes from the insight that only back-up for cultural production and development of discourses in culture are related to the existence of the institutions. [...] From our experience, destabilization of the institutional sphere leads to destabilization of the entire field.'[7] What this insight shows, is that the so-called neo-conservative backlash is destructively reactionary rather than conservative. A sense of duty towards institutional culture is awakened in the independent cultural scene once again. For instance, Ivet Ćurlin of WHW remarked that, 'looking back, I doubt whether it was a good decision to abandon the institutions at such early stage' in the 1990s.[8]

## A BODY WITH TWO RIGHT HANDS

The past five years have shown that there is a remarkable interrelation between neoliberalism and neoconservatism in the case of Croatia, in the sense that these phenomena are mutually stimulating rather than mutually exclusive. To my understanding, neoliberalism is essentially an anti-modern economic progressivism. It is, in Wendy Brown's words, the 'stealth revolution' of the progressive marketisation and commodification of all facets of life – including health care, education, public transport, and housing. It abandons any traditional liberal-humanist aspiration of democratic emancipation in the name of the market and individual freedom. Accordingly, the liberal tradition of appreciating critical and emancipatory cultural practices is replaced with nationalistic and neoconservative reactionary cultural

---

7   Vidović, interview by author, 9 April 2018.

8   Ivet Ćurlin, interview by author, audio recorded interview, Galerija Nova, 25 May 2018.

identity politics. In this definition, neoconservatism is the nationalist, post-historic, identity-political supplement of neoliberalism: a culture based on market fueled traditionalism devoid of the aspiration to emancipate or evoke a sense of historical justice. Neoliberalism and neoconservatism then appear to be two sides of the same coin.

The dynamic between neoliberalism and neoconservatism in Croatia is exemplified by the dismantling of social security and community ownership. Since the 1960s the free market has slowly taken over in Yugoslavia and has dramatically increased in the last three decades. This has led to sky-rocketing property prices and incessant gentrification in urban centers.[9] Simultaneously, the system of social security from the socialist-Yugoslav era has been almost entirely dismantled. This privatization and insecurity have been compensated for by the national security politics of a militarized state, keen on fending off 'alien bodies'.[10] Typical neoliberal tendencies are fixed by typical social conservative ones. The discriminatory logic that is the basis of these policies is informed by Catholic-oriented identitarianism and authoritarian nationalism.

It is sometimes thought that the current decline of the hegemony of Fordist labor relations, which was based on the independence of the man and the domestication of the woman, leads to the emancipation of women

---

9   The process of gentrification in Zagreb is different from that in cities like New York, London, Paris or Amsterdam. According to urbanist Jens Brandt, this is largely due to the fact that there are no tax disadvantages connected to holding multiple mortgages. Therefore, with rising property prices, it is advantageous to retain ownership of multiple properties, even when not actively using them or doing maintenance. Jens Brandt, interview by author, 20 March 2019, Zagreb.

10  Lorey, *State of Insecurity*, 80-81.

as workers. In Croatia, however, the opposite can be observed: while the Yugoslavian constitution included a right to work for women and men alike, women today seem to become more domesticated in Croatia. In close resemblance of the case of America, as analyzed by Melinda Cooper, the evaporating system of social security in Croatia were replaced with 'family values' and 'responsible paternity'.[11]

Tomislav Medak considers the 2008 financial crisis to be a historical turning point in the resurgence of Croatian conservatism:

> This [global financial crisis] showed how the hegemony of liberal democracies can no longer be sustained. It seems clear that globalization, free markets, internationalization of capital has put limits on democratic process to have a say in what is most fundamental to the people -- how they work and how they can reproduce themselves. [...] In Croatia, this has a lot to do with the plight of rural areas after the collapse of Socialist (semi-) planned economy, which set up factories in smaller places across this rural territory, creating along institutions of welfare, healthcare, education, culture. After 1991 those factories collapsed. In those areas, the expanded family is now the dominant institution of welfare, and the church the dominant institution of culture. So, the principle concerns of neoconservatism these days ("gender ideology", minority rights,

---

11   For an analysis of the American case, see Melinda Cooper, *Family Values: Between Neoliberalism and the New Social Conservatism* (New York: Zone Books, 2017). Wendy Brown wrote about de-democratizing entanglement of neoliberalism and neoconservatism in America in her 2006 article, 'American Nightmare: Neoliberalism, Neoconservatism, and De-Democratization,' *Political Theory*, vol. 34, no. 6 (December 2006), 690-714.

multiculturalism) echo the actual reality of these people.[12]

Therefore, the clerically promoted, family-based model of production is more thoroughly established in Croatia now than it was under Yugoslav socialism. At the same time, present-day neoconservatism can be considered exactly a solidifying counter-reaction which allows global neoliberalism to find its way into the local tissues of Croatian society.[13] Neoliberalism and neoconservatism in the Croatian context cannot be understood as opposing tendencies, but as different aspects of the same self-contradictory condition. Croatia is a prime example of 'repressive liberalism'.[14]

For independent cultures, this understanding presents some important questions. If the precondition for the existence of independent cultures is the result of neoliberalization while independent cultural actors have also struggled against the neoconservatism for decades, the following paradoxical situation ensues: the common ground that civil society and independent cultures created in their struggle might have served the enemy that was the very reason of the commonality of their struggle.

---

12  Tomislav Medak, correspondence with the author, 25 March 2018.

13  On the different trajectories through which neoliberalism plays out in the context of different nation-states, see Cornel Ban, *Ruling Ideas: How Global Neoliberalism Goes Local* (Oxford: Oxford UP, 2016).

14  Pascal Gielen, *Repressief liberalisme: opstellen over creatieve arbeid, politiek en kunst* (Amsterdam: Valiz, 2013).

# The State of Civil Society

The ultimate question in this discussion is: to whom does the civil sphere belong? Whose words have the most influence there? What makes this question so tricky is that the openness of the civil sphere and of public spaces is sometimes self-undermining. In being common, spaces of civil action are always constantly re-negotiated and vulnerable to appropriation.

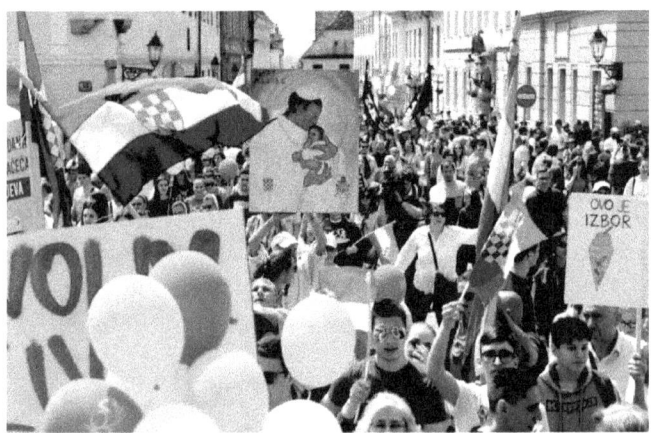

*The 2019 rally of U ime obitelji (In the name of the family). 'Ovo je izbor' translates to 'This is a choice'.*

Independent cultures in Croatia today are harshly confronted with these ideological contradictions. Organizations like Right to the City, Clubture, and Zagreb je NAŠ!, that are in fact institutionalized NGOs,

have continued to use grassroots strategies. But in the early 2010s, a new right-wing and conservative movement emerged, which used the same trick: In the Name of the Family. Rather than a real grassroots organization, this movement was coordinated by the politician Zeljka Markić, promoting pro-life and anti-queer sentiments 'in the name of the family'.[15] This movement has dominated the forum of public space over the past years, in pro-life marches and a petition against the Istanbul Convention (a treaty to fight domestic violence).[16] Ivet Ćurlin said that 'the emergence of In the Name of the Family was a turning point and wake-up call for all of us as to what civil society is and how they caught up with us and appropriated it'.[17]

At the same time, progressive spaces are being cut, reformed, or closed. In 2017, while In the Name of the Family received the government funding it applied for, WHW, Documenta – Centre for Dealing with the Past, DrugoMore, and Močvara did not. Studentski Centar, which has been running independent programs in theatre, film, and art since the 1960s, is slowly but structurally choked – the last in a series of incidents being the eviction of Klubvizija, an amateur film club, from their film lab. One more example is the NGO behind Kino Europa, who have successfully run their venue for a decade with generally high-quality screenings and, for instance, hosting the Subversive Festival. Milan Bandić,

---

15  See, for instance, pro-life organization Hodza Život: https://www.hodzazivot.hr.

16  'March for Life Starts in Zagreb,' *N1*, 19 May 2018, http://hr.n1info.com/a303506/English/NEWS/March-for-Life-starts-in-Zagreb.html. The Istanbul Convention is a Council of Europe Convention 'on preventing and combating violence against women and domestic violence' formulated in 2011. For the full text of the treaty, see: https://www.coe.int/fr/web/conventions/full-list/-/conventions/rms/090000168008482e.

17  Ćurlin, interview by author, 25 May 2018.

the mayor of Zagreb, served them notice of eviction, meaning that the organization would have to vacate their premises within months. He cited 'renovations' as the cause for such disruption. Spontaneous crowds, mobilized through social media, amassed in protests of the eviction, but to no apparent effect.

If it wasn't obvious before, these occurrences made it very clear that civil society is not per definition critical or progressive, nor the exclusive terrain of independent cultures. It is a space that is extremely vulnerable to corruption and can be appropriated by anti-European, nationalistic movements, as well as clerical organizations and anti-egalitarian campaigns.

The growing understanding of these developments has caused actors within the independent cultural scene to question their position within the social and cultural system – as a result they have become less optimistic and more critical.[18] They had already realized by the mid-2000s that they could be instrumentalized, being products, to some extent, of neoliberal mechanisms. However, now, as neoliberalism and neoconservatism are more and more clearly revealed as two sides of the same coin, the question rises if it will not be the independent cultural organizations that will be instrumentalized, but the systemic space they created. Tomislav Tomašević noted:

> We can see the limits of liberal discourse of human rights. As if these rights only entail the already existing legal procedure, the conservatives say: "You cannot change the constitution." "Why not?" "Because the

[18] The panel discussion on the definition of civil society at Galerija Nova that is debated in the introduction of this text is a good example of this increasingly critical self-reflection in systemic terms.

constitution is democratic." We say: "We are for democracy, but not that kind of democracy." And so, you enter this level of abstraction. It's this liberal trap you fall into, really. [...] So, there are limits to the discourse and concepts of civil society, and people are quite aware of it since the referendum against gay marriage. Now, some are even saying that there are two civil societies in Croatia, even though it doesn't make sense conceptually.[19]

What to make of this schizophrenic condition of civil society? How to deal with these new insights?

## THE LIMITS OF DISCOURSE

This pressing topic on the status of civil society has been much-discussed on the scene. For instance, a panel discussion with Ekaterina Degot, Lidija Krienzer Radojević, Goran Sergej Pristaš, and Branislav Dimitrijević took place at WHW's Galerija Nova on the 7th of May 2018.[20] It addressed the theoretical problematics around the concept of civil society, its historical developments, and its relation to critical cultural production. The question raised was whether civil society is to be understood as a Gramscian-Marxist concept or as an essentially (neo)liberal model.

The most interesting position was developed by Ekaterina Degot who addressed the relationship between civil society and civil disobedience, as present in two different traditions of thought: the former Western and

---

19  Tomašević, interview by author, 9 May 2018.

20  For details about the event, see: http://www.whw.hr/galerija-nova/then-and-now.html.

the former Eastern traditions. Degot remarked that there were certain romantic ideas in Eastern Europe during the post-WWII era which led to the establishment of the Leninist parallel infrastructure of workers' and other clubs – an infrastructure which functioned were independent from the state.[21] It was this romantic idea, Degot argues, which was the foundation of the present-day concept of 'civil society'. Important to note is that this independent infrastructure was basically conceived of and used as a structure for civil disobedience. According to Degot, it was this very same romanticism of independence and disobedience – still present in today's former-Eastern notion of civil society – that made critical voices naïvely tolerant of the market after 1989.

However, in the former West, civil society was always anti-market, yet it had its own forms of naivety. These (former) Western civil society organizations tended to regard the state as a system that has social obligations and therefore assumed it to be a reliable partner for collaboration. Yet, the core characteristic of neoliberal government is its unreliability, or disinterest, in the field of general welfare and social goods. While the state retreats, it appropriates the rhetoric of the traditionally left-leaning civil society (social impact, resilience, participation, etc.) to realize its liberal agenda of transferring social responsibility to civil society and especially to culture. Degot concluded with the remark that civil society today could learn something from the former Eastern, romantic tradition of state-critical civil disobedience.

We find a similar critique of civil society's liberal naivety in Sezgin Boynik's somewhat controversial article

---

21  In this respect, the situation in Yugoslavia was like that in the Eastern Bloc.

*New Collectives: Art Networks and Cultural Policies in Post-Yugoslav Spaces* (2012).[22] Other than the title suggests, this article speaks exclusively about the independent cultural scene in Zagreb. Boynik described the emergence of independent cultures in the 1990s as a 'shift from a state-centered socialist planning strategy to de-centralized and neo-liberal open-market networking' in the field of cultural production.[23] He argues that independent cultures (called 'new collectives' by Boynik) invoke a flattened-out understanding of the heritage of socialist self-management in order to managerialize and instrumentalize artistic and cultural production. Thereby, independent cultures reduce art and culture 'to a pillar for the unobstructed flow of the capital'.[24]

Boynik is right in pointing out that exactly through the pragmatism of resistant, critical, anti-nationalist, pacifist, queer, and Marxist cultural practices, neoliberal values and models were (accidentally) adopted too, ultimately leading to the instrumentalization of the cultures at hand or the systemic territory they created.[25] In similar vein, the Slovenian philosopher Slavoj Žižek formulated a profound suspicion of civil society's identity-politics in his typical ruthless style as early as 1999:

> The domain of global capitalist market relations is the Other scene of the so-called repoliticization of civil society advocated by the partisans of

22   Boynik, 'New Collectives,' 81-105.

23   Boynik, 'New Collectives,' 81.

24   Boynik, 'New Collectives,' 103.

25   This sort of critique should be formulated with apt caution of fatalism, as was illustrated extremely well by Jacques Rancière in his analysis of Boltanski, Chiapello, Sloterdijk, and Bauman. Jacques Rancière, 'The Misadventures of Critical Thought,' in *The Emancipated Spectator* (New York: Verso, 2009), 37-70.

> "identity politics" and other postmodern forms of politicization: all the talk about new forms of politics bursting out all over [...] ultimately resembles the obsessional neurotic who talks all the time and is otherwise frantically active precisely in order to ensure that something – what really matters – will not be disturbed, that it will remain immobilized.[26]

The tone and style of Žižek's words simultaneously uncover the positives and negatives of generalizing critique of civil society such as Boynik's and his own. Boynik's and Žižek's highly theoretical and univocal analyses of civil society are on one hand productive and necessary provocations. On the other these critiques should be critiqued for they reduce civil to the monolithic Other – the exact strategy employed by the nationalists and conservatives.

For instance, the division between Yugoslav era 'first collectives' and present-day 'second collectives' which Boynik needs in order to uphold his critique as valid, is too simple or monolithic when confronted with the 'evidence' – the track record of independent cultures. Tomašević remarked truthfully:

> Traveling around Europe, I often encounter this paradigm on civil society as a (neo)liberal instrument within leftist movements. But in Croatia, a good part of the NGOs have been fighting these tendencies and undermining the neoliberal project, while using money from the EU, etc. The simplified narrative of civil society

---

26   Slavoj Žižek, *The Ticklish Subject* (London and New York: Verso, 1999), 353-354.

does not completely fit the reality of the NGOs established in Croatia over the past 20 years.[27]

Besides, there is no art market in Croatia, and there never was. It is therefore nonsensical to say that independent culture marketized cultural production in Croatia. And even if culture was reduced to a mere instrument of capital by anyone in post-1991 Croatia, it was in the circles of nationalist-conservative politicians and policy-makers. To disqualify independent cultures as a pillar of the unobstructed flow of capital or as the frenzy of a neurotic is simply cynical.

The rejection of this type of cynical critiques would then lead to a liberal-leaning interpretation of the state of civil society: that the current model *does* work. Yet, the current problems can't really be denied either. What happens when civil society is theorized based on supportive solidarity rather than cynicism? A good example is Pascal Gielen and Philipp Dietachmair's introduction to their book *The Art of Civil Action* (2017). Gielen and Dietachmair produced three concepts to make sense of the construct of civil society: 'civil space', 'civic space', and 'public space'.[28] They define civil space as 'a space that remains fluid, a place where positions still have to be taken up or created'.[29] It is not yet a regulated space, at the doorstep of legality, inherently risky to enter. Civil space is the space inhabited by grassroots movements. As such, civil space is contrasted to civic space, which is defined as 'the place that is established or has taken

27  Tomašević, interview by author, 9 May 2018.

28  Philipp Dietachmair and Pascal Gielen, 'Introduction: Public, Civil and Civic Spaces,' in *The Art of Civil Action: Political Space and Cultural Dissent*, Philipp Dietachmair and Pascal Gielen, eds. (Amsterdam: Valiz, 2017), 11-33.

29  Dietachmair and Gielen, 'Introduction,' 15.

roots in policies, education programs, regulations or laws'.[30] It follows from this opposition between civil and civic spaces that there is a possibility to insurrect the fluidity of civil space – to question, criticize, and alter the dominantly ossified civic space. Gielen and Dietachmair convincingly interpret the recent wave of civil protest in Europe (Zapatistas, Theatro Valle, Recetas Urbanas, Maagdenhuis, Refugees Welcome, etc.) as such contra-civic civil resistance.[31]

Then there is a third space defined by Gielen and Dietachmair: public space. Public space is 'the space we can enter freely, that is or should be accessible to anyone'.[32] It is differentiated from civil space, in the sense that the former is a passive, faciliatory space of free exchange, whereas the latter is a space of active organization and formation. Civil space thus needs public space, but public space also needs civil space for it to be claimed as public. 'The interaction between both constitutes the famous *praxis*, where the action is suited to the word but also where actions can and may be put in words'.[33]

---

30  Dietachmair and Gielen, 'Introduction,' 15.

31  Drawing on a broad variety of examples, ranging from the Zapatistas (Latin America), Pussy Riot (Russia), Recetas Urbanas (Spain), the Umbrella Movement (Japan), the Maagdenhuis appropriation (The Netherlands), Teatro Valle (Italy), Culture2Commons (Croatia), Hart boven Hard (Belgium), and Refugees Welcome initiatives (Europe), Gielen and Dietachmair state that 'all over Europe, discourses in civil society have started to question, criticize, and attack the traditional role of the state in culture and its established civic institutions'. Because these various 'discourses in civil society' are very situated and different, it is problematic to consider them to be manifestations of a single development. Gielen and Dietachmair aim, perhaps, to be inspirational and activating rather than analytical. Dietachmair and Gielen, 'Introduction,' 16.

32  Dietachmair and Gielen, 'Introduction,' 17.

33  Dietachmair and Gielen, 'Introduction,' 18.

Gielen and Dietachmair ingeniously borrow conceptual tools from both Marxist and liberal-democratic discourse to differentiate between civil and civic space and therefore to avoid essentialism or cynicism. As a result, it becomes impossible to claim that all civil society is simply an instrument to power, while it accounts for the threat that instrumentalization might always happen. Yet, this theory of 'civil', 'civic', and 'public' spaces falls short because it upholds an unproblematized acceptance of Habermasian liberal-democratic values ('human rights', the 'sovereign public', 'civil rights') and the teleology implied in liberal-democratic discourse (every society strives for openness and democracy). The examples it discusses are selected through progressive cherry-picking, leaving out examples like In the Name of the Family. It fails to account for the fact that civil society and grassroots organizations throughout Europe, especially in the former East, are increasingly advocating nationalism, ethno-centrism, protectionism, religious dogmatism, and other values that are in direct contradiction to the classical concepts of democracy and human rights. The existence of these organizations highlights the inherent contradictions within the model of liberal-democratic capitalism.[34] And so, the discussion loops back on itself. Neither the liberal model nor the Marxist critique can account for the actual phenomena as they played out historically. Neither a cynical, nor a defensive take on the potentials of civil society leads anywhere.

The trick is to be realistic and see the truth in both. The urban sociologist Kerstin Jacobsson spent many years researching civil society and grassroots movements

---

34   This is especially surprising since Gielen has proven before to be very conscious of these problems. See, for example, Pascal Gielen, *Repressief Liberalisme: Opstellen over creatieve arbeid, politiek en kunst* (Amsterdam: Valiz, 2013).

in former Eastern Europe, often asking the same question: is civil society resistant and independent, or instrumental to the neoliberal system? In *The Development of Urban Movements in Central and Eastern Europe* (2016), she concluded that 'an "either-or view" of social movements – either they are engaged in contentious action or they become service organizations or self-help groups – is not helpful to understand collective action in this social context [of post-socialist countries]'.[35] True enough, there is something to say for both Marxist and liberal interpretations of civil society, as resistant and as affirmative, even though the cultural dominants at present are most certainly neoliberal. But for a definite answer, this question is much too generalizing.

It is most helpful to acknowledge the internalized neoliberal values and strategies in independent cultures in order to decode those strands of their subjectivities and retain a critical moving base. In other words, the situation calls for what Irit Rogoff called 'criticality' rather than dismissive self-critique:

> That double occupation in which we are both fully armed with the knowledges of critique, able to analyse and unveil while at the same time sharing and living out the very conditions which we are able to see through. As such we live out a duality that requires at the same time both an analytical mode and a demand to produce new subjectivities that acknowledge that we are what Hannah Arendt has termed "fellow sufferers" of the very conditions we are critically examining.[36]

---

35  Kerstin Jacobsson, 'The Development of Urban Movements in Central and Eastern Europe,' in *Urban Grassroots Movements in Central and Eastern Europe*, Kerstin Jacobsson, ed. (New York: Routledge, 2016), 4.

36  Irit Rogoff, 'From Criticism to Critique to Criticality,' *European Institute for Progressive Cultural Policies*, January 2003, http://eipcp.net/transversal/0806/rogoff1/en.

Criticality, in the current situation, calls for a questioning of independent cultures' fundamental common subjectivities. For if post-Foucauldian scholars like Judith Butler, Isabell Lorey, and Wendy Brown have taught us anything, it is that neoliberalism is not a system outside of the subject, but an internalized governance of living bodies.[37]

## RESISTANT OR COMPLAISANT PRECARIZATION?

To go one step further into this discussion, let's return to the intricacies of precarious life once again. The issues of the neo-conservative backlash, precarization of the cultural sphere, and right-wing appropriation of civil society call for a re-evaluation of precarious labor and a differentiated understanding of precarity. It is clear by now that precarious life is one of the most prominent and arguably defining characteristics of independent cultures. But what is independent culture's relation to governmental precarization?[38] Is it complaisant or resistant?

The shrinking system of social security and the closed off nature of Croatia's institutional cultural system necessitated independent cultures to establish and professionalize *outside* of any social security.[39] Tomislav Medak remarked:

---

37  See, for instance, Wendy Brown, *Undoing the Demos: Neoliberalism's Stealth Revolution* (London and New York: The MIT Press, 2015).

38  See 'Precarization' in the introduction of this book for my elaboration of 'governmental precarization' as well as the other three dimensions of precarity as distinguished by Lorey.

39  Institutional culture in Croatia is highly precarious in its own right, but that's off-topic for now.

> It's basically self-exploitation all the way. I'm active in BADco., which is the most established and institutionalized dance company and theatre collective in the independent culture in Zagreb. Our funding is such that we, a group of six, cannot live off of that. The level of precarity is huge.[40]

According to Dea Vidović, this precarious position of post-Fordist labor was adopted readily by many actors within the field, including herself:
> When we started to operate, we were completely obsessed with what we did. We said that we worked 24/7, all the time, during the weekend. We worked as if we were working for some multilateral company. […] We contributed to the creation of this precarious condition for ourselves. We interpreted not having long-term contracts as being mobile'.[41]

This individualized promise of autonomy in precarious life reflects a *double ambivalence of self-governance* observed by Isabell Lorey. The pastoral power system of Western governmentality exists exactly by the grace of such individualization. Moreover, since the 18th century, the laws on which this pastoral power system is based were no longer on the authorities of the king or the church, but

---

40    Medak, interview by author, 29 March 2018.

41    Vidović, interview by author, 9 April 2018.

that of the sovereign citizens.[42] This means that the self-determination of individual sovereign citizens cannot be dissociated with a voluntary acceptance of the historical reality of collective sovereignty. The double ambivalence observed is, therefore, this: the ambivalence of self-government and being governed, and the ambivalence within self-governance, of a voluntarily making oneself complaisant and refusing to do exactly that.[43]

The question whether independent cultures hold a complaisant or resistant attitude towards neoliberal governance and the resulting precarization is most convincingly answered by: both.

Precarization in independent cultures is both a strength and a weakness, a basis of struggle against and vulnerability to neoliberal governance. Independent cultural workers have dealt with this in several ways over the past few years. This ambivalence between resistant and complaisant precarization brings up the question whether the civil society can be territorialized as a commons.

## COMMON/S

Seeing as independent cultures adapt and morph continuously, the practice of the commons presents

---

[42] This Foucauldian genealogy of Westphalian power does not apply to Croatia to an exact degree, since Croatia was never a colonial power. Enlightenment ideals and the idea of a sovereign citizenry collected in a nation-state were imported to Balkan countries by local elites educated in Western Europe in the late $18^{03.th}03\_$ and early $19^{03.th}03\_$ centuries. Nonetheless, the contemporary consequences of the history of pastoral Westphalian power are, I believe, very similar in Croatia. For a detailed account on the rise of Enlightenment ideals in the Central-Eastern European region, see: Mark Mazower, *The Balkans: A Short History* (New York: The Modern Library, 2000).

[43] Lorey, *State of Insecurity*, 14-16.

one of the different shapes they might take. In fact, if there is any common political agenda to the actors on the independent cultural scene today, it is probably the collective struggle for the commons. As such, commons discourse provides a framework for resistant precarization.

For at least twenty-five years, Zagreb has seen a tendency of incessant enclosure of commons: loss of socialist-era civil rights, sand streaming of institutional culture, destruction of monuments, privatization of public spaces, and the impoverishment of the (higher) educational system. I would even go as far as to say that the recent right-wing appropriation of the sphere of civil society, in being an instrumentalization of open space for repressive ends, is an enclosure of the commons – an enclosure, moreover, against which proponents of a functional, open, liberal civil society were not and could not have been harnessed.

As almost always, protests against these enclosures seem to have had little effect and are mostly perceived as one-off actions. Still, appreciation for the commons, and anger against their often-corrupt enclosures, are broadly shared sentiments and a basis of struggle. The logic of liberal democracy, which divides everything into private and public, fails to accommodate for commonality. But also, the traditional materialist conceptions of the commons held by both traditional social scientists and Marxists fall short here. A struggle for the commons can never be a one-off action to (re-)appropriate material resources or means of production from the possession of dominant regimes. The territorialization of civil society as a commons instead requires a continuous process of

*commoning*, which includes care, community-building, and the cultivation of common subjectivities.

Silvia Federici has studied commons around the world for years from a feminist perspective. Two 'lessons' from Federici's *Feminism and the Politics of the Commons* give insight in what this continuous process of commoning is:

> The first lesson we can gain from the [global historical] struggles is that the "commoning" of the material means of reproduction is the primary mechanism by which a collective interest and mutual bonds are created. It is also the first line of resistance to a life of enslavement and the condition for the construction of autonomous spaces undermining from within the hold that capitalism has on our lives.[44]

This means that commoning has a profound function, not only in the distribution of resources, but also in the autonomous, or independent, production of social values. The 'impact' of commoning is therefore never just the material result of particular actions or protests. It also contributes to the creation of a counter-subjectivity, which works towards a common world. The second lesson follows from this social and ethical position of commoning:

> No common is possible unless we refuse to base our life and our reproduction on the suffering of others, unless we refuse to see ourselves as separate from them. Indeed, if commoning has any meaning, it must be the production of ourselves as a common subject. This is how we must understand the slogan "no commons

---

44  Silvia Federici, 'Feminism and the Politics of the Commons,' *The Commoner*, http://www.commoner.org.uk/wp-content/uploads/2011/01/federici-feminism-and-the-politics-of-commons.pdf, accessed 11 Mach 2019.

> without community." But "community" has to be intended not as a gated reality, a grouping of people joined by exclusive interests separating them from others, as with communities formed on the basis of religion or ethnicity, but rather as a quality of relations, a principle of cooperation and of responsibility to each other and to the earth, the forests, the seas, the animals. [45]

Federici's lessons uncover the necessity of a glocal approach to commoning. It needs both a micropolitics based on empathetic subjectivities that are generated by inclusive local communities, in addition to a macropolitics that is informed by an awareness of the globally shared condition – one where we all have to live with limited resources.

Some powerful examples of micropolitical commoning are found in Zagreb's independent cultural and civil society scenes. For decades, both MAMA's transcendental shack and Booksa have been functioning as common rooms for various communities. Most of BLOK's programs, such as 'artists for neighborhood', the 'political school for artists', and 'micropolitics', explicitly address the commons. In 2015, the Institute of Political Ecology (IPE) was established, a small research institute which proactively aims to forge connections between grassroots organizations and academia (similarly to what the Centre for Women's Studies has been doing since 1995). Mainly, it publishes books such as *Commons in South East Europe: Case of Croatia, Bosnia & Herzegovina and Macedonia* (2018) and practices Dionysian commonism by organizing the Green Academy summer school on the Adriatic coast. Thereby, IPE underpins the discourse on

---

45  Federici, 'Feminism and the Politics of the Commons.'

topics like climate justice, commons, green economies, commons, and degrowth with academic credibility in Croatia.

*Ana Kuzmanić, installation shot of* A Change from the Bench *(2017), Voltino neighborhood park, Zagreb. Commissioned by BLOK. Winner of the Radoslav Putar Award. Courtesy of the artists. The sign reads:'Voltino is a workers' block. That's how things were built under socialism, so you had everything you needed in one place. The people who lived there used to be the priority, and today it's investors.'*

But, as said, these micropolitical practices are just one half of commoning. A macropolitical practice-discourse of commoning is necessary to complement the micropolitical, because commons are often instrumentalized by dominant regimes. Federici warns: 'We must be very careful not to craft the discourse on the commons in such a way as to allow a crisis-ridden capitalist class to revive itself, posturing, for instance,

as the environmental guardian of the planet'.[46] Michael Hardt goes as far as to claim that capitalist hegemony (which he calls *Empire*) already exists today, by the expropriation of the common.[47] A new futurology is needed to connect commoners around the globe. This would require to reconceptualize the international, while preventing the rebirth of capitalism, or being a folk political blip.

If I sound messianic, that's not a problem! It's popular amongst commons-thinkers (maybe amongst the global left in general) to be messianic. Michael Hardt and Antonio Negri, for instance, don't shy away from the pulpit. At the end of their preface to *Commonwealth* (2009), a passionate autonomist tractate in defense of the common, Hardt and Negri proclaim: 'We want not only to define an event but also to grasp the spark that will set the prairie ablaze'.[48] They were joined in the messianic movement by Nico Dockx and Pascal Gielen, who, as editors of *Commonism: A New Aesthetics of the Real* (2018), proudly present themselves as *ideologists of commonism* and prophesize that 'the era of the "disclosure of the commons" is now dawning'.[49]

Jokes aside, despite the occasional moralism displayed by various ideologists, commoners around the world show that commoning is one of the few credible ways to put forward tangible alternatives under today's regimes of global neoliberalism and in the climate crisis. It also

---

46    Federici, 'Feminism and the Politics of the Commons.'

47    Michael Hardt, 'The Common in Communism,' *Rethinking Marxism*, vol. 22, no. 3 (August 2010), 346-356.

48    Michael Hardt and Antonio Negri, *Commonwealth*, (Harvard: Harvard UP, 2009), xiv.

49    Dockx and Gielen, 'Introduction: Ideology & Aesthetics of the Real,' 55.

shows that it is difficult to combine commoning values – such as care, horizontal reciprocity, and durability – with the upscaling and political organization necessary not to be instrumentalized by the powers that be. Nonetheless, the commons discourse has clearly been proliferating in Zagreb in terms of culture and ecology and has become much more widely adopted into political discourse. It has even informed a shift in the party-political landscape on the left.

# Whose Zagreb?

Zagreb has been ruled for a spectacular two decades its Mayor Milan Bandić – a previous communist official, who joined the socialist party after the disintegration of Yugoslavia and ran over to the conservative party while remaining in office continuously (except for a brief period spent in jail for corruption charges). When it comes to cultural policy, Bandić focuses exclusively on constructing fountains in order to realize his dream and make Zagreb into 'little Rome'.[50] Balkan Insight cited him in 2018, stating that 'Rome has 224 fountains; when will we catch up with Rome? We are four times smaller than Rome, so we should have 50 fountains. Now, when we add them up, we have ten, so we need to build another 40'.[51] On the morning of the 28th of February 2017, a group of activists revealed a statue of Milan Bandić. The bronze bust was located on a white pedestal in front of Paromlin, a site just behind Zagreb's central station and one of the five last industrial architectural complexes in Zagreb. Despite its status as a monument, Bandić has left Paromlin abandoned and decaying and even had the site illegally 'cleaned up' (i.e. demolished) after a storm ruined the property in 2014.[52] In the inaugural speech of the monument, Tomislav Tomašević declared: 'SDP, HDZ, HNS and HSLS have been acting as the opposition for years, but are actually in agreement with Bandić, and

50   To this end, he reportedly undertook 62 inspirational trips to Rome between 2011 and 2017. Sven Mikelic, 'The Zagreb Mayor's Roman Romance Has Me Worried,' *Balkan Insight*, 21 May 2018, https://balkaninsight.com/2018/05/22/the-zagreb-mayor-s-roman-romance-has-me-worried-05-21-2018/.

51   Mikelic, 'The Zagreb Mayor's Roman Romance Has Me Worried.'

52   'Zagrebački Paromlin,' *Wikipedia*, https://hr.wikipedia.org/wiki/Zagrebački_Paromlin, accessed 8 March 2019.

they are all equally responsible for the current situation. Zagreb belongs to us, not to Bandić and the parties that keep him in power'.⁵³

*Zagreb je NAŠ, Statue of Milan Bandić (2017), https://www. index.hr/vijesti/clanak/nakon-16-godina-rada-bandic-dobio-spomenik-u-gradu-zagrebu/953422.aspx.*

This moment marks the establishment of the local political platform party Zagreb je NAŠ! (Zagreb is OURS!). According to their website, Zagreb je NAŠ gathers 'citizens from all walks of life (activists, cultural workers, trade unionists, social entrepreneurs etc., many of whom have been previously active for years in social movements in Zagreb)'. It should be noted that the small group of initiators was probably more educated than

---

53   'Nakon 16 Godina Rada Bandić Dobio Spomenik u Zagrebu,' *IndexHR*, 28 February 2017, https://www.index.hr/vijesti/clanak/nakon-16-godina-rada-bandic-dobio-spomenik-u-gradu-zagrebu/953422.aspx.

the entire government of Zagreb.[54] As Tomislav Medak, also active in Zagreb je NAŠ!, has elaborated, the group started addressing 'neighbourhood initiatives, social justice, labour activism, environmentalism, student occupations, independent media, cultural activism, LGBTIQ activism, education, [and] refugee relief'.[55] They tried to intervene in the ossified structures of the political system, which could not 'even detect this space of agency as a space of transformation [because politicians feared] the demos' so much.[56] And, of course, they have attempted to actually oust Bandić.[57] Getting 7.4% of the votes during the last local elections, Zagreb je NAŠ! has been reasonably successful so far.

Many of those running Zagreb je NAŠ have been previously active in Right to the City, Operation:City, Clubture, Kursiv, MAMA, BADco., as well as younger para-political organizations like Breed. So, through Zagreb je NAŠ, independent cultures entered into politics. What does that mean? Was this an anti-systemic and anti-establishment move, or an attempt to re-establish a fluid, mutually informative relation between public (institutional) space and civil action?

A clear explanation of how the self-defining discourse was recalibrated by the establishment of Zagreb je NAŠ! is found in *From Independent Cultural Work to Political*

---

54    'Zagreb is OURS!', *Zagreb je NAŠ! website*, http://www.zagrebjenas.hr/zagreb-is-ours/, accessed 4 June 2018. For a list of the people involved here and their respective (educational) backgrounds, see 'Nakon 16 Godina Rada Bandić Dobio Spomenik u Zagrebu.'

55    Dietachmair, 'From Independent Cultural Work to Political Subjectivity,' 224.

56    Dietachmair, 'From Independent Cultural Work to Political Subjectivity,' 222.

57    'Croatian Intellectuals Unite to Oust Bandic From Zagreb,' *Balkan Insight*, 6 March 2017, http://www.balkaninsight.com/en/article/political-platform-fights-for-zagreb-s-depersonalisation-of-power-03-03-2017.

*Subjectivity* (2017). This text is a published version of an interview between Medak and Philipp Dietachmair, in which Medak identifies a direct relationship between the practices of independent cultural spaces and the production of political agency in new forms of experimental democracy.[58] Medak hypothesized that the establishment of Zagreb je NAŠ! signified a leap from cultural work to representative political action, something he deemed a logical step in the historical trajectory of independent cultures. Medak states that politics and culture share the 'need to find new forms of democratic political agency that would allow disenfranchised citizens to make their claims, as well as a need to produce a new vision of society that starts from a realistic assessment of where they stand and what they can collectively produce'.[59] The platform-structures previously used by organizations such as Clubture and Right to the City proved to be useful outside the cultural sphere too. By doing so, the networking and platforming experiments of independent cultures inspired a large group of people from the scene to be a part of a larger mobilization to create a new political platform-party.[60]

---

58  Dietachmair, 'From Independent Cultural Work to Political Subjectivity,' 207-230.

59  Dietachmair, 'From Independent Cultural Work to Political Subjectivity,' 222.

60  Medak elaborated that the model was adopted 'following the municipalist methods that we have seen being successfully developed and put in practice in Spain'. Dietachmair, 'From Independent Cultural Work to Political Subjectivity,' 223.

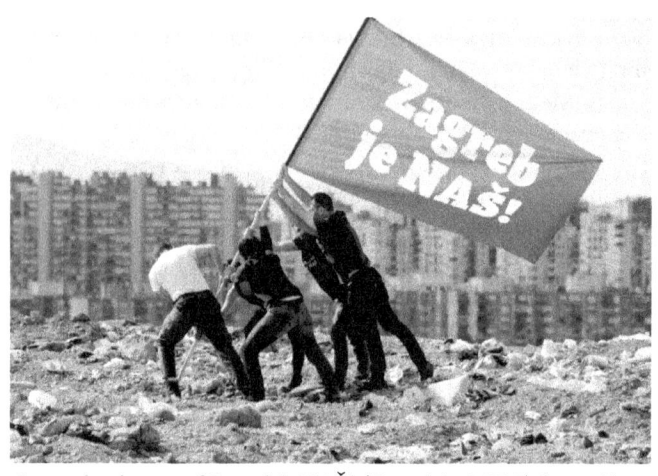

*Campaign image of Zagreb je NAŠ! (Zagreb is OURS), https:// www.facebook.com/ZagrebJeNAS/photos/a.390842304627264/ 414337625611065/?type=1&theater.*

From the way that it presents itself, it is clear that Zagreb je NAŠ is inspired by the history of visual culture. The Bandić bust brings to mind the public interventions of the young Braco Dimitirijević's *Random Passer-by* series, the party's campaign and Facebook image is an obvious reference to Joe Rosenthal's *Raising the Flag on Iwo Jima* (1945). Yet, I would argue that the establishment of Zagreb je NAŠ presents the most definitive break with the post-Peace Movement praxis of independent cultures up to today, despite the fact that there are clear continuities between independent cultural work and representative political work. By moving into the terrain of representative politics, cultural workers have partly abandoned counter-political politics in the field of the social and returned to the field of the party and the state. In doing so, they answer the systemic question of the

nature of civil society and the organizational question of the left today.

It must be noted here that the questions at hand are neither new nor specific to the Croatian context. In her 2016 book, *Crowds and Party*, Jodi Dean uses Marxist-psychoanalytical theory to re-examine the party within the context of several recent international uprisings.[61] She notes that most of these uprisings, from Arab Spring, the Tahrir Square protests, Occupy (Wallstreet), protests Turkey and Greece, in Madrid and Moscow, in Women's Marches and at Standing Rock, lack lasting political effectiveness. In order to establish the lasting import of the party for the global left, she argues that civil society action in itself is simply not enough:

> Newness and experimentation, not to mention preoccupations with changes at the level of the individual and actions focused on media and culture, take the place of a politics targeting capitalism and the state, ensuring that they continue doing what they do. At some point, however, an encounter with the state or the economy becomes unavoidable as one or the other becomes a barrier to movement ideals.[62]

After decades in which subjectivity arose with every individual movement – the Peace Movement and Right to the City being prime examples – and sank back into the gap between individual agency and the collective

---

61  Jodi Dean, *Crowds and Party* (London and New York: Verso, 2016). I find Dean's well-formulated theorizations about the state of today's left and its political ineffectiveness helpful. However, I do *not* subscribe to Dean's view that the only viable and right solution to the question is a global, exclusive, monopoly-holding Communist Party which uses propaganda and ideological suppression to stigmatize, divide, and disempower political opponents.

62  Dean, *Crowds and Party*, 255-256.

subject of politics, today the simultaneous tendencies in independent culture of incessant precarization and institutionalization are likely to be such a barrier. Following Dean's logic, the role of the party in this situation is that of being a *site of transferential relations*: 'The party is a form that accesses the discharge that has ended, the crowd that has gone home, the people who are not there but exert a force nonetheless.'[63] It is an answer to the question: what happens when nothing happens? For this reason, I am inclined to view the abandonment of the cultural as a reformation of the subjectivities found in independent cultures informed by criticality, rather than an adoption of the system of cultural dominants. By creating a durable, stable and dependable framework to address structural problems such as precarization, impact-driven financing of social institutions, gentrification, and urbicide, Zagreb je NAŠ! might prove a valuable tool not only in realizing political and social effectiveness, but also in decoding the global and neo-imperial regimes of neoliberalism and independent cultures' own implication in them. But did this renewed focus on the organizational, political and systemic questions come in time? And where does it leave culture?

---

63    Dean, *Crowds and Party*, 282-283.

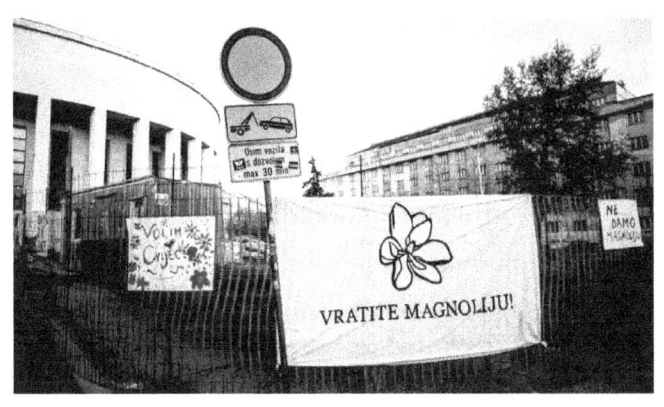

*The Vratite Magnoliju! campaign against demolition of the (magnolia) trees around the Meštrović Pavillion as part of a clean-swiping urban development program, https://faktograf.hr/2018/04/26/grad-nema-niti-planira-pribaviti-dozvole-za-dr-manje-po-mestrovicevom-paviljonu/.*

# Clash of Generations

STRUCTURAL DIFFICULTIES OF
REJUVENATION

Galerija Miroslav Kraljević invited the Danish artist Minna Henriksson for a residency in 2006. During her two-month stay in Zagreb, Henriksson researched the local scene and used this as the basis for her project. This resulted in two works, one of which is *Zagreb Notes*: a wall drawing that maps Henriksson's encounters in the Zagreb art world. *Zagreb Notes* constitutes the only substantial, although not exhaustive, visual mapping of Zagreb's cultural infrastructure up till now. The image includes Henriksson's general observations about the Zagreb art world and is therefore also a time-stamped evaluation of the scene. This in itself makes her work an interesting snapshot. Notably, the first remark highlights the downside of independent cultures' focus on advocacy and prefiguration: 'NGOs have gone too deep into cultural policy and lobbying. They are not organizing so many events anymore'.[64] In 2006, Henriksson had already noticed a problematic generational issue within independent cultures:

> The 70's conceptual artists are still regarded as the only contemporary artists. Younger generations get hardly shown. […] There are no theoreticians

---

[64] Minna Henriksson, *Zagreb Notes* (2006), drawing on wall, reproduced on paper 70 x 100 cm, http://minnahenriksson.com/wp-content/uploads/2012/05/zagreb-notes-original.jpg.

> in Croatia writing about young artists. […]
> NGOs are run by people who are 30-something.
> There are no new younger people who want to
> get involved. […] Young artists nowadays don't
> organize themselves & form groups/collectives
> to demand what they need & want. They are […]
> spoilt and not interested in the scene.[65]

Independent cultures still struggle with the same issues more than a decade on. The average age of core staff of most independent cultural organizations is higher than in the 1990s. Independent cultures are hardly non-institutional anymore. At the same time, independent cultural work has not become any less precarious.

All of the 40- or 50-something year old cultural workers running the important organizations are remarkably open about and aware of their precarious privilege. Mika Buljević points out that independent cultures are 'still very much dependent on [her] generation – middle-aged people. That's why I think this hybridization or semi-institutionalization, as well as institutional reform, is really urgent. I'm afraid of what will be there in 20 years, what the picture will be'.[66] Milat reflects: 'We ask ourselves what our future is here, in Zagreb and Croatia. If there is someone who's almost 20 years younger than we are, and we want someone like that to make MAMA 2.0 or 3.0, to get them into the organization to do programming and other things with us, it was very hard to tell them: "Although we now have some very big problems, you can count on us going on."'[67]

---

[65] Henriksson, *Zagreb Notes*.

[66] Buljević, interview by author, 15 March 2018.

[67] Milat, interview by author, 8 March 2018

*Minna Henriksson, Zagreb Notes (2006). Wall drawing reproduced on paper 70 x 100 cm, http://minnahenriksson.com/wp-content/uploads/2012/05/zagreb-notes-original.jpg. Courtesy of the artist.*

Medak even argues that 'in the long run, the success-story of independent culture in Croatia might turn out just to be a blip in the continuity and stability in this older cultural system'.[68]

During the 1990s and 2000s, the then-younger generation sought to overcome the generation divide between them and their elders. Now, thirty years later, the responsibility to bridge a gap rests on their shoulders once again, this time with the generation below. Time for the spoiled younger generation to take some responsibility and act, it seems. Unfortunately, the issues that make it so hard to bridge the gap are of a deeper and less individual character than acknowledged by the anonymous critique cited by Henriksson. First of all, since the independent cultural scene inherited its legacy from Yugoslav-era alternative culture, it is hard for people who never personally experienced that cultural system to take ownership of that legacy. This has resulted in younger generations choosing what Tomislav Medak calls 'another path of subjectivation' during, for instance, the 2009 student protests: 'The new generation just had a different trajectory in understanding how culture and politics are operating'.[69]

Moreover, the argument that independent cultures are a seemingly generational phenomenon has led to critique from younger generations. They claim that it is the older generation who are privileged. By professionalizing and institutionalizing, yet maintaining their fringe position, older actors in independent cultures are thought to leave no space for new culture. Ivet Ćurlin of WHW is aware of this problem and said that they: 'would like to open

68   Medak, interview by author, 29 March 2018.

69   Medak, interview by author, 29 March 2018.

Galerija Nova more to younger artists and curators, but it's hard to raise funds for this [...] We're also afraid that our withdrawal from the gallery might result in closing or changing it, like it happened to Galerija Karas'.[70] Therefore, instead of leaving their organizations in the hands of younger people, older independent cultural actors use methods such as schools and educational programs, including the Kurziv Journalistic School, BLOK's Political School for Artists, the WHW Academy and IPE's Green Academy, as novel ways to bridge the generational gap.

These alternative educational programs are all the more urgent since the official educational system does not encourage critical thinking about arts and culture. Art history student Maja Flajsig remarked that the set-up of the program at the University of Zagreb is 'pretty much traditional'. She described how some professors simply forbid their students to write about 'progressive topics' such as the depiction of Roma people in Croatian Naïve Art or the genealogy of images of genitals in Croatian school books.[71] As a result, Flajsig argues, 'people don't have the knowledge to understand what independent culture looks like or the topics it talks about, like migration, racism, and the history of antifascism'.[72] It's unsurprising, then, that the practice of independent culture starts to seem abstract, less relatable and more

---

70    Ćurlin, interview by author, 25 May 2018.

71    The places most welcoming to progressive or alternative research are student art history magazines and the student conferences held yearly in Zagreb, Split, Rijeka, and Belgrade, amongst other places. It's almost like under Yugoslav socialism, even though the dominant taste has changed from modernism to traditionalism. Maja Flajsig, interview by author, audio-recorded interview, Kino Europa, 12 March 2018.

72    Flajsig, interview by author, 12 March 2018.

elitist to the broader public—despite attempts from the scene to make it more accessible.

A last problem that Ivet Ćurlin pointed out is that it's very hard to be a young artist in Zagreb today – even harder than it is to be a cultural worker. Not only is there no art market and very little institutional support, the level of interest former Eastern art in the West is also very low compared to the situation in the 1990s and 2000s. Ćurlin: 'Eastern art is not fashionable.'[73] Since Croatia entered the EU, young artists leave for the West, rather than Western curators searching for artists in. Since those remaining often have little money to travel, Ćurlin perceives that Zagreb has 'become a kind of closed circuit'.[74]

The current situation shows that independent culture might indeed be a short-lived, generation-specific phenomenon. Altogether, making a generational leap seems to be a highly urgent issue within independent cultures today. But it is clear that there is more at hand than the practical or economic obstacles when it comes to rejuvenation. At stake is the very desire of creative criticality at the heart of independent cultures. Do younger generations still have this desire for creative critique? Is independent culture still critical? What is its present-day legitimacy? Is the 'path' of independent cultures still promising, or dead-ended? At least, it's fair to say that new generations have so far not been able to the synergy that makes the older one so effective in independent culture.

---

73    Ćulrin, interview by author, 25 May 2018.

74    Ćulrin, interview by author, 25 May 2018.

## CURRENT INITIATIVES

Despite all the difficulties of establishing new cultural organizations, financial or otherwise, new initiatives do spark up. Not all independent cultural organizations find it as hard to cope with the generational issue. Kontejner is currently working with its third generation of curators.[75] So is GMK. In Booksa, there are always new young people at work. Why is it seemingly easier to rejuvenate for these organizations? I would say because Kontejner, GMK, and Booksa don't try so much to educate their younger collaborators by standards of the elder. Their mission is not to conserve. They instead embrace the energy and motivation inherent to youth and allow it to reinvent the existing organizational structures. Without wanting to get too promotional, I want to acknowledge the existence of young initiatives and to mention some of these energetic, inspiring, exciting, hopeful examples.

On Ilica, the small Galerija Greta hosts new exhibitions every week.[76] At this gallery, the speed with which exhibitions rotate means that the programming is very broad. They feature mostly Croatian artists but occasionally artists from elsewhere too, some of them established, many of whom are still young and unknown. It is no exception if these exhibitions are announced less than a week in advance, if at all. Because of this refreshing exhibition strategy, it is always a surprise to visit Greta on a Monday night. One week, I ran into the dry, minimal, conceptual work of independent culture veteran Slaven Tolj: two pictures on one wall, rest of the space empty, beers being sold in the back, crowd on the

---

75   Sunčica Ostoić, interview by author, 12 June 2019.

76   For Greta's official website and program, see: http://greta.hr/en/.

sidewalk in front.[77] Some months later, the space was filled with the eerie clones and durational movements of the rising inter-Balkan art world star Marko Gutić Mižimakov.

*Marko Gutić Mižimakov*, A Performing Site for Affective Clones & Whatever They Want *(2018). A durational performance made in collaboration with: Ana Jelušić, Ivana Rončević, Ana2 & AnaG8, Ivana2 & IvanaG8, Marko2 & MarkoG8 as well as some other clones.*

Another gallery bridging the generational gap is Galerija Miroslav Kraljević (GMK), a little paradise floating on oil.[78] It's a hip exhibition space attracting those who search Zagreb to find Berlin and those who merely look for free gemišt – however it is not simply a white cube space. The gallery was established as one of the workers' clubs of the Yugoslav state oil company INA. In the early

77 Conceptual artist and curator Slaven Tolj was the director of Atelijeri Lazareti in Dubrovnik throughout the 1990s and now heads the Museum of Modern and Contemporary Art in Rijeka.

78 GMK was established as one of the workers' clubs of Yugoslavia's national oil company INA. It has since developed into a contemporary art gallery central to the independent scene. See: http://www.g-mk.hr/hr/home/.

1990s, it was transformed into a professional gallery for contemporary art. After the disintegration of Yugoslavia, INA was privatised but continued to fund GMK.[79] The gallery has therefore remained in its space up until today, in the basement of the disused INA headquarters, next to the INA senior citizens club and the INA choir.[80] Strangely enough, GMK has become one of the spaces that are most independent from the independent cultural scene. This is largely due to the mission, expressed by one of GMK's curators Lea Vene, that 'young people, even straight out of the Art Academy, should feel like this an inclusive space, their space'.[81] GMK strives to realize this ideal by working with multiple generations at the same time, and constantly trying to bridge generations within its program. Its exhibition program balances (mostly young) artists from the local context with foreign artists who intervene in the local scene. It hosts community projects with the Roma population in Zagreb, courses for high school students as well as senior citizens, it formulates institutional self-reflections, holds residencies, lectures and other public programs. They have also recently programed open studio events.

More than interesting galleries, nomadic organizations and festivals like Otokultivator, Urban Festival, QUEER Zagreb, Kontejner, Subversive Festival, and the Human Rights Film Festival have been an important component of the independent cultural scene. The format of the festival has its problems: it tends to be spectacularized, commodified, ephemeral, gentrifying, and so on. But still, wonderful things can happen at festivals, of which

---

79   INA is now part of the Hungarian MOL Group.

80   Lea Vene, interview by author, audio recorded interview, Galerija Miroslav Kraljević, 26 April 2018.

81   Vene, interview by author, 26 April 2018.

one example stands out to me today. The small collective Organ Vida organized its tenth annual international photography festival in September 2018, *Engaged, Active, Aware: Women's Perspectives Now*, in the MSU and various smaller spaces throughout the city.[82] Despite the festival's large scale and small organizational team, the quality of the exhibitions, programs, talks, screenings and lectures Organ Vida presented was impressive, thoroughly setting the feminist agenda of the scene.

*Ilona Szwarc,* She Herself Is a Cave Full of Echoes, *from the series* Indeed a New Woman. *Courtesy of the artist. This work was exhibited at Organ Vida's tenth International Photography Festival in 2018.*

Then, there are the so-called unorthodox practices. If a return to the party is one of the responses to the rising precarization and ossification of cultural infrastructures

---

82   For the website of the Organ Vida Festival, see https://ovfestival.org, and for an overview of past editions, see https://organvida.com/festival/.

in independent culture, a second one, closer to the practice of young cultural workers, is the reconsideration of squatting. After a long and slow process of transformation, the established cultural free haven Medika is at this point dysfunctional as an experimental space.[83] Looking to accommodate the need for open and experimental spaces, independent cultural workers and activists have taken to squat new properties. Working outside of existing (funding) structures, this tendency also allows for the participation of younger generations.

In Zagreb like anywhere, a crucial characteristic of a functional squat is that it must show a counterexample, an embodiment of something better than what existed before. An upside in this respect is that the gentrification of Zagreb does not follow the same trajectory as that of cities like New York, London, Paris, and Amsterdam. There, it is usual for both governments and companies (often joint collaborations of both) to cheaply rent out abandoned (industrial) properties with poor facilities to creatives for a small number of years, knowing that this will improve the attraction of the neighborhood, the price of the property and the profitability of development. The government of Zagreb takes another approach: it lets the (monumental) property rot away emptily until it is so deteriorated that it must be demolished, and the site can be redeveloped. It's hard for squatters to create a positive counterexample to gentrifying cultural workers in flourishing 'cultural hubs'. It's easier to create counterexamples in beloved

---

83   Squats often tend to slowly shift from being subversive entities on the brink of legality to cheap private property, which is the case here too. Since it has been legalized, Medika has structurally received government funding, which is ambiguously spent and of which the benefits hardly—if at all—reach the community beyond the old factory's walls. Medika has effectively become a complex of cheap studios for privileged artists and a nice place to party, where some extra money is made by selling beers under the counter.

buildings literally crumbling due to corruption – this is exemplified by the fate of properties such as Badel, Gorica, and Paromlin.

Several squats emerged in Zagreb over the past years, all occupying abandoned spaces in order to create something better, thus proving that experimental open spaces can be created in and by communities. These counterexamples challenge both corrupt government property management and de-squatted spaces like Medika. For example, during some months in the summer of 2018, the Croatian Dancers' Association first rented, then semi-squatted, a property on Ilica 69 which they called FuturDrugi.[84] It was a promising space where the community worked on self-historicizing by means of a collaborative time-line exhibition and a dance/performance festival initiated by Tala Dance Centre. There were dance workshops, communal meals, yoga classes, massage sessions, and karaoke evenings. Denying FuturDrugi's social function, the city government started asking the informal organization to pay an absurd rental price and threatened them with eviction. It was then decided to abandon the space. Unsurprisingly, the property has remained disused ever since.

---

84  See: https://www.facebook.com/futurII/. 'Futur drugi' translates to 'second future', 'other future' and 'future perfect'.

*Facebook profile picture of the short-lived independent dance space FuturDrugi on Ilica 69, https://www.facebook.com/futurII/.*

Around the time FuturDrugi came into being, the former school for blind children Vinko Bek—another abandoned building—was squatted by the local Food not Bombs-group. This turned into Drustveni Centar Bek (Social Center Bek).[85] Not unlike FuturDrugi, Bek hosts an open

---

85  'Vlasti traže da se skvoteri isele iz napuštene zgrade u Zagrebu,' *Aljazeera Balkans*, 10 November 2018, http://balkans.aljazeera.net/video/vlasti-traze-da-se-skvoteri-isele-iz-napustene-zgrade-u-zagrebu.

*Aljazeera Balkans news images shot inside of Social Center Bek, 10 November 2018, http://balkans.aljazeera.net/video/vlasti-traze-da-se-skvoteri-isele-iz-napustene-zgrade-u-zagrebu.*

and collaborative program of community meals, yoga sessions, concerts, exhibitions, and more.[86]

In a similar vein to the renewed squatter movement, the oscillation between mainstream and subculture in independent cultures can be observed. There are some new actors, like This Town Needs Posters and Zgerila, who've been spreading posters, tags, stickers, and graffiti throughout Zagreb.[87] Then, there are the organizations that have simply continued subcultural activities for decades, without ever going mainstream. This is, for instance, what the anarchist bookshop and publisher

---

86    For an overview of their programs, activities and mission, see: https://bekkolektiv.com and https://coopfunding.net/en/campaigns/bek-autonomous-space-for-free-social-and-cultural-activities/?fbclid=IwAR3j5bbRBKbWL5ubq4QgmxpVLooGnUQCoqMnZHfrlo3A3--5j-nwIz52H2w.

87    See an interview with Zgerila at Saša Šimpraga, 'Grafit može spasiti život,' *Vizkultura*, https://vizkultura.hr/grafit-moze-spasiti-zivot/, 12 March 2019, and #zgerila on Instagram, https://www.instagram.com/explore/tags/zgerila/?hl=en.

Što Čitaš? has been doing since 1999 and underground comic publishing platform Komikaze since 2003.[88] In fact, these latter two organizations are doing very well: the racks in front of Što Čitaš? are always full with free-to-take zines and booklets, temporary works of public art put there by both the shop and its community, and Komikaze has compiled a library of 44 mind-blowing publications. Does punk really never die?

Antonio Negri has said: 'They say that, when the Nazis had Tito surrounded, he saved himself by hiding in a cave. This is how it is in the Balkans: the resistance is often forced to conceal itself in caves and forests. But it never goes away'.[89] This is a strange remark, because it holds true for resistance in every part of the world – but, yes, also in the Balkans. Even if most independent cultural organizations are not – or are no longer – subcultural, the existence of these zines and posters show that there will always be subculture to take over.

---

88  For Što čitaš, see https://www.stocitas.org/o%20sto%20citas.htm and for Komikaze, see https://komikaze.hr.

89  Antonio Negri, *Welcome to the Desert of Post-Socialism*, eds. Horvat and Štiks, back cover.

*This Town Needs Posters, Poster for the concert of the Swans in Rijeka, 27 March 2017.*

# Towards a Feminist History of (Post-)Yugoslav Art

The histories of independent culture and feminist activism in Croatia are intertwined. Feminism was one of the important perspectives in the Anti-War Movement, and the Center for Women Studies was established from it.[90] Lana Pukanić, worker at the Institute of Political Ecology and founder of feminist portal MUF, stressed the importance of this connection:

> [Zagreb in the 1990s and early 2000s had] no feminist education except for two venues: Center for Women's Studies, which publishes the magazine Treća, and Ženska Infoteka, which is closed now but published a magazine called Bread and Roses [Kruh i ruže].[91] [...] If you look at their contributors and editorial board, you see these names that you can see throughout civil society and independent culture. Since there was no official feminist education of any kind, these

---

90    For the official website of the Center for Women's Studies, see https://zenstud.hr.

91    The Women's Infoteque was a feminist library and knowledge center and, like the Center for Women's Studies, it was established by the ZaMir (the For-Peace Movement) network. It published *Kruh i ruže* from 1993 into the 2000s.

artists got together, and informally shared their knowledge through these magazines.[92]

From the mid-2000s onwards, several NGO's were set up in order to serve as information desks for feminist issues, informational feminist portals, such as Vox Feminae and Libela. These provided a platform for the voices of famous Croatian women and worked on Croatian translations of content from English-speaking websites.[93] Yet newer feminist portals, such as MUF and Krilo, took this a step further. They created spaces to have fun with essays and long-reads which went beyond basic feminist concepts and attempted to queer the heavily gendered Croatian language.[94]

Yet, even though feminist activism and independent cultures have been intertwined in several ways, the dominant art historical narrative of Yugoslavia shows a lack of feminist art history. In the Croatian case, this resulted in a male-dominated narrative running from Exat '51, via Gorgona, Tomislav Gotovac and New Tendencies, to the Group of Six Artists and Braco Dimitrijević.[95] Sanja Iveković's work is an important but tokenized exception to this rule. No study has addressed that the famous artists, Tomislav Gotovac, Mladen

---

[92] Lana Pukanić, interview by author, audio-recorded interview, Institute of Political Ecology, 9 May 2018.

[93] For the websites of these organizations see: Vox Feminae, https://voxfeminae.net; Libela, https://www.libela.org.

[94] For the MUF website, see http://muf.com.hr.

[95] Good examples of thorough and influential art or cultural historical accounts that nonetheless reinforce the dominant narrative, while failing to address the gender issue, are Medosch, *Automation, Cybernation and the Art of New Tendencies (1961-1973)*, and Ješa Denegri, "Inside or Outside "Socialist Modernism?" Radical Views on the Yugoslav Art Scene 1950-1970," *Impossible Histories: Historical Avant-gardes, Neo-avant-gardes, and Post-avant-gardes in Yugoslavia, 1918-1991*, ed. Dubravka Djurić and Misko Suvaković (Cambridge, Mass., London: The MIT Press, 2003), 170-208.

Stilinović, and Braco Dimitrijević, all were, and still are, largely dependent upon their wives' less visible labor to sustain their practice.[96] This is not to say that the individual works of these artists lacks quality, but that the general framework of history that they are represented in is flawed.

I would not dare to say that there is a general lack of feminism in independent cultures. In fact, a lot of feminist theoretical and artistic work has been done over the past decades to intervene in the general view of history. Just some examples: In April 1998, works of Sanja Iveković, Vlasta Delimar, Jelena Perić, Ksenija Turčić, Ivana Kesser, and Magdalena Pederin, were presented as the Croatian iteration of Women Beyond Borders, curated in Melong Space by Nada Beroš, then head curator of the MSU.[97] By writing about the politicizing artworks of female artists like Jagoda Kaloper and Edita Schubert, scholars suchs as Leonida Kovač have made feminist issues visible, readable and speakable, thus raising the profile of feminist perspectives on art and art history in the former Yugoslav area.[98] Further important

---

96   For a good part of his artist career, Tomislav Gotovac was financially dependent upon his wife. Darko Šimičić, interview by author, 12 March 2018. Stilinovoć's and Dimitrijević's respective partners, Branka Stipančić and Nena Dimitrijević, are both art historians and made significant discursive contributions to their husbands' work.

97   'Croatia,' *Women Beyond Borders*, https://womenbeyondborders.org/croatia/, accessed 24 April 2019.

98   Leonida Kovač, *Jagoda Kaloper: In the Mirror of the Cultural Screen* (Zagreb: Croatian Film Association, 2013). Another book by the same author, only published in Croatian under the title *Anonimalia: Normative Discourses and Self-representation by 20th Century Women Artists* (2010), comes close to such account. Leonida Kovač, *Anonimalia: Normativni diskurzi i samoreprezentacija umjetnica 20.stoljeća* (Zagreb: Izdanja Antibarbarus, 2010). A last important contribution was made by Ljiljana Kolešnik: *Feminist Art Criticism and Feminist Theory of Art,* a collection of translated canonical feminist art theoretical texts published by the Centre for Women's Studies. Ljiljana Kolešnik, *Feminist Art Criticism and Feminist Theory of Art* (Zagreb: Centre for Women's Studies, 2000).

interventions have been produced on the intersection of art and theory, such as *Feminist Takes on Yugoslav Black Wave Film* at the Academy of Drama Arts by DelVe in 2015, *Zagreb's Squares Do Not Remember Women* by BLOK, Sanja Horvatinčić and Mario Kikaš during the 13th UrbanFestival.[99]

Despite this presence of feminism in independent cultures, a comprehensive feminist (critique of) Yugoslavian art history is yet to be formulated. Still, the import of such a general historiography is fairly clear. For instance, its absence results in the contradictory fact that many actors in the scene, such as WHW, BLOK, and DelVe, draw inspiration from Marxist-informed feminist theory but at the same time invoke the dominant narrative of artistic modernisms as a source of inspiration.[100] Exactly what type of historical justice is resurrected in the present and extrapolated into future justice?

The question of feminist art or cultural history is also relevant on a more pragmatic level. Even though most organizations in today's independent cultural scene are more balanced and self-conscious in terms of gender than their Yugoslav equivalents were, say, 50 years ago, disbalances and lack of diversity still exist within

---

99   For *Zagreb's Squares Do Not Remember Women*, see http://urbanfestival.blok.hr/13/en/zagrebs-squares-do-not-remember-women/index.html.

100  See, for instance, Ana Dević's argument in Ana Dević, 'Politicization of the Cultural Field: Possibilities of a Critical Practice,' *Život Umjetnosti*, 85 (2009), 17-33.

the various organizations.[101] Especially in times of rising neoconservatism, while the feminist outlets are being suffocated by the Croatian government, a proper feminist evaluation of the history of new media, the Soros scene, and the broader cultural history of (post-) Yugoslavia could shed valuable light on the present situation of one of independent cultures' most central actors. At the same time, seeing as the Faculty of Philosophy of the University of Zagreb is finally about to inaugurate a department of gender studies, changes arise to forge the connections and solve this lack of feminist art history.

---

101   Two examples would be the Institute of Contemporary Art and the Multimedia Institute. The Radoslav Putar Award, which has been awarded by the Institute for Contemporary Art for seventeen years and is the most important at prize in Croatia, has been awarded to a female artist merely five times. There are no significant external structural reasons for this disbalance, which testifies to the absence of sufficiently critical historical consciousness. Every year's nominees and winners of the Radoslav Putar Award can be found here: http://nagradaputar.scca.hr/en/home.html. A fairly different, but also important example is MAMA, which has operated in the historically gendered fields of new media, tech, film, electronic music, and philosophy. In this case, gender is an issue consciously and actively dealt with for a long time. From the start, it has been a major point of micropolitcs to actively involve women in the organization. Moreover, engaging with Zagreb Pride and other queer community activities, MAMA has contributed to general deconstruction of gender norms and models. Yet, gender-disbalance, both in terms of members and audiences, remains an issue that presents problematic situations for the organization that are not easily overcome. Milat, interview by author, 8 March 2018. Medak, interview by, 21 May 2018.

*Still from Jagoda Kaloper,* Behind the Looking Glass, *1965-2016.*

# PART III

# DIMENSIONS OF INDEPENDENCE: WHAT IS INDEPENDENT CULTURE?

*We have to proclaim the end of the end of history, to reclaim the future, and to start building. Eventually, we end up asking ourselves: Is there room for utopia after utopia?* – Laura Naum and Petrică Mogoș[1]

---

1    Laura Naum and Petrică Mogoș, 'Dear Reader,' *Kajet: a journal of Eastern European encounters* vol. 1, no. 2 (Autumn 2018), 7.

# Independencies and Futurologies

What can we learn about the concept of independence given the previously conveyed information? In the first place, a strictly situated definition of independence can be derived from the genealogy. Looking at the practice of independent cultures in Zagreb and the use of the term 'independent culture' by actors in the scene, it seems that there are at least four dimensions of independence inherent to the scene.

At the basic level, there is formal independence. This can be defined as economic and governmental independence from any external body or force. Even if independent cultures have grown to be formally dependent upon the successive Croatian governments, their identification with the term 'independence' denotes the historically specific, often marginal position of Croatian civil society. Independent culture consists of those actors that were pushed out of the institutions during the post-Yugoslav institutional crisis and regrouped in civil society. The formal dimension of independence in the context of Croatia thus mainly signifies a systemic position: independent culture is formally opposed to institutional culture.

Then, there is the political dimension of independence. I once met someone at a gallery opening who did not work in the cultural field. I asked her: 'Are you familiar with the notion of independent culture?' She

laughed at me and said: 'Of course I am! Everybody in Croatia knows that'. I realized there and then that the very term independent culture is a topos of political contestation. It simply goes without saying that politics are an important aspect of independent cultures. Maja Flajsig characterized independent culture saying: 'It's always against oppressive systems and it's always on the left'. True enough, with hardly any exception, these organizations are politically left leaning, socially engaged, inspired by the traditions of artistic modernisms, the antifascist struggle, and Yugoslav self-management socialism, and aim to be critical and politically effective. Moreover, this public image is enforced by the fact that independent culture is regularly targeted by conservative politicians. The fact that the authorities pay close attention to independent cultures, also legitimizes them and provides them with leverage to address certain issues. Therefore, Maja Flajsig remarked that 'independent culture is corrective of society, because it deals with problematics that are invisible, such as racism, issues of migration and the way that our current politics are trying to forget the antifascist movement'.[2]

A third dimension of independence is signified by the fact that independent cultures in Zagreb represent a semi-open identity – let's call this differentiated independence. Tomislav Medak uses the concept of a 'fault line' to describe the constellation of independent culture 'running from centrist liberalists to anarchist factions' – even though independent culture is definitely predominantly left-oriented.[3] If Booksa is on the liberal side of the spectrum, BLOK is clearly on the Marxist side. At the same time, MAMA is run by

2   Flajsig, interview by author, 12 March 2018.

3   Medak, interview by author, 29 March 2018.

people representing both. Despite the existence of these differences, pragmatic collaborations across fault-lines have taken place and created an important basic sense of trust and collectivity. However, these fault-lines do in effect demarcate independent culture from everything else. Independent culture is not, or at least not at this moment, considered to be a sub-culture. Neither is it propagandistic. It is not direct politics. It is not veteran clubs, museums, or artists' associations. As such, these fault lines demarcate both internal and external differentiation.

A last dimension of independence inherent to the scene independent cultures in Zagreb is aesthetic independence. Since it is simply impossible to neatly define the independence of independent cultures in terms of a uniform political agenda, cultural practice, or identity, it is clear that independent culture cannot be defined exclusively in terms of local contextuality, political agenda, identity, or historical trajectory. Instead, the community of independent cultures is self-questioning, sometimes more porous, other times less, but never hermetic, meaning that it constantly re-negotiates itself. It does so within the scene – a specific common-yet-heterogeneous space of articulation within and beyond normalized ways of seeing and understanding the common world.

According to Goran Sergej Pristaš, the term scene is used in independent culture today exactly to describe and criticize, quite simply, 'what is seen (and what is not)'.[4] When, in an interview, Antonija Letinić differentiated between the apolitical term 'independent culture' and the politicized term 'independent cultural scene', she

4  Goran Sergej Pristaš, interview by author, 14 May 2018.

confirmed that the artistic, cultural and political modes of expression of independent cultures inscribe a sense of community and a division of parts (an in- and exclusion), and thereby act upon the ways in which human sensibility itself is shaped and disciplined.[5] Therefore, by using aesthetic means, independent cultures in Zagreb work towards independently shaping and defining a common world.

These four dimensions of independence emerge from the genealogy of independent culture in Zagreb, the combination of which create a situated definition of independence. The relevance of independence in culture is, however, not limited to the Croatian context. Underpinning the future of independent cultures and their legitimacy in Croatia is the more general question: what can independent culture be today? What independence is at stake here, and on which conception of freedom is it based? And finally, what new perspectives and futurologies can be formulated with this independence? Therefore, I will now attempt a leap from the local genealogy to a general theorization of independent culture. I believe that the first step in adapting a translocal perspective towards a theory of independent culture is to acknowledge the gap between the local and the general and to embrace productive untranslatability.

---

5   Letinić, interview by author, 3 April 2018.

# Untranslatability

In *A Critique of Postcolonial Reason: Towards a History of the Vanishing Present* (1999), Gayatri Spivak reminded the reader that 'the great narrative of Development is not dead' in the post-historical era.[6] The neo-colonialism that has replaced colonialism in the decades after 1989 was characterized by the progressive imperialism of globalization that subsumed international discourses on emancipation of the subaltern into the flow of capital and the American hotpot. Especially today, during the decline of American hegemony and the rise of anti- or alter-globalist sentiments amongst neoconservative elites throughout Europe and beyond, it seems important to reconsider the implication of independent cultures in the dominant cultural order and the flow of capital in terms of capacity of formulation. For what is the question of a new futurology but the question of capacity to formulate one's own (collective) future?

With regards to the genealogy above, there are two issues that can be elaborated at length. Firstly, how civil society in Croatia is a contested area between 'indigenous NGOs', local nationalist movements, and progressive imperialist organizations, and, secondly, how the experience and political reality of the Non-Aligned Movement is historically under-represented. On these issues and their interrelation, Spivak stated:

> The governments of developing nations are, with the disappearance of the possibility of nonalignment in the post-Soviet world, heavily

6   Gayatri Spivak, *A Critique of Post-Colonial Reason: Towards a History of the Vanishing Present* (Cambridge, MA and London: Harvard UP, 1999), 371.

mortgaged to international development organizations. The relationship between the governments and the spectrum of indigenous non-governmental organizations is at least as ambiguous and complex as the glibly invoked "identity of the nation". The NGOs that surface at the "NGO Forum"s of the UN conferences have been so thoroughly vetted by the donor countries, and the content of their so organized by categories furnished by the UN, that neither subject nor object bears much resemblance to the "real thing," if you will pardon the expression.[7]

In other words, (memories of) radical, decolonial, grass-root positions are almost impossibly formulated now that cultural dominants in the globalized field of civil society are (former) Western organizations such as the UN, the EU, the World Bank, the Soros Foundation, and the Erste Bank. Even though the money from these sources can, of course, be used in great ways – most of the independent cultural scene in Zagreb would not have existed without it – these money flows also represent neo-imperialist reason.

One crucial characteristic of this neo-imperialist logic is the imperative of complete, commensurable translatability of language, experience, economies, and social systems for the good of accumulating and expanding capital. This is why the post-1989 condition is, as Boris Buden calls it, *translational*.[8] The simple example of the Big Mac Index, produced by

---

7   Spivak, *A Critique of Post-Colonial Reason*, 372.

8   Boris Buden during 'Rad i jezik nakon prevodivih društava: Kratko predavanje Stefana Nowotnyja i razgovor s Borisom Budenom,' Galerija Nova, 25 May 2018, http://www.whw.hr/galerija-nova/radi-i-jezik-nakon-prevodivih-drustava.html.

*The Economist* every year since 1986, is self-evident.[9] This supposed translatability applies to all aspects of social and personal life: the free market, the institutions of liberal democracy, universal human rights, the English language, free culture and press, and certainly to the arts, too. Mladen Stilinović once made a banner which said it all in a single sentence: 'An artist who cannot not speak English is no artist.'

Within Europe, the translational condition is defined by a simple dichotomy: the (former) East and the (former) West. The (former) West functions as the original, always one step ahead, the (former) East as the translation, always one step behind.[10] Since this book is situated in between (former) East and (former) West, the question of translatability is of import here. Over a coffee at the now-endangered Kino Europa, Boris Buden advised me: 'You have to put yourself into question here [in Zagreb], because let us be frank about what we [interviewees] are to you. We are Native Informants'.[11] The point was that, as a researcher educated within the dominant cultural regimes of (former) Western academia, I am also implicated in this neo-imperialist discourse. The voice of the activist striving for emancipation in the (former) East is typically considered to be the testimony of a Native Informant, that is, a univocal representation of an entire social group, and as such it can be instrumentalized by the (former) West as a justification for interventionist

---

9    'The Big Mac Index,' *The Economist*, https://www.economist.com/content/big-mac-index, accessed 24 June 2018.

10   Buden, 'Rad i jezik nakon prevodivih društava: Kratko predavanje Stefana Nowotnyja i razgovor s Borisom Budenom.'

11   The Native Informant is the central figure in Gayatri Spivak's *A Critique of Post-Colonial Reason* and as such has been picked up by many postcolonial thinkers. Boris Buden and Dejan Kršić, interview by author, audio recorded interview, Kino Europa, 5 May 2018.

politics and military action.[12] The question becomes, then, how to avoid this assumption of translatability which would serve primitive accumulation and further centralization of Europe. To simply acknowledge the effects of a long history of colonial repression and infantilization would be a good start, but nowhere near enough. It also requires critiquing my own subjectivity and the discourse that sustains it.

In *Reconfiguring the Native Informant: Positionality in the Global Age* (2005), Shahnaz Khan attempted to 'rethink the relationship between researcher and informant' in order 'to produce an account that is neither orientalist nor apologetic and to work toward building transnational feminist [decolonial] solidarity' drawing on experience of her specific research on Pakistan's *zina* laws.[13] Khan distinguishes between at least three types of native informants: the native informant *over there* (the conventional native informant), the native informant *over here* (the researcher in the (former) West), and the reader. What makes interviewee, writer, and reader into native informants is the contribution their own frames of reference and layers of meaning, which simultaneously render complete understanding of the other impossible and create space for creating of new knowledges. This differentiated understanding of the native informant allows for a transgression of the 'imagined monolithic and homogeneous Other', to borrow

---

12 This problematic conception of the native informant is unpacked in Sharareh Frouzesh, 'The Politics of Appropriation: Writing, Responsibility, and the Specter of the Native Informant,' *The Yearbook of Comparative Literature*, vol. 57 (2011), 252-268.

13 Shahnaz Khan, 'Reconfiguring the Native Informant: Positionality in the Global Age,' *Signs*, vol. 30, no. 4 (Summer 2005), 2018-2028.

Sharareh Frouzesh's words.[14] Instead, a gathering of native informants with different local experiences may constitute a differentiated (in the most direct sense of the word) translocal perspective, a 'moving base', with a privileged insight in global regimes of power and how they play out locally.[15] It is with this understanding of native informing that I hope to, in Sarat Maharaj's words, 'recode the international' while taking into account 'the untranslatability of the term other'.[16]

This is certainly not an easy balancing act. For there should be some caution with regard to the naïve optimism about alter-globalism that arguably characterized critical discourses in the 1990's. During a talk at Galerija Nova a few days after our coffee, Buden explained how the global economic crises and 'migrant crisis' have impacted the way we look at societies and their material borders. We no longer live in the translational condition of incessantly fluid borders. A renewed call for walls and borders is supposed to soothe the sense of crises initiated by waves Middle Eastern migrants, floods of cheap low-quality products from Asian countries, and streams aggressive investors from the U.S. Therefore, the condition we live in is not a simply globalized and translatable one (although it's not de-globalized either). Throughout Europe, the general discourse regarding moving bodies has radically altered,

---

14    Sharareh Frouzesh, 'The Politics of Appropriation: Writing, Responsibility, and the Specter of the Native Informant,' *The Yearbook of Comparative Literature*, vol. 57 (2011), 253.

15    'Moving base' is a term employed by Spivak in *A Critique of Postcolonial Reason* to define the positional-methodological space for transnational examination of the vanishing present. Spivak, *A Critique of Postcolonial Reason*, x.

16    Sarat Maharaj, 'Perfidious Fidelity: The Untranslatability of the Other,' in *Global Visions: Towards a New Internationalism in the Arts*, Jean Fisher, ed. (London: Kala Press and the Institute of International Visual Arts, 1994), 28.

and we find ourselves in a *transitional* condition.[17] Even though the globalization of capital continues as Google offers readymade meaning carried over by automated translation with incessant ease and new world powers have risen to challenge the lasting hegemony of the US in its own language, national languages and identities in the transitional condition are reinforced by strictly redrawing (time and again) the borders of nation state territories. In other words, the demand of translatability of commodities – whether it is the translation of any good into any currency or the word of any language into its English equivalent – continues to exist, but the absolute untranslatablity of identities is continuously set against it – a magic spell to neutralize the frustrations of globalization. Every country becomes a tectonic plate of socio-cultural unity: better to stay on the safe, homogenous middle ground than on the dangerous edges. This tendency has been going on for a while now and, as a result, the average European citizen speaks only two languages: the national mother tongue and English.[18] Therefore, Buden asserts that transition has led to a change in the general condition of language. The new condition no longer presumes complete commensurability, but entails what he calls a *revernacularization*.[19] Hence, once again, national borders are becoming the explosive areas of direct confrontation with the Other.

---

17  Buden, 'Rad i jezik nakon prevodivih društava,' 25 May 2018.

18  Boris Buden, 'Translation after History: On Revernacularization of National Languages,' *The Future of the Humanities and Anthropological Difference: Beyond the Modern Regime of Translation*, Cornell University, 10 July 2016, New York, https://vimeo.com/174556290.

19  Buden, 'Translation after History.' Buden borrows this term from the German linguist and philologist Jürgen Trabant.

Thus, by the simultaneous regimes of globalization and revernacularization, the dangerous image of the wide and heterogeneous world is effectively reduced to a single, all-encompassing (global) market divided into neat little homogenous compartments (countries). Rather than in an age characterized simply by globalization, we live in a time of vernacularized globalism. To recode the international would be to subvert this dual hegemony of, on the one hand, clannish language of neoconservative nationalism, and the commensurable language of neo-imperialist reason on the other – in the context of the unspeakable traumas of war and migration.

## FROM AUTONOMY TO INDEPENDENCE

Written from the position of a semi-outsider to the scene, I would also like to see my research as a contribution to the destabilizing of both unproblematically commensurable and unquestionably vernacular linguistic practices. Especially when it comes to locally applied yet internationally relevant terms such as independent culture, the embrace of the complex and always problematic possibilities of translation combined with critical internationalism offers the possibility to break open entrenched debates and to formulate common futurologies anew.

The discourse of independence in culture is one of those with the ability to break open entrenched debates. In the process of translation of the every-day Croatian term 'nezavisna kultura' to English by a Dutch-speaking person, I reconstructed its 'native' meaning, which was, of course, a pre-failed attempt. The translation necessarily lost the effortless, self-evident nuances inherent to the collective political and cultural

consciousness of the Croatian historical trajectory. But at the same time, the act of translation reinvented ways of expression to recapture these nuances – only to end up with new inventions, new meanings, rather than the forever-lost original. This, then, is the status of the word in the time of technical translatability: caught in limbo between absolute commensurability and absolute incommensurability, ridden of the aura of originality. But beyond the re-vernacularized mind-set, beyond the totalities of clannish and commensurable language, beyond the myth of original meaning, and beyond the fear of the monolithic Other, the realm of the untranslatable opens up as one of possibilities rather than loss. Exactly in the very untranslatability of the term independent culture, in the ways in which the term refuses to uncover its fundamental meaning to the outsider, the word 'independence' becomes a crystal of significance and a catalyst of meaning-making towards a theory of independent culture.

One of my biggest limitations is my inability to speak Croatian, which leaves myself, the interviewees, and the produced book unable to escape the hegemony of the English language.[20] My use of the word 'independent cultures' is therefore something very different yet also really the same as when used by the native informant *over there*. It refers to the same material condition but implies different cultural connotations. In the Netherlands, discussion of the dependence-independence pair belongs to political theory much more than to cultural discourse. My peers in Amsterdam (and probably in London, Paris, and Berlin), still under the spell of Frankfurt school critical theory or in some cases the Italian autonomists,

20   During the research and writing process, I have started learning Croatian, but my proficiency is nowhere close to mastering all seven conjugations and a good part of the Slavic vocabulary yet.

would much rather speak of autonomy-engagement. Why do these differences in discourse exist? Are these simply (former) Western European and (former) Central-Eastern European versions of the same discussion, or is there something else going on? It could very well be associated with the general tendency in the former West to disqualify avant-gardes under socialism for their lack of autonomy, or with the lasting influence of Soros's 'open society'-discourse and its promotion of independent media and culture, but this I do not know for sure. In any case, I do insist that the intervention of the term 'independence' into the autonomy-engagement couple allows for an important re-evaluation of the entrenched debate on the possibility of critical culture under neoliberalism. In order to effectively do so, however, a further consideration of independence is required, this time departing from concepts rather than practice.

# The Problem of Formalism

SOVEREIGNTY

The definition of independence could be pursued as formal self-determination. In this definition, independence equals the complete absence of dependence. This is intuitively the most 'direct' meaning of independence, and maybe the most deceptive. It is both passive and negative: it refers to a systemic position in pre-given material structures. Designed to function as a demarcation principle, delineating everything that independence cannot ever be, namely dependence, formal independence is as exclusive as it is static. It can only describe a situation of absolute power of self-determination, which is always-already and completely outside of the realm of dependency.

There is a simple historical reason for this intuitive interpretation. The application of the formal notion of independence to media is commonplace. Also, 'independent culture' emerged as the cultural antipode of 'independent media' in Croatia's autonomist circles of the tactical media scene. So, it could easily be concluded that, like in media, independence in culture implies: integrity; transparency about incomes and spending; party-political impartiality; absence of bias and (self-) censorship; the goal to be an uncompromising and corrective mirror to society. Even though the values behind this idea are relatively unproblematic, it is

unlikely that this idea of independence as a pillar of a 'healthy' democratic society is as applicable to culture as it is to media. Yet, theoretically, formal independence suggests something more than a correlation between independent media and independent culture. With its references to the function of culture in democratic and 'open' societies, this notion of independence invokes the discourse of liberal political theory proper and the philosophy of freedom associated with it.

Now, in Westphalian political theory, of which liberal political theory is a part, independence is often considered to be the condition resulting from *sovereignty*. Sovereignty is in turn defined as supreme (legal) power – the only power which is not derived from a higher power. This independence-sovereignty pair was an invention of generations of political experts translating theology into secular concepts, in order to transfer absolute power from God to the sovereign rule of nation-states, whether that be monarchies or republics.[21] Within this secularized theological order, independence has little meaning unless the proclaimer of sovereignty has the power to force others (in power) to recognize and believe in it. Moreover, since the secular has come to equal the marketized in late capitalism, sovereignty exists only as the equilibrium between two possibly conflictual entities, both choosing to acknowledge each other's sovereignty in order to avoid costly conflict and to promote trade.

The problem of applying this formal concept of independence to culture, the equating of independence

---

21  Foundational books on sovereignty in political theory from early to late modernity include: Jean Bodin, 'De la souveraineté,' in *Les six livres de la République* (Paris: Scientia, 1567), Thomas Hobbes, *Leviathan* (1651), the works by Jean-Jacques Rousseau, Carl Schmitt, *Politische Theologie: Vier Kapitel zur Lehre von der Souveränität* (München & Leipzig: 1922).

with the exercise of sovereignty is evident. Some entities, such as the global financial markets or tech companies, might be sovereign today. But even the sovereignty of nation-states is crumbling due to incessant globalization – the panic-stricken reactions to which we witness today throughout Europe: Brexit, cultural conservatism, the 'Eastern European crisis', and rising autocracy. In this context, independent media are under heavy pressure and the idea of sovereign culture seems wishful thinking, to say the least. All cultural production is dependent upon factors determined by power structures which are external to the realm of cultural production, and which can never reasonably be expected to become internal: the presence or absence of private money, the presence or absence of public money, the possibility or impossibility of contribution of unpaid labor, etc. In this sense, critical cultural production simply lacks the position of power to have its claims of sovereignty met with acknowledgement. So, if independence is the condition resulting from the exercise of sovereignty, the closest thing to independent culture is culture that works in line with the dominant ideas of the still-mostly-sovereign nation-state it functions within. In other words, if independence follows from sovereignty, critical independent culture does not exist today.

## ENTREPRENEURIAL FREEDOM

One might object to the idea of absolute sovereignty, arguing for the possibility of partial or individual sovereignty of cultural workers. It is true that artists might work in their free time, independent of the monetary economy; that digital curation practices can be sustained by independent crypto-mining; independent publications by crowd-funding campaigns; community

festivals by the sales of coffees and sandwiches; and social design documentaries by pay-what-you-want donations and sustainable merchandise. But even though these may be wonderful types of independence temporarily, defining personal or partial independence without questioning the framework of sovereignty inherent to the globalized and neoliberalized condition of today, is a losing battle. The reason for this is simple: the freedom to build something at one's own initiative, power, and risk, independently from any external actor, depends on the myth of magical volunteerism.
It's American Dreaming.

The idea at the basis of this dream, which is the idea of the absolute freedom derived from sovereign creation of the self (the self as first cause), still always sub-ordinated to a divine or moral Cause, is what Julia Kristeva called *entrepreneurial freedom.* Kristeva explains the concept in a technically complicated, yet striking way:

> […] in a society more and more dominated by technique, freedom thus conceived progressively becomes a capacity to adapt to a "cause" always exterior to the "self". […] Little by little, this productivist causality becomes less and less moral, and more and more economic, to the point that it reaches its proper saturation, it brings the necessity of a support through its symmetrical guarantee that is the moral and/or spiritual causality. In this order, freedom appears as a freedom to adapt itself to the logic of causes and effects: to the logic of production, of science, and of economy, itself supported by the interdicts of moral reason. The logic of globalization and that of liberalism are the outcome of this freedom, in which you are free … enclosing you in the process

of causes-effects in search of goods, and/or of the supreme Good. The supreme cause (God) and the technical cause (Dollar) end up appearing as the two variants that sustain the functioning of our freedoms within this logic.[22]

As it functions politically today, entrepreneurial freedom is the ability to try and to fail, to try again and fail better, and, maybe, to succeed at some point. (*Success*, of course, meaning nothing more or less than the approval of our divine cause called *Market*.) It is, in other words, the freedom to compete. This notion of entrepreneurial freedom is inherent to neoliberal logic and since the idea of independent cultures is, amongst other things, a product of neoliberalism, it has been used in independent cultures too. Entrepreneurially free independent culture is the wet dream of neoliberal power: individuated, fragmented, precarious, governable, harmless.

## THE OTHER FREEDOM

We know from practice that independent cultural organizations generally find more freedom in collaboration than in competition, and that, especially in the age of digital networks, subaltern voices *can* be heard. We also know that such a thing as criticality in culture still exists under regimes of suppression and instrumentalization. Examples are plenty and various. In 1980s Amsterdam, the housing situation was so poor that youths and students took to squatting en masse. They established the very vocal and resistant squatter movement to demand affordable housing, in the process saving the centuries-old inner city from deterioration

[22] Julia Kristeva, 'A Mediation, a Political Act, an Art of Living,' in *Psychoanalysis, Aesthetics, and Politics in the Work of Julia Kristeva*, eds. Kelly Oliver and S.K. Keltner (New York: SUNY Press, 2009), 23-24.

and demolition.[23] During the regime of Ferdinand Marcos in the Philippines, small independent publishers started spreading critical newspapers and exposés, establishing the so-called Mosquito Press. Similarly, in the Soviet Union, grassroots dissident publishing took place in *Samizdat*, a wide-spread underground network of writers, readers, publishers, and distributors who spread reading material amongst each other illegally. As Vladimir Bukovsky put it: 'Samizdat: I write it myself, edit it myself, censor it myself, publish it myself, distribute it myself, and spend jail time for it myself'.[24] Today, those types of critical cultural expression are often mediated by the internet. Inspired by memes of 'Nubian Queen' Alaa Salah, large crowds protested against 30 years of militarist rule on the streets of Khartoum in the spring and summer of 2019. Quite obviously, this freedom of the speaking subject is a type of freedom unaffected by the repression of political and market powers. If anything, the desire to be freed and to speak freely is stirred up by the threat of its own extinction.

Kristeva's topology of freedom accommodates for this non-entrepreneurial freedom. If, to Kristeva, entrepreneurial freedom is 'the instrumentalization of the speaking being', the other type of freedom is 'the being of the speech that is opened up': 'In desiring, [this freedom] gives itself, and in presenting itself thus as other to itself and to the other, freedom is freed. [...] It is a question of inscribing freedom in the essence of the speech of man as the immanence of

---

23   For a good account of the Dutch squatter movement, see Adilkno, *Cracking the Movement: Squatting Beyond the Media*, trans. Laura Martz (New York: Autonomedia, 1994).

24   Vladimir Bukovsky, *To Build a Castle: My Life as a Dissenter* (New York: Viking Press, 1979), 141.

infinite questioning'.[25] This other freedom, beyond entrepreneurship, let's call it emancipatory freedom, is closely related to the many faces of resistance. In a Foucauldian manner, it could be argued that emancipatory freedom comes into play when an individual states: 'I choose not to be subjected *like this.*'

*'Nubian Queen' Alaa Salah orating to a sea of cellphones in Khartoum, 12 April 2019. 'Soudan: Alaa Salah, le visage de lá revolution,' RTL France, 12 April 2019, https://www.rtl.fr/ actu/international/soudan-alaa-salah-le-visage-de-la-revolution-7797417372.*

This does not mean that freedom of infinite questioning is the endless whining about the inevitable deterioration of everything usually displayed by reactionaries. On the contrary, the previous examples show that the freedom of opening up space is resistance against the non-communicability of the impartible Other. To cite Kristeva once more, resistant and emancipatory freedom

25   Kristeva, 'A Mediation, a Political Act, an Art of Living,' 24.

is based on the human endeavor of empathy and 'the radical experiences of sharing the unsharable [*de partage de l'impartageable*]'.[26]

While on this tour through French critical theory, it is worth making a quick stop at the work of surrealist novelist-philosopher George Bataille. While I went to some length to reject the use of the notion sovereignty, as it is commonly understood, to theorize independence in culture because of the political theoretical framework implied in that notion, Bataille's work offers an understanding of sovereignty which is more apt to the theorization of emancipatory freedom, therefore more helpful to a theory of independent culture. To him, sovereignty is 'to enjoy the present time without having anything else in view but this present time'.[27] Thus, strikingly, Bataille thinks of sovereignty as a phenomenon entirely unconnected to administrative or legal issues and, more importantly, one entirely distinct from utilitarian or market reason. This sovereignty exists in the moment of direct act upon desire, in the moment of unknowing. Think of shamelessly eating that whole bar of chocolate, or of the sovereign surrealist art of automatic writing. Also, think of the cases of emancipatory freedom discussed above. Squatting the Amsterdam canal houses or meming the Nubian queen has not primarily been an act of utilitarian reason – even though it's had its effects. In the first place, it was an act upon desire: the desire for shelter and feel at home; the desire to shout out and express one's opinion; the desire to be the multitude and celebrate freedom in commonality.

26   Kristeva, 'A Mediation, a Political Act, an Art of Living,' 25.

27   George Bataille, 'Sovereignty,' *The Accursed Share*, vol 3. (New York: Zone Books, 1988 (1949)), 199.

While Bataille's sovereignty is an individual matter, emancipation goes a step further: through individual sovereignty, a common claim to reality is established. By the individual act of speech aimed at sharing the unshareable, common desires, hopes, fantasies, knowledges and values are recalibrated. New ways of looking at past, present and future can be imagined outside of the technical cause (Dollar). So, even if resistance begins with the individual, emancipatory freedom is a collective matter that requires common agency. Is it possible to theorize this mediation of individual sovereignty and collective emancipation in today's cultural praxis?

# The Aesthetics of Independence

Slavoj Žižek once said that because of Rancière's 'passionate advocacy of the aesthetic dimension as inherent in the political […] his thought today is more actual than ever: in our time of disorientation of the Left, his writings offer one of the few consistent conceptualizations of *how we are to continue to resist*'.[28] Rancière's work is diverse, covering topics ranging from ideology to student protests and from theatre to the crisis of democracy, but it is always concerned with a 'cartography of a common world' created by means of excavation of the regimes of the distribution of the sensible.[29] Rancière defined this distribution of the sensible as 'the system of self-evident facts of sense perception that simultaneously discloses the existence of something in common and the delimitations that define the respective parts and positions within it'.[30] In other words, it is the aesthetic-political process by which regimes of power make visible and invisible, audible and inaudible, tangible and intangible, thinkable and unthinkable. If the question of emancipatory freedom is one of perception and speech, of what is speakable and

---

28    Slavoj Žižek, 'The Lesson of Rancière,' in Jacques Rancière, *The Politics of Aesthetics*, Gabriel Rockhill, ed. and trans. (New York: Bloomsbury, 2004), 75.

29    Jacques Rancière, 'Time, Narration, Politics,' in Modern Times: Essays on Temporality in Art and Politics (Zagreb: Multimedia Institute, 2017), 12.

30    Jacques Rancière, *The Politics of Aesthetics: The Distribution of the Sensible*, trans. Gabriel Rockhill (New York: Continuum, 2004 (2000)), 7.

what unspeakable, an important lesson from Rancière would be that it is also a question of aesthetics.

Here, the possibility to theorize independence in culture beyond sovereignty and entrepreneurial freedom presents itself. The freedom in its independence relies on two things: first, independent political subjectivity; and, second, the aesthetic independence of collective (re)distribution of the sensible. As long as the cultural dominates the political, it will remain caught up with the bourgeois myth of autonomy, while the domination of the cultural by the political leads to the dead-end street of homogeneity and propaganda. Independent culture can therefore only exist when art and politics play with one another through independence.

The common practice of independent cultures, in being aesthetic in Rancière's sense, is not necessarily directly political, but always inherently of political consequence. It speaks about why this or that photograph is framed as it is, but also raises the question of why I always run into the same people in the city center of Zagreb, even though the city has a million inhabitants. Why are most of them invisible to me? The answer can be: because of gentrification and lack of mobility, but also: because of an 'aesthetics of the real'.[31] Aesthetics, in this sense, is not the discipline of beauty and ugliness. It talks about the regimes of distribution of the sensible and the agency of determining them. It talks about dependence and independence of perception. At stake is a communal independence, rather than an individual one, for regimes of distribution of the sensible are never structurally re-determined individually. What is it that brings

---

31   Nico Dockx and Pascal Gielen 'Introduction: Ideology & Aesthetics of the Real,' in *Commonism: A New Aesthetics of the Real* (Amsterdam: Valiz, 2018), 53-71.

some people together in the struggle for perception and articulation, while not including others?

To further elaborate how this aesthetic independence in culture functions, I must turn to aesthetics proper and address a question I have avoided up to now: what is the relation between independence and art in the Rancièrean notion of aesthetics that I am using?

Rancière has traced three major regimes of distribution of the sensible in Western history: the ethical, the representative, and the aesthetic regimes. In the ethical regime, which Rancière traces back to Plato's *The Republic,* all images ought to be concerned with the ideal forms in such a way that they would serve the ethical development of the community. The representative regime, which became dominant in the 17th and 18th centuries as the liberal arts were separated from the mechanical arts, foregrounded the ideals of mimesis and liveliness: the codification of expressions of thoughts or feelings in art, such that art was so real that it could give make insightful human nature. The aesthetic regime, which came into dominance when the representative regime broke down during the revolutions of the late 18th century, and the clear distinction and hierarchy between the different arts broke down too, and instead postulated art as a privileged category of its own in which pure form and everyday worldliness belong together.

Rancière has spent the better part of two decades tracing different regimes of distribution and their workings in an endless chain of essays. In this analysis, he restricts himself to the formal analysis of art works or media, so as to unveil the 'major forms' that 'bring forth

[...] figures of community equal to themselves'.³² For instance, he analyzed how the major form of the novel led to novelistic democracy, how Art Deco, Bauhaus and Constructivism created new forms for a new life through their handling of ornamentation and purity, and how the (re-)invention of perspective in Renaissance painting asserted the ability of painting to capture living speech.³³ In this vein, Rancière notes that:

> The important thing is that the question of the relationship between aesthetics and politics be raised at [...] the level of the sensible delimitation of what is common to the community, the forms of its visibility and of its organization. [...] The arts only ever lend to projects of domination or emancipation they are able to lend them, that is to say, quite simply, what they have in common with them: bodily positions and movements, functions of speech, the parceling out of the visible and the invisible.³⁴

It follows from this statement that the aesthetic politics of art can never be declarative. On the contrary, the meaning of the work of art is inherent to the sensible impact of the formal, perceptible qualities of the artwork on its observer (or on the community of observers it creates).

Some important theoretical tools to take Rancière's theory and apply it to the actual circuits of cultural production and distribution were created by Boris Groys

---

32   Rancière, *The Politics of Aesthetics*, 12.

33   Rancière, *The Politics of Aesthetics*, 9-10.

34   Rancière, *The Politics of Aesthetics*, 13-14.

and Claire Bishop. Even though this debate is pretty well-known today, it deserves a closer look.

Under the current aesthetic regime, according to Rancière, art is conceived of as the collection fo (possibly ephemeral) objects ought to deliver aesthetic experience to their observers, or to ostensibly fail delivering such aesthetic experience, thereby delivering anti-aesthetic experience. In this sense, the conception of art under the aesthetic regime as described by Rancière is formalist. In his book *Going Public* (2010), Boris Groys launched an avid critique against this formalist art concept of the aesthetic regime. A cultural theoretician subjectivized in the circuits of the Russian samizdat and Moscow Conceptualists, Groys grew tired of aesthetic theory's focus on the consumer or spectator. As Groys says, this focus has been dominant ever since since it emerged during the Enlightenment, simply because there are always more spectators than artists.

Groys reversed this question, and instead of asking why the public should consume art, he inquires: why does the artist create art? He rightly remarks that the work of art is not the natural and therefore inexplicable product of a genius, but a product of technical and political decisions by the maker. Therefore, he argues, 'the politics of art has to do less with its impact on the spectator than with the decisions that lead to its emergence in the first place'.[35] Consequently, in order to study the politics of art, one should start before the art work, which is impossible for aesthetics. So, to replace aesthetics altogether, Groys argues for a *poetic* view of art, which focuses on the creation of art as autopoietic practice: the self-creation of

---

35    Boris Groys, 'Introduction: Poetics vs. Aesthetics,' in *Going Public* (Berlin and New York: Sternberg Press and e-flux, 2010), 15.

the artist as public persona. 'In fact,' Groys states, 'there is a much longer tradition of understanding art as poiesis or techné than as aesthetis or in terms of hermeneutics. The shift from a poetic, technical understanding of art to aesthetic or hermeneutical analysis was relatively recent, and it is now time to reverse this change in perspective'.[36] Away with consumption-based analysis of art, towards production-based logic.

The resonance of Groys's critique is notable: every self-respecting critical art institution today prefers *poetics* over *aesthetics* in the titles of their exhibitions. As Rancière says, the politics of art are not (always) actively defined by the intention of the artist, to the extent that it is an object of aesthetic contemplation. But, Groys counters, neither are the politicity of the artwork or the artist defined exclusively by the way in which the formal qualities of the work can impact the spectator. The work was political from its very commencement, even if it never reached the stage of aesthetic product, because art also has politicity of active and intentional subjectivation through praxis – as does every action within the fabric of discourse. It follows that, in the exploration of the relation of independent culture, politics and art, the creation of independent culture as much as its consumption should be considered. The *techné* of independent cultural praxis is as important as its being-aesthetic.

There is, moreover, a second level to Groys's critique of aesthetic discourse. He argues that, since aesthetics subordinate art production to art consumption, they automatically equal art to real social relations and thereby subordinate art theory to sociology too. As Groys

---

36   Groys, 'Introduction: Poetics vs. Aesthetics,' 16.

rightly points out, artists of the historical avant-gardes acknowledged the social situatedness of art and sought to exert social effects through artistic practices. Groys identifies these tendencies as the roots of exactly those concepts that seek to conceptualize art in a way that will ultimately undermine it: avant-gardes such as Dada, the Surrealists, CoBrA, and the Situationist International always strived for the unity of art and life, and therefore for the end of art. Hence, the plethora of end-of-art-narratives that surrounded and explained modern art. But since the end of history happened to precede the end of art, and the result turned out to be far from utopian, the avant-gardes and their end-of-art-narratives are believed to have faded.

To Groys, sociology's theoretical enclosure of art in reality is problematic for two reasons. First, he argues, 'art was made before the emergence of capitalism and the art market, and will be made after they disappear. Art was also made during the modern era in places that were not capitalist and had no art market, such as the socialist countries'.[37] Second, 'art cannot be completely explained as a manifestation of "real" cultural and social milieus, because the milieus in which artworks emerge and circulate are also artificial. They consist of artistically created public personas – which, accordingly, are themselves artistic creations'.[38] This second level of Groys's critique is less convincing than his critique of consumption-focused analysis. Even though it is true that art has existed outside of capitalist regimes, this does not mean that art under capitalism should not be considered as such. Also, even if art is the product of artificial milieus, it's unclear why this artificiality would

37 Groys, 'Introduction: Poetics vs. Aesthetics,' 18.

38 Groys, 'Introduction: Poetics vs. Aesthetics,' 18.

somehow be unreal or non-real. The imagination of art, artists, and artist personas can transgress the status quo of dominant regimes, but there is no need to presuppose that (the inspiration for) art comes from outside reality.

While Groys traces back the subordination of art to sociology to the sociological attitudes of Dada and the Surrealists, the debate at hand here has relatively little to do with the historical avant-gardes. It is much better contextualized in the distinctly post-avant-garde trend that entered the art world in the 1990s and stayed there until today: the participatory art of the *social turn*. In the context of booming biennales, underpinned by theories like Nicolas Bourriaud's *Relational Aesthetics* (1998), the global art world has brought to fore the practices of artists like Rirkrit Tiravanija, Thomas Hirschhorn, Jeanne van Heeswijk, and the collectives Ruangrupa and Assemble: participatory, dialogic, communal, etc. In her seminal *Art Forum* essay 'The Social Turn: Collaboration and its Discontents' (2006), Claire Bishop described this phenomenon and avidly critiqued its discourse.

Just like Groys, Bishop disapproves of the sociological dominance over artistic practice. In her view, the discourse of the social turn tries to prove that the artworks it discusses are socially relevant with such dogmatism, that it reduces artists to ethical agents and forgets to acknowledge art *as art*. (On a side note, this conception of art as social tool which forgets art as art feeds directly into the neoliberal discourse that aims to instrumentalize culture for gentrification and other social projects.) However, rather than seeing this sociological dominance as an inherent result of the aesthetic regime, as Groys does, Bishop considers it to be a result of lack of aesthetic discourse. She argues that

'these practices are less interested in a relational *aesthetic* than in the creative rewards of collaborative activity'.[39] Those who really look at art as a social product and thereby subordinate art to sociology, have lost sight of its aesthetic potentials. This insight leads Bishop to a major contribution to the discourse:

> The emergence of criteria by which to judge social practices is not assisted by the present-day standoff between the nonbelievers (aesthetes who reject this work as marginal, misguided, and lacking artistic interest of any kind) and the believers (activists who reject aesthetic questions as synonymous with cultural hierarchy and the market). The former, at their most extreme, would condemn us to a world of irrelevant painting and sculpture, while the latter have a tendency to self-marginalize to the point of inadvertently reinforcing art's autonomy, and thereby preventing any productive rapprochement between art and life.[40]

The general misconception at the heart of this standoff is, as Bishop points out, that art's autonomy or heteronomy are mutually exclusive: the idea that autonomous production and engaged practice can never exist in the same work – you have to pick one or the other. Bishop argues that, yes, autonomy and heteronomy are opposed, but this doesn't mean that they are mutually exclusive. On the contrary, they are mutually dependent. According to Bishop, this is the exact contradiction in which art exists and which makes it lively. In reference to Rancière,

---

39   Claire Bishop, 'The Social Turn: Collaboration and its Discontents,' *Art Forum*, vol. 44, no. 6 (February 2006), 179.

40   Bishop, 'The Social Turn,' 180. This insight would later be the starting point for Bishop's seminal book *Artificial Hells* (2011).

she remarks that, under the aesthetic regime, we need the ability to think 'the productive contradiction of art's relationship to social change, characterized precisely by that tension between faith in art's autonomy and belief in art as inextricably bound to the promise of a better world to come. [...] The aesthetic doesn't need to be sacrificed at the altar of the social, as it already inherently contains this ameliorative promise'.[41] While social impacts cannot be all-encompassing measuring tools of art, it remains true that, as Rancière remarked: 'Art does not exist in itself; it is an outcome of a complex set of relationships between what one is allowed to say, to perceive, and to understand. Events and objects only exist within the fabric of discourse, and are perceived as art, or a revolution in art, only within this fabric'.[42] Even without the regimes of ethical responsibility, art is always-already inherently political because of its sensible agency.

As the distinction between art and reality thus fades, and the barrier between poiesis and the real as well, it appears that a technical-poetic view of art is not necessarily opposed to the aesthetic one. Rather, hermeneutic analysis of distribution of the sensible and the understanding of art as techné complement one another. Hence, the challenge that follows is this: to stick to the benefits of hermeneutic analysis offered by aesthetics, to add to that consideration of the creative process and techné, and to avoid formalism and consumption-based logic. With this insight, at last, we return to the relevance of independence in the debate. Analysis of independence in independent cultures

---

41    Bishop, 'The Social Turn,' 183.

42    Duncan Thomas, 'The Politics of Art: An Interview with Jacques Rancière,' *Verso*, 9 November 2015, https://www.versobooks.com/blogs/2320-the-politics-of-art-an-interview-with-jacques-ranciere.

under the aesthetic regime can help to break open the entrenched debates on autonomy, because independence is a way of thinking the contradiction between autonomy and engagement.

To go further into this, it's time to go back to the practices of independent cultures and look at them more closely. So, where to look? Where does independent culture take place?

# A Theory of the Scene

Distribution of the sensible is manifest in the *arrangements of partaking*, according to Rancière. That is to say, regimes of distribution of the sensible function through the simultaneous constitution of parts (based on spaces, times, and forms of activity) within a common unity. In the case of independent cultures, the scene is the common unity in which partaking is arranged. If independent cultures constitute a community engaging in the practice of mapping, understanding, and transforming the common world, the scene is the lived context and the discursive fabric in which this community exists. To cite Rancière once again, the scene is an embedded but independent mode of sensibility, which we can observe by analyzing the shifting community of independent cultures that engages actively with the distribution of the sensible, mapping 'a common world by determining forms of visibility of phenomena, forms of intelligibility of situations, and modes of identification of events and connections between events' and thereby 'determin[ing] the ways in which subjects occupy this common world, in terms of coexistence or exclusion, and the capacity of those subjects to perceive it, understand it and transform it'.[43] To look at and understand the independence of independent cultures, the scene should thus be examined.

---

43    Rancière, 'Time, Narration, Politics,' 12.

When he elaborated on his book *Aesthetis: Scenes from the Aesthetic Regime of Art* in an interview for Verso, Rancière explained that he understands scene as 'a general mode of intelligibility' that 'suspends the opposition between the narrative of the fact and its explanation'.[44] Through this suspension, the scene effaces the distinction between illustration and theory, being both a locus and a mode of praxis. Even though Rancière's conception of the scene refers to theatrical scenes more than to social unities, it is remarkably applicable to the independent cultural scene. The scene of independent culture is a general mode of intelligibility which includes and excludes actors. It shapes the community as an embedded, sensible coexistence. By shaping itself in the scene and coming into existence through the scene, independent culture articulates its independence.

The notion of the scene has a wild history before becoming a classification of choice to the communities of critical practice in Zagreb in the 1990s. The English word 'scene' is derived from ancient Greek *skènè* (meaning 'tent', 'hut', or 'shelter providing shade'), which initially referred to the theater house in the back of the stage in Greek theatre and later also to the wooden stage itself. Unlike the casual entertainment business of today's theatre, the comedies and tragedies of Athenian theatre were yearly ritualistic happenings in the religious festival to honor Bacchus. The skènè was then the décor in the context of which actors engaged in collective practices based on systemic functions and roles in the social, political, and religious life of the City State. Moreover, besides being social, religious, and entertaining, these roles were also antagonistic, for the ancient Greek theatre was the space

---

44   Thomas, 'The Politics of Art.'

where the ideal of *parrhesia* (free speech) was publicly displayed and propagated.

For instance, in Euripides' tragedy *The Phoenician Women* (c.411-409 B.C.), Oedipus' mother and wife Jocasta tries to convince her two (grand)sons not to wage war against each other over the inheritance of the throne. Jocasta asks the younger son Polyneices, who's been living in exile for a year: 'What is an exile's life? Is it great misery?' Polyneices replies: 'The greatest; worse in reality than in report.' 'Worse in what way,' Jocasta further enquires, 'What chiefly galls an exile's heart?' 'The worst is this: right of free speech does not exist,' Polyneices responds, to which Jocasta exclaims: 'That's a slave's life – to be forbidden to speak one's mind'.[45]

The speaking of one's mind which is at stake here, described by the Greeks as *parrhesia*, is defined by Michel Foucault as 'a verbal activity in which a speaker expresses his personal relationship to truth, and risks his life because he recognizes truth-telling as a duty to improve or help other people (as well as himself)'.[46] The figure of Socrates in the writing of Plato might be the best, or at least the best-known example of the parrhesiastes. Based on nothing but courage, virtuosity, and sense of duty, the parrhesiastes speaks truth to those who hold power over her or him, regardless of the

---

45 Euripides, *The Phoenician Women*, 411-409 B.C., as cited in Michel Foucault, 'Parrhesia in the Tragedies of Euripides,' second lecture of 'Discourse and Truth: the Problematization of Parrhesia', delivered between October and November 1983, at the University of California, Berkeley. This series of six lectures by Foucault in California in 1983 was dedicated entirely to the notion of parrhesia and the activity of speaking truth in the face of power, as it occurs in Greek tragedy and other texts from the Fifth Century BC to the Fifth Century AD.

46 Michel Foucault, 'The Meaning and Evolution of the Word "Parrhesia",' first lecture of 'Discourse and Truth: the Problematization of Parrhesia', delivered between October and November 1983, at the University of California, Berkeley.

harm they come to face as a consequence.[47] The ethical criterion of 'good art' so prominently present in Plato's aesthetic theory, according to Rancière signals the beginning of the ethical regime of art.

In parrhesiastic speech under the ethical regime, the ontological status of the spoken truth was not determined by some mental evidential experience. Instead, the truth of parrhesia lies in the very verbal activity, something that 'can no longer occur in our modern epistemological framework', i.e. something that is hardly thinkable since positivism has become the common way of establishing truth.[48] Yet, however hard to understand, judging from Greek theatre and philosophy, it appears that this always-necessarily *true activity* of parrhesia was thought to be a fundament of democracy. In the continuation of the conversation cited above, Polyneices makes it very clear that any ruler who claims who claims absolute power by denying his citizens the right to parrhesia, makes his citizens into slaves and himself into an idiot.

Now, of specific interest here is something Foucault did not pay too much attention to: the architectural space in which parrhesia took place as part of theatre's techné. The theatre constituted a common space for parrhesia between actors embodying power relationships in front of the public through the 'split reality of the theatre' (that's Rancière again).[49] The theatrical space of parrhesia was not a space of direct politics, but an

---

47 Michel Foucault, 'Discourse and Truth: the Problematization of Parrhesia', delivered between October and November 1983, at the University of California, Berkeley.

48 Michel Foucault, 'The Meaning and Evolution of the Word "Parrhesia".'

49 Rancière, *The Politics of Aesthetics*, 9.

*The skēne in an ancient Greek theatre.*

*Braco Dimitrijević,* Casual Passer-By I Met at 1.15 PM, 4.23 PM, 6.11 PM, Zagreb, 1971, *1971.*

image-space in which society presented itself to itself. The aesthetic-political function of the skènè within this presentation was exactly that of demarcating the split reality: the reality of the image and the reality of the world. It was simultaneously an entry point to the stage and a cover from the visibility of the stage, as well as the division between the spaces of theatre and of 'normal life'. Therefore, the skènè was the material boundary determining who was taking which part in the common activity of sensible presentation of society to itself, and who was not. So, when parrhesia occurred in theatre, the freedom of the speaking being was *staged*, as it was both engendered and restricted by the scene.

After a long absence from discourse, the notion of the skènè recurred in 16th century French scène, meaning a *specific part of a theatre play*. Then, in the 20th century, it took on different meanings in a variety of contexts, yet these had striking similarities on closer examination. The scene as a *site of crime* was first attested by Agatha Christie in 1923. In 1940s America, the word scene was frequently used by journalists to describe the *marginal and bohemian environment* associated with jazz.[50] A decade later, the scene came to denote a self-defined *setting or milieu for a specific group or activity* in America's Beat circles. Since, the word has been especially popular amongst music communities: in addition to Beat scenes, we've seen rock scenes, punk scenes, metal scenes, goth scenes, and indie scenes.

The consistent relation between the notion of the scene and the tradition of the performing arts – from Athenian

---

50  John Bealle, 'DIY Music and Scene Theory,' Revision of paper presented at the meetings of the Midwest Chapter of the Society for Ethnomusicology Cincinnati, Ohio, April 13, 2013, https://www.academia.edu/4406896/DIY_Music_and_Scene_Theory.

theater to American underground music – shows a strong convergence of scene with locality. A cultural activity is staged *on* the scene. An event has to take place at the right place (country, city, venue, studio) to be the real deal. But despite this system of street credibility, the 20th-century scene was not restricted to locality, nor was it necessarily underground or subcultural. The more successful scenes became so popular, that initial subcultures boiled over with exportable surplus production. Aspiring members in other cities started reproducing the scene that they liked, in order to establish a similar one in their own city. It helped that local scenes grew to be more translatable as they became more distinct from the mainstream, providing clearer criteria for the development of similar scenes elsewhere. Because of this, the scene came to mean a locality as well as a translocal phenomenon throughout and beyond America: *the* rock scene, *the* punk scene, *the* art scene, etc.

In this 20th-century meaning, the scene was still a space of freedom. Yet, since the ethical regime of art under which Greek theatre took place was replaced – first by the mimetic and later by the aesthetic regime – it was no longer primarily a space of speaking truth in the face of power. Rather, it was the space of autonomous and independent production and aesthetic practice, made possible by a distinctive position of relative marginality and (trans)local engagement. Scenes were the spaces where 'alternative cultures' could be independent unities, sometimes diverse and sometimes homogenous, as long as they retained their opposition to the mainstream industries. The marginal attitude of these musical scenes sometimes attracted – but, in many cases, already implied – transgressive attitudes on different levels: queer sexualities and genders, militant political

subjectivities, the cultivation of 'low life'. As such, the popular concept of the scene became a type of semi-open community, a buffer zone between pop- and subculture, and between hedonism and serious political action. Scenes became alternative mainstreams.

The phenomenon of the scene, designating (pseudo) transgressive communities with a strong attachment to locality, was at its height in the 1970s and 80s, but declined thereafter as quickly as it emerged. Today, Agatha Christie's definition of the crime scene still lingers around while the Beat definition seems hopelessly outdated. Indeed, the (trans)locally embedded scene is diametrically opposed to the contemporary cultural dominant of globalized network culture. Cultural expressions of the latter sort, mediated by platforms, social media, and other features of the internet, not to mention cheap air travel, are detached from geographical locality and strict social boundaries (or at least, that's the promise). In the 1990s, the internet seemed to create a possibility to have scenes that extended beyond any fixed locality. This was when online communities commenced and were recognized as scenes. Inspired by Hakim Bey's notion of the Temporary Autonomous Zone (TAZ), offline communities would sometimes start using digital networks to emerge in a guerilla space, dissolve before the authorities could catch up, and re-form elsewhere.

But, in early 2000s, the colonization of the internet by tech companies and nation-states started. As Jean Baudrillard remarked, 'the categorical imperative of communication' was instated through (digital) networks, giving rise to the obscene state of over-proximity in which we all know what our friends had for breakfast

thanks to Instagram and in which porn has overtaken sex.[51] Non-place and ex-timate relationships grew more and more important, weak links replaced strong links, the relation between scene and space was loosened, and, as a consequence, the scene itself largely disintegrated. The *screen* replaced the *scene*, Baudrillard concluded.[52]

## AFTER THE END OF THE LOCAL

What is the place to the scene and what is the role of locality now that culture went global? There is a general division between two camps with two very different answers.

On one hand, a common reaction on the left (certainly also in the art worlds) to these growing levels of abstraction and complexity has been a return to the local, the transparent, the human-sized. After the dot.com-bubble, the legacy of the TAZ was reduced to lol-fueled flash mobs and the Burning Man festival. If in the 90s, the internet held the promise of independence on several levels, the question of independence has become one of avoiding the web in today's age of Facebook, Amazon, and Instagram. There is no refuge in a return to the state either, since governments are enabling corporations more than culture or individuals. If not before, the implementation of Article 13 made this very clear: through this new copyright law, the European governments have enabled companies to survey and

---

51 Jean Baudrillard, *The Ecstasy of Communication* (Los Angeles: Semiotext(e), 2012), 30.

52 With the observation of this replacement, Baudrillard refers to his psychoanalytical claim that 'the schizophrenic can no longer produce himself as a mirror [...] He is now himself a pure screen embedded itself in a "influent" network'. Isabel Millar, 'Baudrillard: From the Self-Driving Car to the Ex-timacy of Communication?' *Everyday Analysis*, 24 February 2019, https://everydayanalysis.org/2019/02/24/baudrillard-from-the-self-driving-car-to-the-ex-timacy-of-communication/.

control individuals in ways that they could never do themselves.[53] Only on the local level, it seems, is it still possible to pose the localized left as a critical antipode of the renewed power of the family, the clan, and the Church.

Also, art under neoliberalism is reduced to an instrumental tool. Its three main functions are to serve as a catalyst for gentrification, to keep intact the identity of the nation-state, and to be a commensurable vehicle of capital in the abstract global markets. Autonomous cultural production is pushed into the corner of community work and localist autonomism. Not that this pushing is uncomfortable: in individualized societies and competition-driven art worlds, it feels nice to do something based on sense of community and solidarity once again. In this perspective, the return to the scene – and thereby to independence based on local social embedding – is a sensible reaction to the current condition.

On the other hand, the preference of locality over globality is vernacularizing. In the midst of globalizing neoliberalism, centralizing media, austerity measures, and climate crisis, to simply go back to perspectives of local independence seems all too easy. What happens in cases where locality is pursued like this? When does the reduction of abstract problems to locality lead to overlocalization? The first problem of overlocalization is that going local is not attainable to everyone. Not everyone can afford a 'digital detox', nor does everyone have the time or means to practice permaculture or

---

53  See Evelyn Austin's explication of Article 13 during the conference Urgent Publishing: New Strategies in Post-Truth Times, as I blogged about it on the website of the Institute of Network Cultures: http://networkcultures.org/makingpublic/2019/05/29/memes-as-means/.

to do community art. Locality is just one more filter bubble, and what's worse, it is mediated by privilege. It requires privilege to avoid social media and food packed in plastic. A second problem is a reduction of complex structural problems to individualized ethical-economic issues. 'Organic' is a profitable branding asset, selling to the consumer the choice to buy a better world. The social turn, too, is a prime example of overlocalization. Artistic production in the social turn is focused so much on local contextuality, that art itself has been reduced to social context. In the social turn, the role of locality has been reduced to a mere reactionary counterforce to globalization.

The book *Inventing the Future: Postcapitalism and a World Without Work,* by Nick Srnicek and Alex Williams, is an attempt to finally and definitively put the discussion of localism versus globalism/universalism to rest. In it, the authors identify phenomena like overlocalization on the political left as *folk politics*. They define folk politics as:
> A constellation of ideas and intuitions within the contemporary left that informs the common-sense ways of organising, acting, and thinking politics. […] At its heart, folk politics is the guiding intuition that immediacy is always better and often more authentic, with the collar being a deep suspicion of abstraction and mediation.[54]

According to Srnicek and Williams, underneath the desire for immediacy and resistance of abstraction, lies the human desire for freedom. But, as the authors claim, the only viable way to uphold any prospect of liberation is exactly by long-term organization and tactical

54  Nick Srnicek and Alex Williams, *Inventing the Future: Postcapitalism and a World Without Work* (New York & London: Verso, 2015), 9-10.

demands beyond folk politics. As discussed before while talking about commoning, micropolitics that fail to leap to macropolitics remains vernacular and will almost certainly be instrumentalized at some point.[55] This is why Srnicek and Williams categorically reject folk politics and instead propose another way to deal with the rising complexities of neoliberalism and globalization. The left, they argue, should bond and focus on two simple but universal demands: full automation of work funded by the state and universal basic income.

However nice as it might sound, the hope of automation as source of liberation held by Srnicek and Williams is also problematic. While they validly critique widespread techno-skepticism on the left, they fall into the trap of unbridled techno-optimism. Just imagine everyone having loads of free time and being liberated from family relationships as they exist now. What would happen to the world population? Where would all the recourses come from to feed all these mouths and to build the machines that should produce for them? Accelerationism, the school of thought in which Srnicek and Williams participate, simply brushes over the fact that full automation will deplete the earth in no-time. Also, what happens to the values of love and care in this scenario? Apart from that, accelerationism considers technology to be the neutral material that will create the condition

---

[55] Srnicek and Williams do not discuss commoning whatsoever. In his review of *Inventing the Future*, Joseph P. Moore states that Srnicek's and Williams's argument against wage labor 'ties in with the historical and ongoing popular struggles against the enclosure of the commons whose existence has enabled to resist being forced into wage labor. Surprisingly, Srnicek and Willams have little to say about those defensive battles, perhaps because their often rural and agrarian character does not fit so well with Srnicek's and Williams's high tech and urban-oriented political program and imaginary.' Joseph P. Moore, 'Nick Srnicek and Alex Williams *Inventing the Future: Postcapitalism and a World without Work*: Reviewed by Joseph P Moore,' *Marx and Philosophy*, 13 November 2016, https://marxandphilosophy.org.uk/reviews/8206_inventing-the-future-review-by-joseph-p-moore/.

for human freedom. But in the time of machine-learning dominated by algorithmic arrogance, there is no denying the social, cultural, and economical biases of technology. In many cases, technology is designed to solidify suppression rather than to lift it. Automated labor is a reality in Amazon distribution centers, where it combines a return to Fordist alienation with extreme precarity, and in the robot fields produced by Fanuc.

*A Fanuc-automated car factory. There are two humans in this picture. Can you spot them?*

*Inventing the Future* is thus not an economically, ecologically or even politically coherent manifesto, and its solutionism is probably overly utilitarian.[56] Still, I think that it is a good book, mainly in being a strong provocation addressing the lack to collective imagination caused by the fear of the black box of technology.

---

56  For instance, Jonny Elling's review in *The Oxonian Review* critiques Srnicek and Williams for overlooking theory of value, which allegedly leads to inconsistencies in their argumentation. Jonny Elling, 'Inventing the Future,' *The Oxonian Review*, 9 May 2016, https://www.oxonianreview.org/wp/inventing-the-future/.

Publications like *Inventing the Future* and its successor *The Accelerationist Manifesto* have brought to the table critiques of localism and techno-skepticism and increased the popularity of cybernetics and accelerationism. Thereby, Srnicek and Williams have contributed to the re-emancipation of a long-standing and theoretically rich tradition of imagination.

The most intriguing art to have dealt with automation and a world without, and for me the highlight of cybernetics up until today, is Constant Nieuwenhuys's *New Babylon* (1956-1969). Like the Russian Constructivists and the Lettrist International had done before him, the Dutch artist propagated the 'unity of the arts': the synthesis of painting, sculpture, architecture, poetry, philosophy, and psychoanalysis into the design of lived urban environment – and, ultimately, the synthesis of art and life.[57] He went about this grand idea with surprising pragmatism. With stainless steel, Perspex and bicycle spokes, Constant constructed scale models for collective living units without strict borders, which could be realized with materials available all around the world. He also made built environments and (détourned) geographical maps, drawings, paintings, tractates, lecture performances and a *New Babylon* newspaper.

When combined, the various immersive iterations of *New Babylon* provide a peek into a post-capitalist world

---

57  On the 'absolute unity of the arts,' see, Constant, 'From Collaboration to Absolute Unity Among the Plastic Arts,' trans. Robyn de Jong-Dalziel, *NOT BORED!*, accessed 27 June, 2019, http://www.notbored.org/absolute-unity.html. On the relationship between the Lettrist International and Russian Constructivism with Constant, see Laura Stamps, 'Constants New Babylon: Pushing the Zeitgeist to Its Limits,' in *Constant New Babylon: Aan ons de vrijheid,* eds. Els Brinkman, Sandra Darbé Laura Stamps and Hadewych van den Bossche, (Den Haag: Gemeentemuseum Den Haag and Hannibal, 2016), 12-27.

without work.[58] In this world, all labour is automated and takes place in large underground factories. Above these factories, the surface of the earth is filled with nature, monuments of the old world and a vast network of highways. Even higher, 16 metres above the surface, the real, lived space of *New Babylon* arises. A network of connected platforms of 50 to 100 acres called 'sectors' spreads all over the globe, creating lines that are connections rather than borders. As labour is superfluous, and every product for personal use can be accessed at any time and place, humans are no longer bound to specific geographical areas. In *New Babylon*'s superstructure, humankind is liberated from all duty, free to live their lives playfully, nomadically, and creatively.

Constant Nieuwenhuys, *Gele sector / Yellow Sector* of *New Babylon*. Collection Art Museum The Hague, photo by Tom Haartsen.

58 Constant, 'New Babylon,' *NOT BORED!*, accessed 27 June 2019, http://www.notbored.org/new-babylon.html.

Importantly, *New Babylon* never pretended to be a blueprint for the world to come, nor even a sociological experiment. Rather, it is a Leitmotiv for humankind at its most playful. In 1970 Constant wrote:

> New Babylon, perhaps, is not so much a picture of the future as a Leitmotiv, the conception of an all-comprehensive culture that is hard to comprehend because until now it could not exist, a culture that, for the first time in history, as a consequence of the automation of labor, becomes feasible although we do not yet know what shape it will take, and seems mysterious to us. Will man of the future be able to play his life?[59]

Humans in *New Babylon* do nothing but play. Constant argues: no freedom without creativity, and no creativity without playfulness. He dubbed the inhabitants of New Babylon *homines ludentes,* drawing on Johan Huizinga's book *Homo Ludens*.[60] But the play-notion at stake goes back way further.

To trace the tradition of thought from which Constant's idea stems, we have to go back to the very foundations of humanist aesthetics: the German Romantics. Friedrich Schiller's *Über die ästhetische Erziehung des Menschen in einer Reihe von Briefen (A Series of Letters on the Aesthetic Education of Man)* (1795), written in the aftermath of the French Revolution, sets out to establish the importance of free, aesthetic contemplation and Bildung to the functioning

---

59   Constant, 'New Babylon: The World of Homo Ludens,' *NOT BORED!*, accessed 28 June 2019, http://www.notbored.org/homo-ludens.html.

60   Johan Huizinga, *Homo Ludens: A Study of the Play-Element in Culture* (London: Routledge, 1944 (1938)).

of democratic societies.[61] According to Rancière, the *Aesthetic Letters* are the foundational theory of the aesthetic regime. Indeed, they are an avid plea for the ability of the aesthetic faculty to dialectically think the contradiction between engagement in the world and ethical thought free from the world.

To Schiller, aesthetics and beauty are the only way to overcome the gap between two fundamental yet opposing human drives that tear humanity apart: *Formtrieb* and *Sinnestrieb*. Formtrieb, or form drive, is the urge to change and to satisfy human lusts. It is the iconoclastic and revolutionary drive. Sinnestrieb, or sensual drive, is the urge to find universal moral claims. The object of Sinnestrieb is all that is material, the category of *life*, being-in-time. The object of Formtrieb is *form*, that is to say, all forms and formal relationships. Morality is the result of Formtrieb, while being-in-the-world and being-of-nature is the result of Sinnestrieb. If a person or system focuses solely on either drive, they neglect half of their own being-human and will ultimately lose control over themselves. Hence, reason must accept the double ontology of humankind, and demand that both drives must be served equally well in order to be truly humane. This desired synthesized experience of Sinnestrieb and Formtrieb, which Schiller calls *living form*, and in which humans are aware of both their physical being in time and moral being in freedom, can only be achieved once the domination of both drives is deflected and freedom is achieved.

The synthesis of Formtrieb and Sinnestrieb dialectically constitutes an entirely new drive, *Spieltrieb*. In the realm

---

[61] Friedrich Schiller, *On the Aesthetic Education of Man* (New York: Courier Corporation, 2012 (1795)).

of play, which is to Schiller entirely aesthetical, these drives are working together and prevent one another from dominating. Spieltrieb annuls time *within time* and renders humans free both morally and physically. If humans can only be fully human by serving both drives, and if this can only be achieved through independence towards both, and if this, in turn, is only possible in the realm of free aesthetic play, Schiller's thesis follows logically: 'man [sic] only plays when he is in the fullest sense of the word a human being, and *he is only fully a human being when he plays*'.[62]

What is interesting when comparing Schiller's notion of aesthetics to other foundational aesthetic theories, like those of Immanuel Kant or Edmund Burke, is that Schiller is not concerned with the human faculty of disinterested pleasure conceived through the experience of beauty or the sublime.[63] To Kant and Burke, aesthetics belongs to the realm of the senses and may simply remain there. Beauty and function are opposed and mutually exclusive. Those notions of disinterested pleasure led to the consumeristic notion of art pointed out by Boris Groys, in which spectators passively sit and wait to receive a dose of pleasant stimuli. But, in Schiller's view, aesthetics is a crucial mediator between ethical judgment and practical urges, exactly because it is a free realm belonging to the senses. It is never simply disinterested, but always mediating between disinterest and functionality.

---

62   Schiller, *On the Aesthetic Education of Man*, 58. Original italics.

63   The major works of aesthetic theories by these philosophers, which Schiller critiques, are Edmund Burke's *A Philosophical Enquiry into the Origin of Our Ideas of the Sublime and Beautiful* (1757) and Immanuel Kant's *Kritik der Urteilskraft* (1790).

Back to *New Babylon*. The point is not simply that New Babylonians play all the time (even though that is true), but that the vision of *New Babylon* allows for aesthetic contemplation and the imagination of life as play. In the end, *New Babylon* is not about political demands (although it could be used to formulate them), but about ways to imagine freedom. It is a humorous yet serious mind-game, always aware of its own status as a brainchild. The importance of cybernetics to this brainchild is that the embrace of technology and the promises of overproduction provide Constant with tools to think up a condition of material *independence*. Thanks to this hypothetical state of material independence, imagination is freed to perform aesthetic contemplation and thinking freedom (meaning here: thinking the contraction between heteronomy and autonomy). *New Babylon*'s striking quality is not so much its societal impact, but its aesthetic capacity to create complex constellations using cybernetics in a non-utilitarian way. Based on meticulous observations on the material condition of the world, this blurs the boundaries between fiction and reality, and thereby creates the possibility of sensing the world differently.

## TRANSVALUING THE TRANSLOCAL

Now, what does this tell us about independent culture, such as it takes place in the scene? Since Beat times, the scene has been a vehicle of translocality. As the production of local subcultures boiled over, providing exportable surplus value and the independence of entrepreneurial freedom, this local cultural surplus production was marketed and exported to the extent that scenes watered down and almost ceased existing altogether, except for those places where the cultural production remained vernacular and/or identitarian.

This leaves a bleak situation: allowing overproduction to be instrumentalized is not great, but to avoid translocality and remain vernacular is not a viable alternative. Then again, scenes happen to exist. People in urban contexts get together and create meaningful encounters, durable relations, and semi-porous social circuits of cultural production, regardless of any theoretical reflection. The question then becomes how to translocalize otherwise, without any overdetermination by the powers that be. How to transvalue local overproduction to recode the international?

I am convinced that avoiding overdetermination requires avoiding the dominance of sociological categories. The scene, after all, is not just a locus of praxis prone to commodification. It is also a general mode of intelligibility that effaces the distinction between illustration and theory. In a time in which they seemingly should not exist anymore, scenes seem to constitute some kind of outside category. I don't know whether they're retromorphs, anomalies, or wonders. I just know that they exist as places of independence between autonomy and engagement, and that they are important.

If there had to be any concluding determination, for it seems that a book needs a conclusion, this would be mine:

The scene is contraband smuggled into the digital age. In the folds and niches of globalized neoliberal power, it creates spaces for playful being otherwise. It is always on the brink of commodification, but never quite there. Just as Constant looked at the material circumstances of the world around him closely, in order to set himself free and think the contradiction between autonomy and

engagement, looking closely at today's world can set us free, so that we can playfully, independently transvalue the scene.

# BIBLIOGRAPHY

INTERVIEWS

Transcripts and/or audio recordings of the interviews can be provided by the author with consent of the interviewee(s).

Buden, Boris and Dejan Kršić. Former workers at Arkzin, designer at WHW/What, How and for Whom?, and theoretician at EIPCP/European Institute for Progressive Cultural Policies. Interview by author. Audio recorded interview. Kino Europa, Zagreb. 5 May 2018.

Buljević, Miljenka. Director at Kulturtreger and former worker at Operation:City. Interview by author. Audio recorded interview. Booksa, Zagreb. 14 March 2018.

Ćurlin, Ivet. Member of curatorial collective WHW/What, How and for Whom? Interview by author. Audio recorded interview. Galerija Nova, Zagreb. 25 May 2018.

Flajsig, Maja. Student of Art History at the University of Zagreb, worker at Galerija Nova and Booksa. Interview by author. Audio recorded interview. Kino Europa. 12 March 2018.

Fritz, Darko. Independent artists and director at Grey Area. Interview by author. Audio recorded interview. Darko Fritz's studio, Zagreb. 19 March 2018.

Jakšić, Jasna. Curator at the Museum of Contemporary Art, Zagreb. Interview by author. Audio recorded interview. Museum of Contemporary Art, Zagreb. 13 March 2018.

Kutleša, Ana and Ivana Hanaček. Members of curatorial collective BLOK. Interview by author. Audio recorded interview. BAZA, Zagreb. 11 May 2018.

Letinić, Antonija. Director at Kursiv. Interview by author. Audio recorded interview. Kursiv office, Zagreb. 3 April 2018.

Medak, Tomislav. Worker at Multimedia Institute and BADco., activist in Right to the City. Interview by author. Audio recorded Skype call. 29 March 2018.

Milat, Petar. Worker at Multimedia Institute, programmer at Human Rights Film Festival. Interview by author. Audio recorded interview. MAMA, Zagreb. 8 March 2018.

Ostoić, Sunčica and Olga Majcen Linn. Programme consultant and curator at Kontejner and librarians at the City Library of Zagreb. Audio recorded Skype call. 12 June 2019.

Pristaš, Goran Sergej. Worker at BADco. and lecturer at Centre for Drama Arts and Academy of Drama Arts. Interview by author. Audio recorded interview. Mali Café, Zagreb. 14 May 2018.

Šimičić, Darko. Researcher at the Tomislav Gotovac Institute. Interview by author. Audio recorded interview. Tomislav Gotovac Institute, Zagreb. 12 March 2018.

Tomašević, Tomislav and Lana Pukanić. Workers at Institute of Political Ecology and spokesperson/Mayoral candidate of Zagreb je NAŠ! Interview by author. Audio recorded interview. 9 May 2018.

Vene, Lea. Curator at Galerija Miroslav Kraljević and Organ Vida Festival. Interview by author. Audio recorded interview. GMK, Zagreb. 26 April 2018.

Vidović, Dea. Director at Kultura Nova. Interview by author. Audio recorded interview. Kultura Nova office, Zagreb. 9 April 2018.

Vukmir, Janka. Director at the Institute of Contemporary Art, Zagreb, and former director of the Soros Center for Contemporary Art, Zagreb. Interview by author. Audio recorded interview. Institute of Contemporary Art, Zagreb. 9 March 2018.

## LITERATURE

*Antiratna kampanja 1991.-2011.: Neispričana povijest.* Edited by Vesna Janković and Nikola Mokrović. Zagreb: Documenta – Centar za suočavanje s prošlošću, 2011.

Barada, Valerija, Jaka Primorac, and Edgar Buršić. *Osvajanje prostora rada: Uvjeti rada organizacija civilnog društva na području suvremene kulture i umjetnosti.* Zagreb: Biblioteka Kultura nova, 2016.

Bartulin, Nevenko. *The Racial Idea in the Independent State of Croatia: Origins and Theory.* London & Boston: Brill, 2014.

Bealle, John. 'DIY Music and Scene Theory.' Revision of paper presented at the meetings of the Midwest Chapter of the Society for Ethnomusicology Cincinnati, Ohio, April 13, 2013, https://www.academia.edu/4406896/DIY_Music_and_Scene_Theory.

Berardi, Franco 'Bifo'. *The Soul at Work: From Alienation to Autonomy.* Los Angeles, CA: Semiotext(e), 2009.

Bien, Joseph, and Heinz Paetzold. 'Praxis School.' *Cambridge Dictionary of Philosophy*, edited by Robert Audi, 731-732. Cambridge, MA: Cambridge UP, 1999. *Gale Virtual Reference Library*. http://link.galegroup.com/apps/doc/CX3450001234/GVRL?u=amst&sid=GVRL&xid=f25e1fba. Accessed 21 May 2018.

Bilić, Bojan, and Paul Stubbs. 'Unsettling "The Urban" in Post-Yugoslav Activisms: "Right to the City" and Pride Parades in Serbia and Croatia.' In *Urban Grassroots Movements in Central and Eastern Europe*, edited by Kerstin Jacobsson, 119-138. New York: Routledge, 2016.

Bjelić, Dušan, and Obrad Savić. *Balkan as Metaphor: Between Globalization and Fragmentation*. Cambridge, Mass., London: The MIT Press, 2002.

Boyadjiev, Luchezar. 'The Balkanization of *Alpha Europaea*.' In *Sweet Sixties: Spectres and Spirits of a Parallel Avant-garde,* edited by Georg Schöllhammer and Ruben Arevshatyan, 304-311. Berlin: Sternberg Press, 2013.

Boynik, Sezgin. 'New Collectives: Art Networks and Cultural Policies in Post-Yugoslav Spaces.' In *Retracing Images: Visual Culture after Yugoslavia*, edited by Daniel Suber and Slobodan Karamanić, 81-105. Boston and Leiden: Brill, 2012.

Brown, Wendy. 'American Nightmare: Neoliberalism, Neoconservatism, and De-Democratization.' *Political Theory,* vol. 34, no. 6 (December 2006), 690-714.

Buden, Boris. 'Children of Post-Communism.' In *Welcome to the Desert of Post-Socialism: Radical Politics after Yugoslavia,* edited by Srećko Horvat and Igor Štiks, 123-141. London and New York: Verso, 2015.

Buden, Boris. 'The post-Yugoslavian Condition of Institutional Critique: An Introduction on Critique as Countercultural Translation.' *European Institute for Progressive Cultural Policies*. November 2007. http://eipcp.net/transversal/0208/buden/en.

Buden, Boris. 'Translation after History: On Revernacularization of National Languages,' *The Future of the Humanities and Anthropological Difference: Beyond the Modern Regime of Translation,* Cornell University, 10 July 2016. New York, https://vimeo.com/174556290.

Car, Viktorija, and Ivana Andrijasevic. *Mapping Ditigal Media: Croatia*. London: Open Society Foundations, 2012.

Cavrić, Branko, and Zorica Nedović-Budić. 'Urban Development, Legislation, and Planning in Post-Socialist Zagreb.' In *The Post-Socialist City*, edited by Kiril Stalinov, 385-410. Dordrecht: Springer, 2007.

Celakoski, Teodor. 'Tactical Newtorking and Right to the City.' Conference paper. *Social Context Conference.* University of Copenhagen. 26 September 2013.

Celakoski, Teodor, Miljenka Buljević, Tomislav Medak, Emina Višnić, eds. *Open Institutions: Institutional Imagination and Cultural Public Sphere.* Zagreb: Alliance Operation City, 2011.

Constant, 'From Collaboration to Absolute Unity Among the Plastic Arts.' Translated by Robyn de Jong-Dalziel. *NOT BORED!* Accessed 27 June, 2019. http://www.notbored.org/absolute-unity.html.

Constant, 'New Babylon.' *NOT BORED!* Accessed 27 June 2019. http://www.notbored.org/new-babylon.html.

Constant, 'New Babylon: The World of Homo Ludens.' *NOT BORED!* Accessed 28 June 2019. http://www.notbored.org/homo-ludens.html.

'Croatian Intellectuals Unite to Oust Bandic From Zagreb.' *Balkan Insight*. 6 March 2017. http://www.balkaninsight.com/en/article/political-platform-fights-for-zagreb-s-depersonalisation-of-power-03-03-2017.

Dean, Jodi. *Crowds and Party.* London and New York: Verso, 2016.

Denegri, Ješa. 'Inside or Outside "Socialist Modernism?" Radical Views on the Yugoslav Art Scene 1950-1970.' In *Impossible Histories: Historical Avant-gardes, Neo-avant-gardes, and Post-avant-gardes in Yugoslavia, 1918-1991*, ed. Dubravka Djurić and Miško Suvaković, 170-208. Cambridge, Mass., London: The MIT Press, 2003.

Dedić, Nikola, and Aneta Stojnić. 'Interview with Jelena Vesić About Her Show *Political Practices of (Post-) Yugoslav Art: Restrospective 01*.' *ArtMargins Online.* 28 September 2012. http://www.artmargins.com/index.php/interviews-sp-837925570/687-interview-with-jelena-vesi-about-her-show-political-practices-of-post-yugoslav-art-retrospective-01.

Dević, Ana. 'Anti-War Initiatives and the Un-Making of Civic Identities in the Former Yugoslav Republics.' *Journal of Historical Sociology*, vol. 10, no. 2 (June 1997), 127-156.

Dević, Ana. 'Ethnonationalism, Politics, and the Intellectuals: The Case of Yugoslavia,' part of 'I: Disintegrating Multiethnic States and Reintegrating Nations: Two Essays on National and Business Cultures.' *International Journal of Politics, Culture and Society*, vol. 11, no. 3 (1998), 375-409.

Dević, Ana. 'Politicization of the Cultural Field: Possibilities of a Critical Practice.' *Život Umjetnosti*, no. 85 (2009), 16-33.

Dević, Ana. 'Reception of Modernism Within the Context of Croatian Art Since the 1950's.' *Apexart*. 2001. https://apexart.org/conference/devic.htm.

Dietachmair, Philipp. 'From Independent Cultural Work to Political Subjectivity: A Conversation with Tomislav Medak.' In *The Art of Civil Action: Political Space and Cultural Dissent,* edited by Philipp Dietachmair and Pascal Gielen, 207-230. Amsterdam: Valiz, 2017.

Dietachmair, Philipp and Pascal Gielen. 'Introduction: Public, Civil and Civic Spaces.' In *The Art of Civil Action: Political Space and Cultural Dissent,* edited by Philipp Dietachmair and Pascal Gielen, 11-33. Amsterdam: Valiz, 2017.

Dimitrijević, Braco. *Tractatus Post Historicus.* Extended version. Edited by Aaron Levy. Philadelphia: Slought Books, 2009 (1976).

Dimitrijević, Nena. *Gorgona: umjetnost kao nacin postojanja*. Exhibition catalogue. Zagreb: Gallery of Contemporary Art, 1977.

Djurasković, Stevo. *The Politics of History in Croatia and Slovakia in the 1990s.* Zagreb: Srednja Europa, 2016.
Djurić, Dubravka, and Misko Suvaković, eds. *Impossible Histories: Historical Avant-gardes, Neo-avant-gardes, and Post-avant-gardes in Yugoslavia, 1918-1991*. Cambridge, Mass., London: The MIT Press, 2003.

Dockx, Nico and Pascal Gielen. 'Introduction: Ideology & Aesthetics of the Real.' In *Commonism: A New Aesthetics of the Real,* edited by Nico Dockx and Pascal Gielen, 53-71. Amsterdam: Valiz, 2018.

Dojić, Zorana. *Political Practices of (Post) Yugoslav Art: Retrospective 01.* Belgrade: Museum of Contemporary Art Belgrade, 2010.

Dolenec, Danijela, Karin Doolan, Tomislav Tomašević. 'Contesting Neoliberal Urbanism on the European Semi-Periphery: The Right to the City Movement in Croatia.' *Europe-Asia Studies*, vol. 69, no. 9 (November 2017), 1401-1429.

Dovč, Dušan, Vesna Milosavljević, Jasna Soptrajanova, Dea Vidović, eds. *From Consideration to Commitment: Art in Critical Confrontation to Society (Belgrade, Ljubljana, Skopje, Zagreb: 1990-2010).* Belgrade, Zagreb, Skopje, Ljubljana: SEEcult.org, ForumSkopje, Kurziv, SCCA Ljubljana, Clubture, 2011.

Elling, Jonny. 'Inventing the Future.' *The Oxonian Review.* 9 May 2016. https://www.oxonianreview.org/wp/inventing-the-future/.

Esanu, Octavian. *The Transition of the Soros Centers to Contemporary Art: The Managed Avant-Garde.* Kiev: CCCK, 2008.

Federici, Silvia. 'Feminism and the Politics of the Commons.' *The Commoner.* http://www.commoner.org.uk/wp-content/uploads/2011/01/federici-feminism-and-the-politics-of-commons.pdf. Accessed 11 Mach 2019.

Fokus Grupa and Jasna Jakšić, eds. *Didactic Exhibition.* Zagreb & Rijeka: Fokus Grupa & Museum of Contemporary Art Zagreb, 2016.

Foucault, Michel. 'Discourse and Truth: The Problematization of Parrhesia.' Six lectures. University of California, Berkeley. October and November 1983.

Foucault, Michel. 'Nietzsche, Genealogy, History.' In *Language, Counter-Memory, Practice: Selected Essays and Interviews,* edited by D.F. Bouchard, 139-164. Ithaca: Cornell UP, 1977 (1971).

Fritz, Darko. 'A Brief Overview of Media Art in Croatia (Since 1960).' *Culturenet.* 18 December 2012. http://www.culturenet.hr/default.aspx?id=23391&pregled=1&datum=18.12.2008%209:43:18

Frousezh, Sharareh. 'The Politics of Appropriation: Writing, Responsibility, and the Specter of the Native Informant.' *The Yearbook of Comparative Literature,* vol. 57 (2011), 252-268.

Gielen, Pascal. *Repressief Liberalisme: Opstellen over creatieve arbeid, politiek en kunst.* Amsterdam: Valiz, 2013.

Gielen, Pascal, and Thijs Lijster. 'Civil Potency of a Singular Experience: On the Role of Cultural Organizations in Transnational Civil Undertakings.' In *The Art of Civil Action: Political Space and Cultural Dissent,* edited by Philipp Dietachmair and Pascal Gielen, 39-66. Amsterdam: Valiz, 2017.

Golub, Marko and Dejan Kršić. *Art is Not a Mirror, It Is a Hammer.* Zagreb: What, How & for Whom and Croatian Designers Association, 2016.

'Gorgona.' Museum of Avant-Garde. No date. Accessed 21 June 2016. http://www.avantgarde-museum.com/en/museum/collection/GORGONA~pe4511/#overlay.

Guzin Lukić, Nada. 'National Museums in Croatia.' *Building National Museums in Europe 1750-2010*. Conference proceedings from EuNaMus, European National Museums: Identity Politics, the Uses of the Past and the European Citizen, Bologna 28-30 April 2011. http://www.ep.liu.se/ecp_home/index.en.aspx?issue=064.

Hardt, Michael. 'The Common in Communism.' *Rethinking Marxism*, vol. 22, no. 3 (August 2010), 346-356.

Hegyi, Lorand, ed. *Aspects / Positions: 50 Years of Art in Central Europe 1949-1999*. Vienna: Museum Moderner Kunst Stiftung Ludwig Wien, 1999.

Henriksson, Minna. *Zagreb Notes* (2006). Drawing on wall, reproduced on paper 70 x 100 cm, and series of 60 photographs. http://minnahenriksson.com/wp-content/uploads/2012/05/zagreb-notes-original.jpg.

Hewitt, Nicole. *This Woman is Called Jasna* (2015). Lecture performance, performed at Sonic Acts Academy 2018, Amsterdam, https://vimeo.com/262744960.

Hoptman, Laura, and Tomáš Pospiszyl. *Primary Documents: A Sourcebook for Eastern and Central European Art Since the 1950s*. New York & Cambridge: MoMA & The MIT Press, 2002.

Horvat, Srećko, and Igor Štiks, eds. *Welcome to the Desert of Post-Socialism: Radical Politics after Yugoslavia*. London & New York: Verso, 2015.

Horvat, Srećko, and Igor Štiks. 'Introduction: Radical Politics in the Desert of Transition.' In *Welcome to the Desert of Post-Socialism: Radical Politics after Yugoslavia,* edited by Srećko Horvat and Igor Štiks, 1-20. London & New York: Verso, 2015.

Huizinga, Johan. *Homo Ludens: A Study of the Play-Element in Culture.* London: Routledge, 1944 (1938).

IRWIN, ed. East Art Map: Contemporary Art and Eastern Europe. New York: The MIT Press, 2006.

Jacobsson, Kerstin, ed. *Urban Grassroots Movements in Central and Eastern Europe.* New York: Routledge, 2016.

Jacobsson, Kerstin. 'The Development of Urban Movements in Central and Eastern Europe.' In *Urban Grassroots Movements in Central and Eastern Europe,* edited by Kerstin Jacobsson, 1-32. New York: Routledge, 2016.

Jacobsson, Kerstin, and Steven Saxonberg. 'Introduction: The Development of Social Movements in Central and Eastern Europe.' In *Beyond NGO-ization: The Development of Social Movements in Central and Eastern Europe,* edited by Kerstin Jacobsson and Steven Saxonberg, 1-25. New York: Ashgate, 2013.

Jakovina, Tvrtko. 'Historical Success of Schizophrenic State: Modernisation in Yugoslavia 1945-1974.' In *Socialism and Modernity: Art, Culture, Politics 1950-1974,* edited by Ljiljana Kolešnik, 7-44. Zagreb: Institute of Art History & Museum of Contemporary Art, 2012.

Jakovljević, Branislav. *Alienation Effects: Performance and Self-Management in Yugoslavia, 1945-91.* University of Michigan Press: Ann Arbor, 2016.

Jaksić, Jasna. 'Art on Tour: The Invention of the Audience.' In *Didactic Exhibition,* edited by Jasna Jaksić and Fokus Grupa, 5-11. Zagreb and Rijeka: Museum of Contemporary Art Zagreb and Fokus Grupa, 2016.

Janković, Vesna, and Nikola Mokrović. 'Arkzine Fact Sheet: Stages, Publicers, Formats, Supplements.' In *Prospects of Arkzin,* edited by Tomislav Medak and Petar Milat, 14-15. Zagreb: Arkzin & Multimedia Institute, 2013.

Jović, Dejan. *Yugoslavia: A State that Withered Away.* West Lafayette, Indiana: Purdue UP, 2009.

Katalenać, Juraj. 'Yugoslav Self-Management: Capitalism Under the Red Banner.' *Insurgent Notes: Journal of Communist Theory and Practice,* 5 October 2013, http://insurgentnotes.com/2013/10/yugoslav-self-management-capitalism-under-the-red-banner/.

Khan, Shahnaz. 'Reconfiguring the Native Informant: Positionality in the Global Age.' *Signs,* vol. 30, no. 4 (Summer 2005), 2017-2035.

Klütsch, Christoph. ''The Summer 1968 in London and Zagreb: Starting or End Point for Computer Art?'' *Proceedings of the 5$^{th}$ Creativity & Cognition Conference*, 109-117. London, 12-15 April 2005.

Kolešnik, Ljiljana. 'The Recent History of Art History in Croatia and the Crisis of Institutions Today.' *Život Umjetnosti,* no. 93 (2013), 4-19.

Komnenović, Dora . '(Out)living the War: Anti-War Activism in Croatia in the Early 1990s and Beyond.' *Journal on Ethnopolitics and Minority Issues in Europe,* vol. 13, no. 4 (2014), 111-128.

Kulić, Vladimir. 'An Avant-Garde Architecture for an Avant-Garde Socialism: Yugoslavia at EXPO '58.' *Journal of Contemporary History,* vol. 47, no. 1 (2012), 161-184.

Kutleša, Ana. 'Culture on the Market: The Gallery of Contemporary Art in the Early 1960's.' In *Didactic Exhibition,* edited by Fokus Grupa and Jasna Jaksić, 206-224. Zagreb and Rijeka: Museum of Contemporary Art Zagreb and Fokus Grupa, 2016.

Lorey, Isabell. 'Presentist Democracy: Reconceptualizing the Present.' In *The Documenta 14 Reader,* edited by Quinn Latimer and Adam Szymczyk, 169-202. Munich, London and New York: Prestel Verlag, 2017.

Lorey, Isabell. *State of Insecurity: Government of the Precarious (Futures).* Translated by Aileen Dereeg. Foreword by Judith Butler. New York and London: Verso, 2015 (2012).

Lovink, Geert and David Garcia. 'The ABC of Tactical Media.' *Subsol.* http://subsol.c3.hu/subsol_2/contributors2/garcia-lovinktext.html. Accessed 26 May 2018.

Lovink, Geert and Ned Rossiter. *Organization after Social Media.* New York: Minor Compositions, 2018.

Maharaj, Sarat. 'Perfidious Fidelity: The Untranslatability of the Other.' In *Global Visions: Towards a New Internationalism in the Arts,* edited by Jean Fisher, 28-35. London: Kala Press and the Institute of International Visual Arts, 1994.

'March for Life Starts in Zagreb.' *N1.* 19 May 2018. http://hr.n1info.com/a303506/English/NEWS/March-for-Life-starts-in-Zagreb.html.

Mazower, Mark. *The Balkans.* London: Weidenfeld & Nicolson, 2000.

Medak, Tomislav, and Petar Milat, eds. *Prospects of Arkzin.* Zagreb: Arkzin & Multimedia Institute, 2013.

Medosch, Armin. *Automation, Cybernation and the Art of New Tendencies (1961-1973).* Artistic Doctoral thesis. London: Goldsmiths University of London, 2012.

Meštrov, Ivana, and Mihaela Richter. 'Conversations – strategies for convergence with curatorial practices.' Conversations with Ivana Bago, Antonia Majaca, BLOK, Branko Franceschi, Iva Radmila, Janković, Kontejner, Leonida Kovač, Sandra Krizić Roban, Zvonko Makovic, Antun Maracic, Tihomir Milovac, Ana Peraica, Davorka Peric, Sabina Salamon, Branka Stipančić, Klaudio Štefančić, Marina Veculin, Janka Vukmir, WHW. *Život Umjetnosti,* no. 85 (2009), 66-188.

Mestrović, Matko. 'The Sixties: Sweet or Bitter?' In *Sweet Sixties: Spectres and Spirits of a Parallel Avant-garde,* edited by Georg Schöllhammer and Ruben Arevshatyan, 327-336. Berlin: Sternberg Press, 2013.

Moore, Joseph P. 'Nick Srnicek and Alex Williams Inventing the Future: Postcapitalism and a World without Work: Reviewed by Joseph P Moore.' *Marx and Philosophy.* 13 November 2016. https://marxandphilosophy.org.uk/reviews/8206_inventing-the-future-review-by-joseph-p-moore/.

Moulton, Aaron, and Geert Lovink, '"The Soros Center was a Perfect Machine": An Exchange between Aaron Moulton and Geert Lovink.' *ArtMargins Online.* 15 July 2019. https://artmargins.com/the-soros-center-was-a-perfect-machine-a-dialogue-between-aaron-moulton-and-geert-lovink/.

Mrakovčić, Matija. 'Channeling Anger and Depoliticizing Happiness.' *European Cultural Foundation: Connected Action for the Commons Archive.* 9 June 2016. http://politicalcritique.org/connected-action/2016/channelling-anger-and-depoliticizing-happiness/.

Mrakovčić, Matija. 'Croatia: An Interview with Alliance Operation City and Platform Upgrade.' *European Cultural Foundation: Connected Action for the Commons Archive.* 24 August 2016. http://politicalcritique.org/connected-action/2016/croatia-an-interview-with-alliance-operation-city-and-platform-upgrade/.

Mrakovčić, Matija. 'The Current State of Socio-Cultural Centers in Croatia.' *European Cultural Foundation: Connected Action for the Commons Archive.* 19 July 2016. http://politicalcritique.org/connected-action/2016/the-current-state-of-socio-cultural-centers-in-croatia/.

Nae, Christian. 'Rhetoric of Display: Curatorial Practice as Art History in Post-Communist Europe.' *Život Umjetnosti,* no. 93 (2013), 50-67.

Musabegović, Senadin. 'Tradition and Cultural Institutions in Bosnia and Herzegovina in the Jaws of Ethno-Nationalism and Neoliberalism.' *Život Umjetnosti,* no. 93 (2013), 23-35.

Peračić, Dinko, and Miranda Veljačić. 'Platforms: Cultural Centers of the Twenty-First Century.' Lecture at the Social Context conference, Copenhagen University, 26 September 2013. https://vimeo.com/87476937.

Pupovac, Ozren. 'Why is The Experience of Yugoslavia Important Today?' In *Sweet Sixties: Spectres and Spirits of a Parallel Avant-garde,* edited by Georg Schöllhammer and Ruben Arevshatyan, 481-496. Berlin: Sternberg Press, 2013.

Primorac, Jaka. 'The Position of Cultural Workers in Creative Industries: The Case of Croatia.' Paper presented at the Eight Mediterranean Social and Political Research Meeting, Florence & Montecantini Terme, 21-25 March 2007, Workshop 9: Mapping the Cultural Economy in the Euro-Mediterranean Region, jointly organised by the Mediterranean Programme of the Robert Schuman Centre for Advanced Studies and the European Cultural Foundation at the European University Institute. https://bib.irb.hr/datoteka/296021.Jaka_Primorac_Article_Florence_2007.pdf.

Rancière, Jacques. *Modern Times: Essays on Temporality in Art and Politics.* Zagreb: Multimedia Institute, 2017.
Rancière, Jacques. *The Emancipated Spectator.* Translated by Gregory Eliott. New York: Verso, 2009 (2008).
Rancière, Jacques. *The Politics of Aesthetics: The Distribution of the Sensible.* Translated by Gabriel Rockhill. New York: Continuum, 2004 (2000).

'Really Útil Confessions: A Conversation between Nick Aikens, Annie Fletcher, Alistair Hudson, Steven ten Thije, and What, How & for Whom/WHW.' In *What's the Use? Constellations of Art, History, and Knowledge: A Critical Reader*, edited by Nick Aikens, Thomas Lange, Jorinde Seijdel, and Steven ten Thije, 448-465. Amsterdam, Eindhoven and Hildesheim: Valiz, Van Abbemuseum, and Stiftung Universität Hildesheim, 2016.

'Repertorium: Praxis.' *Memory of the World*. 28 November 2014. https://www.memoryoftheworld.org/blog/2014/10/28/praxis-digitized/.

Robertson, Jason. 'The Life and Death of Yugoslav Socialism.' *Jacobin Magazine Online*. 17 July 2017. https://jacobinmag.com/2017/07/yugoslav-socialism-tito-self-management-serbia-balkans.

Rogoff, Irit. 'From Criticism to Critique to Criticality.' *European Institute for Progressive Cultural Policies*. January 2003. http://eipcp.net/transversal/0806/rogoff1/en.

Schiller, Friedrich. *On the Aesthetic Education of Man*, translated and introduced by Reginald Snell. New York: Courier Corporation, 2012 (1794).

Schöllhammer, Georg, and Ruben Arevshatyan. *Sweet Sixties: Spectres and Spirits of a Parallel Avant-Garde*. Berlin: Sternberg Press, 2013.

Schrag, Calvin O. 'Praxis.' *Cambridge Dictionary of Philosophy*, edited by Robert Audi, 731. Cambridge, MA: Cambridge UP, 1999. *Gale Virtual Reference Library*. http://link.galegroup.com/apps/doc/CX3450001234/GVRL?u=amst&sid=GVRL&xid=f25e1fba. Accessed 21 May 2018.

Spieker, Sven. 'Interview with WHW Collective (Zagreb).' *ArtMargins Online.* 5 July 2011. http://www.artmargins.com/index.php/5-interviews/635-interview-with-whw-collective-zagreb.

Srnicek, Nick, and Alex Williams. *Inventing the Future: Postcapitalism and a World Without Work.* New York & London: Verso, 2015.

Stalinov, Kiril. 'Taking Stock of Post-Socialist Urban Development: A Recapitulation.' In *The Post-Socialist City,* edited by Kiril Stalinov, 1-42. Dordrecht: Springer, 2007.

Stamps, Laura. 'Constant's New Babylon: Pushing the Zeitgeist to Its Limits.' In *Constant New Babylon: Aan ons de vrijheid,* edited by Els Brinkman, Sandra Darbé Laura Stamps and Hadewych van den Bossche, 12-27. Den Haag: Gemeentemuseum Den Haag and Hannibal, 2016.

Štefančić, Klaudio. 'New Media, New Networks.' Translated by Anita Kojundzić Smolčić. *Monoskop,* 2017 (2008), https://monoskop.org/images/c/c0/Stefancic_Klaudio_2008_2017_New_Media_New_Networks.pdf.

Stipančić, Branka. 'Ivan Kozaric: "Freedom is a Rare Bird".' *Afterall,* no. 31 (Spring 2010), 49-57.

Stubbs, Paul. 'Networks, Organisations, Movements: Narratives and Shapes of Three Waves of Activism in Croatia.' *Polemos,* vol. 15, no. 2 (2012), 11-32.

Stubbs, Paul. 'The ZaMir (For Peace) Network: From Transnational Social Movement to Croatian NGO.' http://bib.irb.hr/datoteka/233303.stubbs.pdf. Accessed 1 July 2018.

Susovski, Marijan, ed. *The New Art Practice in Yugoslavia 1966-1978*. Zagreb: Gallery of Contemporary Art, 1978.

*The Occupation Cookbook: Or the Model of Occupation of the Faculty of Humanities and Social Sciences in Zagreb.* Translated by Drago Markiša. London & New York: Minor Compositions, 2009.

'The Right to the City: Zagreb's Spatial Politics, recorded with Iva Marčetić in Zagreb.' *The Funambulist Podcast.* 1 October 2015. https://thefunambulist.net/podcast/iva-marcetic-the-right-to-the-city-zagrebs-spatial-politics.

Thomas, Duncan. 'The Politics of Art: An Interview with Jacques Rancière.' *Verso.* 9 November 2015. https://www.versobooks.com/blogs/2320-the-politics-of-art-an-interview-with-jacques-ranciere.

TkH [Walking Theory]. 'Yugoslavia: How Ideology Moved Our Collective Body.' *Vimeo.* 11 January 2016 (2013). https://vimeo.com/ondemand/yugoslavia.

'Trojanski konj u Varšavskoj.' *YouTube.* 10 February 2010. https://www.youtube.com/watch?v=hGtwScpvmQU&feature=youtu.be.

Vidović, Dea. 'Razvoj Hrvatske Nezavisne Kulturne Scene (1990.-2002.) Ili Sto Sve Prethodi Mrezi Clubture.' In *Clubture: Kultura kao proces razmjene 2002-2007,* edited by Dea Vidović, 13-29. Zagreb: Clubture, 2007.

Vidović, Dea. 'Summary: The Development of Emerging Cultures in the City of Zagreb (1990-2010).' Unpublished summary of a PhD-Thesis.

Vilić, Nebojša. 'Dissensual Regimes of History of Art.' *Život Umjetnosti,* no. 93 (2013), 68-83.

Visnić, Emina, ed. *Independent Culture and New Collaborative Practices in Croatia: A Bottom-Up Approach to Cultural Policy-Making.* Amsterdam, Bucharest, and Zagreb: Policies for Culture, 2008.

'Vlasti traže da se skvoteri isele iz napuštene zgrade u Zagrebu.' *Aljazeera Balkans.* 10 November 2018. http://balkans.aljazeera.net/video/vlasti-traze-da-se-skvoteri-isele-iz-napustene-zgrade-u-zagrebu.

What, How & for Whom. 'Paper at *The Creative Time Summit: Revolutions in Public Space.*' *New York City Library.* 24 October 2009. http://media.nypl.org/video/live_2009_10_24_creative_summit_day2_whw.mp4.

What, How & for Whom, Dóra Hegyi, Zsuzsa László, Magdalena Ziółkowska, Katarzyna Słoboda, new media center_kuda.org, eds. *Art Always Has Its Consequences.* Zagreb: What, How & for Whom/WHW, 2010.

Wood, Phil. 'Zagreb: Right to the City.' *Subversive Urbanism.* 12 April 2012. http://subversiveurbanism.tumblr.com/post/20976303350/zagreb-the-right-to-the-city.

Žižek, Slavoj. 'The Lesson of Rancière.' In Jacques Rancière, *The Politics of Aesthetics,* edited and translated by Gabriel Rockhill, 66-75. New York: Bloomsbury, 2004.

*Franjo Tudjman Airport, Zagreb.*

# ACKNOWLEDGMENTS: FROM AMSTERDAM TO ZAGREB, BACK, FORTH AND INBETWEEN

I first wrote the text of this book as a thesis for the rMA-program Art Studies at the University of Amsterdam. My supervisor, Prof. Dr. Christa-Maria Lerm Hayes, had recognized my interest in critical studies and practices in the arts years before my graduation and since encouraged me to look beyond the confinements of the art historical canon and the (former) West. Amongst the interests I thus developed was one in the Yugoslav (neo-) avant-gardes like Gorgona, the Group of Six Artists, and New Tendencies. In the summer of 2017, during a holiday on the Croatian coast, I decided to spend some days in Zagreb, going to the various museums and talking to cultural workers about my topics of interest. Who knows what unopened archival file or oeuvre of a long-dead artist I would find… It was idle hope, not least because I did not speak any Croatian. But the visit taught me something much more interesting and important. It taught me about a discursive notion with

a ground-breaking impact on my theoretical frame of reference, a theoretical stealth bomb casually dropped by my conversation partner Mika Buljević: 'independent culture'. I remember myself, sitting on the terrace of Program in the heat of the Zagreb summer, rambling: 'I'm sorry? Independent culture? I don't think I understand you. Culture always depends on money and labor. No one really believes that a thing like independent culture could ever exist, right?' I was, of course, wrong. My notion of 'independence' was too narrow to understand what the term 'independent culture' in Croatia meant. It was necessary to somehow unlearn my understanding of independence so as to be able to formulate a new one. I was hooked and decided to write my thesis about this one question: What is independent culture?

In order to find answers to that question, I had to come back to Zagreb. So, on the first of March 2018, I departed for a three-month stay in the Croatian capital once more. During that time, I did a research internship at the Academy of Fine Arts in Zagreb, under the supervision of Leonida Kovač. This was wonderful for a number of reasons. I remember the first time we had an appointment, one week into my three months. I expected to get fifteen minutes of Leonida's time, some theoretical remarks, and a tip or two about whom to speak to. Instead, five minutes into our two-hour meeting, Leonida picked up the phone and started calling people and handing me the phone to make appointments for interviews. I didn't even have time to realize what was going on or to become shy. Thanks to this head start, I was able to almost twenty people in and around the scene, including Jens Brandt, Boris Buden, Mika Buljević, Maja Flajsig, Darko Fritz, Ivana Hanaček, Jasna Jakišić, Antonija Letinić, Olga Majcen Linn, Tomislav Medak,

Petar Milat, Leonida Kovač, Dejan Kršić, Ana Kutleša, Sunčica Ostoić, Lana Pukanić, Tomislav Tomašević, Goran Sergej Pristaš, Darko Šimičić, Klaudio Štefančić, Lea Vene, Dea Vidović, and Janka Vukmir. Needless but necessary to say, I am very thankful everyone I talked to on tape in Zagreb for sharing their time and thoughts with me.

Fortunately, my life in Zagreb existed of more than only interviews. I went to exhibitions, (private) movie screenings, informal and formal performances, parties, conferences, gallery openings, and dinners. I have been lucky to meet a bunch of wonderful people at and through the Academy – especially the new media department – and make some dear friends: Ana, Gregor, Hrvoje, Ivana, Jasen, Karen, Klaudio, Laura, Leonida, Maja, Mak, Marko, Nika, Sonja, Tara, Tina, and the crews at MAMA and Booksa. As a result, even after the brief period of three months, I felt like I really got some understanding of Zagreb's independent cultures. Since, I have returned to Zagreb several times. During one such trip back, in September 2018, Galerija Miroslav Kraljević hosted me for the lecture *Dimensions of Independence / How Are Independent Cultures Born?* This event allowed me to present the product of my work within the context of the independent cultural scene, and to revise my initial analysis and recognize theoretical dimensions of independence that transcended the local urgency.

Back in Amsterdam and after my graduation, I joined the Institute of Network Cultures as Senior Intern. I continued to work with my friends from the scene in Zagreb and was provided with the opportunity to rewrite and expand my thesis – to make it into a book. I thank Geert Lovink for his pragmatic interventions

in the argument and Miriam Rasch for her thorough editorial work. Without Miriam, this book would be ten times as boringly academic as it is now, and without Geert, I certainly would not have been able to write the exploded essay which is the third part of this book. My dear friends Koen Bartijn and Mari van Stokkum, as well as my mother Lysbet Haverkamp gave me valuable editorial comments. Two friends from Zagreb also kept contributing to my writing substantially in later stages: Klaudio Štefančić with his unrelenting thoughts, comments, and suggested readings, and Marko Gutić Mižimakov by giving me the chance to publish an excerpt from this book in his periodical, *The Hub Between the Iliac Crest and the Public Bone.* Rosie Underwood, my predecessor as INC-intern, was the best proofreader I could have hoped for, for which I am grateful. I've also been extremely lucky to be with Laura Mrkša, who not only happens to be a supportive partner, but also great designer. She created the beautiful bubbly cover of this book. It's an homage to Zagreb, Little Rome, city of fountains.

A last, big thanks goes out to all the artists and heirs who allowed me to reproduce their work, not as ornaments, but as visual arguments: Braco and Nena Dimitrijević, Darko Fritz, Sarah Gotovac and the Tomislav Gotovac Institute, Minna Henriksson, Nicole Hewitt, Jagoda Kaloper and Ana Tajder, Ana Kuzmanić, David Maljković, Marko Gutić Mižimakov, Constant Nieuwenhuys, Mladen Stilinović and Branka Stipančić, Ilona Szwarc, and This Town Needs Posters.

www.ingramcontent.com/pod-product-compliance
Lightning Source LLC
Chambersburg PA
CBHW052309220526
45472CB00001B/42